Henry Peach Robinson

Henry Peach Robinson

Master of Photographic Art, 1830–1901

Margaret F. Harker

Basil Blackwell

First published 1988

Basil Blackwell Ltd
108 Cowley Road, Oxford, OX4 1JF, UK

Basil Blackwell Inc.
432 Park Avenue South, Suite 1503
New York, NY 10016, USA

British Library Cataloguing in Publication Data

Harker, Margaret F.
 Henry Peach Robinson: master of photographic
art, 1830–1901,
 1. Robinson, Henry Peach 2. Photographers
 —— Great Britain —— biography
 I. Title
 770'.92'4 TR140.R5/

ISBN 0–631–15573–2
ISBN 0–631–16172–4 (Pbk)

Typeset in 10 on 11 pt Bembo
by Columns of Reading
Full colour reproduction by Hong Kong Graphic Arts.
Duo-tone and monochrome half-tone reproduction by Butler and Tanner.
Printed in Great Britain by Butler and Tanner of Frome

Contents

ACKNOWLEDGEMENTS vi

GENEALOGY ix

1 DAYS IN LUDLOW 1

2 PUBLISHERS AND BOOKSHOPS 16

3 THE STUDIO IN LEAMINGTON 21

4 PICTORIAL EFFECT 41

5 LIFE IN TUNBRIDGE WELLS 50

6 PICTURE MAKING BY PHOTOGRAPHY 64

7 THE LAST OF LIFE 75

NOTES 85

APPENDICES

 I CONCISE CHRONOLOGY 91

 II COMBINATION PRINTING 97

 III SCHEDULE OF EXHIBITION PICTURES 100

 IV SELECT BIBLIOGRAPHY 115

INDEX TO TEXT 118

ACKNOWLEDGEMENTS

The author wishes to thank the following who have given valuable assistance during her search for material for this book and its compilation: the National Museum of Photography, Film and Television; the Royal Photographic Society; Richard Chamberlain-Brothers, Assistant Archivist, County Record Office, Warwick, who provided information about Robinson's photography business in Leamington and access to the publication *Warwickshire Illustrated*; Brian Coe, Curator, Royal Photographic Society, for information about the Niepce relics; Sir William Crawshay; Edward Daynes, RPS member, for his contribution to library search; Frances Dimond, Curator, Photograph Collection, Royal Archives, Windsor, for searches; Roy Flukinger, Curator, Photography Collection, Harry Ransom Humanities Research Center, University of Texas at Austin, USA, for enthusiastic response to my researches and providing access to the Gernsheim Collection; Margaret A. V. Gill, Museum Curator, Tunbridge Wells Museum and Art Gallery, for access to the Robinson Collection of Photographs, for her enthusiasm and provision of documentary information about the Robinson family in Tunbridge Wells; W. G. Gibbons, Leamington, for help with local history research; Peter Winwood Gossage and Colin Midwood for information about the Gossage family; Bill Jay, Photography Tutor, School of Art, Arizona State University at Tempe, USA, for access to his library files and documentation on N. K. Cherrill; Peter Klein and David Lloyd of Ludlow, for information about the history of the town and its architectural features; Miss M. Laird, for information about John Laird of Birkenhead and the loan of Robinson's photograph of the famous shipbuilder; Jean Mauldon, Divisional Reference Librarian, Tunbridge Wells County Library, for assistance with locating references to Robinson's photography business in Tunbridge Wells; Mr and Mrs George Messer of Brampton Bryan, for information about Walter Vickerstaff Messer and giving access to the Messer album; Weston J. Naef, Curator of Photographs, J. Paul Getty Museum, Santa Monica, USA, for his enthusiastic response and access to the Getty Collection; Eugene Ostroff, Curator, Division Photographic History, Smithsonian Institution, Washington, DC, USA, for his interest in the project and access to the Photograph Collection; Pamela Roberts, Librarian/Curator, Royal Photographic Society, for help in locating material and with illustrations from the Robinson Collection of Photographs; Brett Rogers, British Council, for her encouragement; Major Edwin Rowland Winwood Robinson, great-nephew of Henry Peach Robinson, to whom the author is especially indebted for his long-sustained interest in the project and in making the family archival material available to her, and to his two sons Henry and Nicholas Robinson, who continued their father's collaboration with the author in making documents and photographs available; Stephen Rowson, Ffoto Gallery, Cardiff, for sharing his insights to the Crawshay family; Joan Ryder, Ludlow Historical Group, who has

shown most remarkable and enthusiastic dedication to detailed research of Robinson's life and connections in Ludlow and who explored the genealogy of the Robinson–Winwood families from the mid-sixteenth to the end of the nineteenth century with such thoroughness and to whom I am most grateful; A. H. Slade of Knowbury Ludlow, grandson of Mary Annie Asterley (née Bibby), for information about the Bibby and Robinson families and the loan of the Bibby album; Robert A. Sobieszek, Director, Photographic Collections, International Museum of Photography at George Eastman House, Rochester, USA, for his enthusiasm in the project and assistance with illustrative material; Sara Stevenson, Curator of Photograph Collections, Scottish National Portrait Gallery, Edinburgh, who helped trace the painting of *The Dead Lady*, and Gabriel Summers, who provided the information about Sir Joseph Noel Paton's family which led to *The Dead Lady*; Roger Taylor, Curator of the Kodak Collection, National Museum of Photography, Film and Television, who provided useful information and made copy negatives available of two important photographs; Vera Tomkins, granddaughter of Henry Peach Robinson, who loaned Robinson's Diary and other important documents and provided insights into the last few years of Henry Peach Robinson, and whose daughter, Ann Turner, and son, A. R. Winwood Tomkins, have so kindly provided further documentary evidence relevant to episodes in their great-grandfather's life; John Wilson, researcher and collector of photographically illustrated books, for many discussions on Victorian ideas and ideals.

The author thanks the following for their assistance with the documentation, reproduction or loan of Robinson's photographs and other illustrative items: Meir Berk; the Courtauld Institute; Neil Cross; A. J. Crowe, County Librarian, Shropshire; Philippe Garner, Sotheby's; Mark Haworth-Booth, Victoria & Albert Museum; Hereford Museum and Art Gallery; Hans P. Kraus, Jnr; W. J. Norton, Curator, Ludlow Museum; Joan Schwarz, Public Archives of Canada at Ottawa; Lindsey Stewart, Christie's; Keith and Usha Taylor; John Ward, Science Museum, London; Michael Wilson, assisted by Violet Hamilton; A. J. Williams, Area Librarian, Ludlow Library.

Photography by Prudence Cuming Associates; Rob Cox, National Museum of Photography, Film and Television; Peter Sweatman Hedgeland, ABIPP, ARPS; Jill Morley Smith, ABIPP, ARPS; and others.

Typing of texts by Carole Longhurst.

In particular the author is indebted to Terry Morden, National Museum of Photography, Film and Television, administrator of the Robinson Exhibition which opened at the Museum in Bradford in October 1987, whose invaluable help and enthusiasm never failed. The author acknowledges with thanks the generous co-sponsorship of the Robinson Exhibition by Michael Wilson of Eon Films, and by the Barbican Art Gallery.

Finally, the author wishes to record her indebtedness to her late husband, Richard Farrand, whose help and encouragement in the early stages of research never failed.

GENEALOGY

GEORGE WINWOOD of Hanley Childe, Worcs.
married *c*.1581

ARTHUR WINWOOD (eldest son)
Baptized 25 Sept. 1582. He was Clerk and Receiver of Fines, Ludlow Castle;
later appointed Porter (equivalent to Prison Governor) at Ludlow Castle
married *Jane* (nee ?)

JOHN WINWOOD (5th son)
Baptized 17 July 1631 at Onibury, Shropshire;
married *Marie* (née ?)

BENJAMIN WINWOOD (9th son)
Baptized 5 Oct. 1681;
married *Anne Tew* of Downton, nr. Ludlow, 17 Nov. 1709

WILLIAM WINWOOD (eldest son)
Baptized 3 July 1711. He became a Glover of Ludlow;
married (1) *Elizabeth Gelly*, 19 Apr. 1732
(2) *Hannah Pinches* 23 Aug. 1743 (marriage bond date)

ELIZABETH
Baptized 25 July 1745; married
RICHARD ROBINSON of Richard's
Castle, in 1776 at Bitterley,
Shropshire

Benjamin

Mary

RICHARD ROBINSON
Baptized 5 Dec. 1778. He became a Glover of Ludlow;
married *Eliza Harding* 28 May 1804

John

Ann

Henry

JOHN ROBINSON
Baptized 8 May 1806. He became a National
School Master in Ludlow;
married *Eliza Peach* 11 Aug. 1829;
died 7 Feb. 1885

Eliza

Richard

HENRY PEACH ROBINSON
Born and baptized 9 July
1830; married *Selina
Grieves* of Ludlow in
February 1859;
died 21 Feb. 1901

Clare Elizabeth (Clara)
Baptized 15 June 1834;
married F. H. Gossage at
Widnes, 5 Jan. 1860

Anne
Baptized 5 Feb. 1839;
buried 30 Oct. 1839

Herbert John (Bob)
Born 9 July 1845; baptized
11 July 1845; married
Agnes Esther Tate of
Liverpool 26 Oct. 1876

Edith
Baptized spring 1860;
married Dr George
Abbott in late spring
1892; no issue
(adopted son killed in
1914–18 War);
died 1952

RALPH WINWOOD
ROBINSON
Baptized 11 Sept.
1861; married *Janet
Spence Reid* in 1887;
died 11 April 1942

Maud
Baptized 4 Jan. 1863;
married Dr George
Craigie Bell 28 May
1888; no issue

Ethel May
Born 25 May 1864;
spinster;
died 9 April 1932

Leonard Lionel
Born 1872; married
Kathleen Bell *c*.1896;
no issue

The Robinson family claimed descent from Sir Ralph Winwood, Kt., Principal Secretary of State and Privy Councillor to King James I of England, baptized in 1563 and died in 1617. The Winwood estates were willed to Ralph Montagu, and were absorbed into the Montagu family estates thereafter. It seems unlikely that the Robinson connection to the Winwood family is in direct line to Sir Ralph but rather through Arthur Winwood, a second cousin or second cousin once removed of Sir Ralph Winwood. He was descended from Sir Ralph's grandfather, Lewis Winwood. The obvious link between the Robinson and Winwood families is in 1776 when Elizabeth Winwood married Richard Robinson, of Richard's Castle, at Bitterley, Shropshire. The cap and ring (plate 34) in the possession of the Robinson family are believed to have belonged to Sir Ralph Winwood. From 1861 the name Winwood was given as a second name to members of the Robinson family and descendants of unions between the Robinson, Gossage and Tate families.

1

DAYS IN LUDLOW

I am strongly of opinion . . . that I was prepared *by all my surroundings to become a photographer for years before I first smelt collodion.*

H. P. Robinson, 'Autobiographical Sketches'

Henry Peach Robinson was born on 9 July 1830 at Linney, Ludlow, an old, historic town in Shropshire, England. His father, John Robinson, was Master of the National School of the Church of England from 1827 to 1855. The school was in the Buttercross Building in the centre of Ludlow. His mother, Eliza Robinson (née Peach), was 'full of artistic instincts in advance of her time and was the recognised authority in all matters of art and taste for the town and neighbourhood.'[1]

As he was the first born to them and not a robust child, his anxious parents had him baptized the same day at the parish church of St Laurence, Ludlow, where they had been married on 11 August 1820. This frail beginning could have accounted for the bouts of ill-health to which he was prone throughout his life.

Childhood and Youth

Henry Robinson was profoundly influenced by the circumstances and happenings of his childhood and youth and especially by his surroundings in that mystical region of the Welsh Marches, the borderland between England and Wales in the County of Shropshire, and in particular by the medieval town of Ludlow.

As he emerged from adolescence he developed a marked ability as a writer of descriptive prose in a style which is eminently readable today and he wrote poetry of the vernacular kind so popular with the Victorians. In many instances his own words convey his feelings and thoughts far better than those of a biographer.

Now a word for the paradise into which I was born . . . for I consider it an inestimable blessing to have first seen the light amid beautiful scenery . . . I have never altered my opinion, that it is the most lovely town in any of the visible worlds . . . Beauty, picturesqueness, and all loveliness are the food of art. In Ludlow, these qualities are to be found in perfection. Built on a hill, partly surrounded by two lovely rivers, the Teme and the Corve, the former crossed by many picturesque old weirs which break the water into streams and ripples, leaving streaks of calm lengths for boating; set in an amphitheatre of near and distant hills, with glimpses of Welsh mountains beyond. I suppose there is not so much beauty confined in so small a space anywhere as in my native town. The town itself, dating from Saxon time, rises around one of the finest mediaeval castles in England which, crowning the elevation, composes well with a noble church. There is scarcely a square yard that does not invite the youth blessed with intuition, to become an artist. Ruin, rock and river, woodland and pasture, call for artistic recognition. And, to add to the poetry of the place, here the youthful Milton produced 'Comus' and Butler wrote 'Hudibras'.

However brilliant Ludlow may have been during the days of chivalry, or when it was the Court of the Marches of Wales, as far as personal memory goes, it was always a 'sleepy town', a great addition to its attraction. There was no railway when I lived there, and people never seemed to leave the town from generation to generation; there was no necessity for holidays.[2]

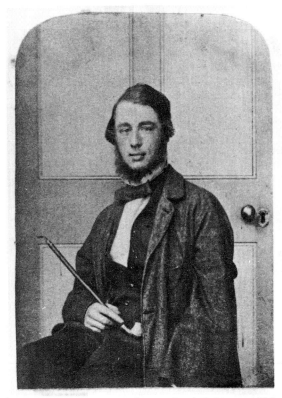

Figure 1 *Self-portrait of Henry Peach Robinson*, 1856.
Private collection

Robinson recalled with some nostalgia that as a small boy he heard the night-watchman in the streets calling the hour and the weather and where even in the last years of the nineteenth century, 'The curfew tolls the knell of parting day'. It was a very romantic place to a sensitive and impressionable youth and under its spell Henry Peach Robinson became a Romantic artist, dedicated to the notion of the Picturesque.

Robinson was not a member of the group of early photographers who led a wealthy, leisured life and enjoyed the benefits of the best form of education of the period, including travel abroad. His father's income as a National schoolmaster would have been modest and his mother's dowry consisted of a number of small properties in Ludlow, which probably accounted for the family's fairly frequent moves from one house to another during Henry's childhood and youth. In his 'Autobiographical Sketches' Robinson said:

It may be as well to state that I am the first child of my parents [in those days this implied responsibilities to home and family which seldom apply today], and though of good family, was not born to what in these

wealthy times would be called affluence, a condition which I have for many years considered was the most fortunate that could have happened to me, for it had much to do with fitting me into the particular groove which beneficent evolution seems to have provided for me . . . As some means of artistic expression was imperative to satisfy the irresistible impulse, I took the gifts the Gods provided, and it proved to be photography, and I think adequate. I can honestly say that if the art has been good to me I deserve it, for it has had the greater part of my thoughts ever since I commenced. I found the right niche into which to fit myself.[3]

Henry's sister Clara was born in 1834. They became good companions and shared many friends, in particular Frederick Herbert Gossage, son of William Gossage, the genius who played an important role in the development of the British heavy chemical industry.[4]

A year later Henry was sent to Miss Tomkins's School (a Dame's School) in Middleton, a very pretty village about three miles from Ludlow, as a boarder for one year. A sequel to this episode is that one of his grandaughters by his son Ralph, Vera Robinson, married into the same Tomkins family *c.*1906.

From 1836, for seven years, Henry attended a small private school in Ludlow, Horatio Russell's Academy in Mill Street, as a day scholar. He was an eager, attentive pupil but also full of fun.

'I verily believe they were the happiest days I shall ever spend,' he recorded in his diary in January 1849, but his schooling there ended when he was only thirteen. Nevertheless it stimulated his desire for learning and from then onwards he developed a love of literature and read voraciously, encouraged by his father, who was a devoted student of Shakespeare, whilst his mother instilled in him a practical interest in the arts in general.

One of Henry's most treasured possessions was his copy of the *Works* of Shakespeare, given him by his godfather as a christening present. After he had acquired a skill for carving in wood and stone in his twenties, he carved covers for this book in wood taken from the famous Herne Oak, mentioned in a Shakespeare play, which had been blown down in a gale in Windsor Park, where it had stood for centuries (plate 15). He illustrated the book with photographs he had taken of places in Warwickshire which have a connection with William Shakespeare (plates 11–14). The practice of illustrating books with actual photographs became popular in the 1850s and provided a modest source of income for the professional

photographers who supplied albumen prints to the publishers. Although Henry Peach Robinson is known to have provided photographic illustrations for publications, notably for *Warwickshire Illustrated* (plates 9–10), which he published jointly with Nathaniel Merridew in 1858, there is no evidence to prove that he illustrated more than his own copy of Shakespeare's *Works*.

On his thirteenth birthday he had been at school eight years. As he knew a little Latin and could repeat a collect, it was decided that his school education was complete.

My *real* education now began. My attainments at this time were very scant; I had, however, little to unlearn, that most difficult preparation for education. Modern languages, the sciences, or drawing were never heard of in my school or, indeed, in any school in the town, but I was not without another kind of knowledge: I could distinguish between upper and lower Silurian rocks and old red sandstone; knew most of the common wild flowers, and could even name the bones and outer muscles of the human body; could dress a fly and stuff a bird, as well as set a moth. I could draw long before I could write, and could now sketch fairly well from nature, and give a good idea of a likeness in pencil. I also remember I had read several of Shakespeare's plays and some of the Waverley Novels, and had tried to write a story.[5]

A keen interest was taken in Natural History in Ludlow. The inauguration of the Ludlow Natural History Society took place in 1833 and the museum was brought into existence in 1834, and filled with remarkable subjects. The youthful Robinson would have been a frequent visitor.

Even at this early age Henry Robinson was drawn irresistibly to the arts and, although at this stage he kept his literary activities of reading and writing separate from his practice of drawing and painting, they were synthesized in his late teens and early twenties when he began to illustrate verse and interpret narrative with drawings, paintings and etchings. This tendency was further developed when he had mastered the techniques of photography.

John Robinson, with some misgivings but appreciative of his son's acute observation of all things visual and knowing of his great love and enjoyment of natural beauty, decided to give him a year's freedom in which to practise drawing and painting, as Henry had expressed his desire to become an artist. This freedom demanded considerable self-discipline on the part of one on the threshold of adolescence. His recollection of that year gives no indication of a structured programme of studies. It seems that he was expected to prepare himself for his intended career in whatever way he thought best, although he was put on his honour to do the best with the time that his conscience dictated. Robinson said that this unusual condition turned out a wise one. Although he often wondered if he was justifying the trust placed in him, he laid the foundation of an education 'absolutely fitted to my needs'.[6]

The year began with mathematics, but as he received little help with the subject he devoted most of his time to drawing, painting and artistic anatomy and to such reading as he could get. Prominent among the books available were the Elizabethan dramatists, old English poetry ('the study of this branch has been a delight to me ever since') and the eighteenth-century writers. He said:

It is usually the struggles of a life that provide the lessons. The early part of mine was full of struggles, but also full of what is called luck that helps effort, and with all its crosses, full of happiness. Taking a calm look backward I think that the episodes I would prefer *not* to have missed are the struggles. The fighting spirit, taken in its best sense, is the most useful a man can have.[7]

This statement throws a light on Robinson's philosophical outlook on life and his determination to overcome obstacles. He was unafraid of hard work and his motto was *Do not despair, persevere*. He was forever an optimist and a cheerful man. He believed that the good things in life outweighed and outlived the bad. He must also have had some faith in destiny. 'The Phrenological Delineation of the Character of Master Henry Robinson', which was drawn up by Edwin Thomas Hicks, Professor of Phrenology, is an interesting and fairly accurate analysis, with the exception of the reference to Mathematics, as indicated by this extract:

There is in this character a disposition to delight in the marvellous, a strong feeling of resentment when opposed, a quickness of temper not easily subdued, at times a degree of obstinacy. He will be vain of himself if the love of approbation be not checked. He has a good power of imitation, would learn to draw well. His perceptive faculties are very fully developed, and well combined with the reflective. He will not do much at music but will be likely to excel at Mathematics and should be trained for a practical chemist or a practical engineer or if circumstances prevent it bring him up to be a practical mechanic.[8]

The lack of formal art education in those days

was a serious drawback to anyone who wished to become an artist. Robinson said:

In 1843 there was not a School of Art in all the land, *now* [1897] drawing is looked upon as of almost as great importance as reading and writing; *then* science was unknown away from the large towns, in our times [1897] there are technical classes in every village. We were not without teachers, but their teaching seldom went beyond accomplishments; and what was accomplished . . . consisted of pencil copies of impossible heads and classical landscapes on smooth Bristol board, and water-colour drawings of distorted flowers. In the practice of drawing the most stupid conventionalities prevailed over nature; the straight stalk of a flower was always made to curve according to the line of beauty, for nothing must be ungraceful, and grace was a system of curves . . . Ludlow was quite fifty years behind the rest of the world. Art was not in very good repute, in fact, it was looked down upon. I believe I was the only serious art student in the town and was alternately encouraged and dissuaded.[9]

In spite of the serious lack of formal instruction in art the youthful Henry had the good fortune to be introduced to Richard Penwarne, a cultured gentleman of leisure, who lived in one of Ludlow's lovely old town houses in Mill Street. The introduction was brought about by one of those 'accidents of fate' of which he took full advantage. In the early autumn of 1843 Henry went with his father to Partridge's, the stationers, to buy some drawing materials. One of Ludlow's most popular residents, Captain Wellings, was in the shop and gave him half a crown towards paying for them, telling him to show him the drawings when done. Henry produced a drawing in chalk of an old man's head and three other heads in pencil and Captain Wellings took Robinson to meet Mr Penwarne, who encouraged him and instructed him in how he could make improvements. From that day for nearly eight years he took his work to Penwarne for criticism and advice.

Richard Penwarne must have considerably aided Henry Robinson's education. He had been admitted as a student of the Royal Academy in 1809 when Henry Fuseli was keeper and John Opie (a lifelong friend of his father's) was Professor of Painting. In addition to his knowledge of the arts, he had acquired many practical skills and developed a keen intellect. Robinson was enchanted by him:

When I call upon him, as I did almost daily for about eight years, he would immediately continue the discussion or argument we were engaged in on the previous day . . . I learnt more than drawing from my old friend. I had the run of his library; he taught me the use of the lathe and etching; his anecdotes of the painters he had known, especially Fuseli, and of society early in the century, were of absorbing interest; and an afternoon's fishing with him was an imposing demonstration. He was a scientific fisherman, and was always inventing ingenious engines to lure the wily trout. He habitually took a quantity of these with him, and when he was mounted on his old white pony, almost smothered in baskets, nets and other impediments, he exceeded the picturesqueness of Dr Syntax himself.[10]

The Teme, even today, is a good trout river and Robinson spoke of the baskets of trout he took home from time to time.

An art which *was* encouraged in Ludlow at this time was music, which, according to Robinson, was

practised to a debilitating degree . . . every young man played the flute, and everyone acknowledged the connection between virtue and flute-playing . . . The sound of the cornet was to be heard on 'The Hill' at night . . . there was not a piano in every dwelling but there were a few in the town. My mother's was an old square, not unlike a harpsichord, but it was the best to be borrowed when travelling singers came to give an entertainment . . . we were all musical. My father was famous for his singing of patriotic songs. It was a town which was always expressing its loyalty, and we were ready to roast an ox on the Castle Green on any occasion; I still remember the Coronation Ox with its gilded horns.[11]

A feature of Ludlow in the 1830s and 1840s was the large number of wealthy and aristocratic families who had houses in the town. Even in the narrow lanes were great Queen Anne and Georgian houses, many of which are still standing.

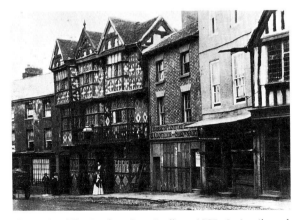

Figure 2 *The Feathers Inn, Ludlow*, 1855–6. Attributed to H. P. Robinson. Courtesy Hans P. Kraus Jnr

The profusion of timber-framed buildings are of much earlier origin, and although the majority are Elizabethan or Jacobean, and were lavishly decorated when Ludlow had its own school of carpenters, others date from the Middle Ages, as roof construction reveals. For very rich clients the carpenters applied a great deal of external decoration in the form of wood carvings.[12] A particularly fine example of this is the Feathers Hotel (formerly Inn), where there are vertical strips of 'barley sugar' moulding and raised heads in the centre of the first floor panels (figure 2). It is not surprising that Henry Robinson took a great interest in architecture, both sacred and secular, and many of the discussions he had with Richard Penwarne would have been on this subject.

Many of the large house owners had estates in the country districts of Shropshire and Herefordshire but spent 'the season' in the more social environment of Ludlow. Trades to support this fashionable centre were built up in the late eighteenth and early nineteenth centuries. Glove making and malting in particular flourished and Ludlow was of continuing importance as a market centre. By Robinson's day a prosperous middle class had emerged and social activities were further extended.[13] An interesting phenomenon was the readiness of Ludlow's inhabitants to transcend class barriers, as Robinson records: 'During the time I was an apprentice to a bookseller and printer I was often invited to the houses of what part of the town diffidently called "the nobility and gentry" . . . several of them seriously furthered my education.'

Richard Robinson, Henry Robinson's paternal grandfather, was a glover, as was his great great grandfather, William Winwood (1711–95). At that time and in earlier days many important positions in the town were occupied by people engaged in the trade. In *Felton's Guide* of 1821 it was stated that 'the glove trade has been brought in late years to great perfection and repute here, and the number of men, women and children employed in it amounts to several hundreds.' When Robinson was a child the trade almost entirely failed partly owing to the introduction of gloves of French manufacture but also to cheaper fabrication in Leicestershire and Nottinghamshire.[14]

Henry Robinson's first introduction to photography came in 1844 when he read an advertisement for Talbot's *Pencil of Nature*, a book published in six parts, from June 1844 to April

1846, lavishly illustrated with calotypes.[15] Subsequently he had a dim recollection of seeing 'a little house of glass' set up in the inner court of the castle 'in which a Mr. Jones, brother of the janitor of the castle, was said to take portraits on little bits of silver plate . . . Then came a blank and I recall no more of photography until about 1850.'[16]

The Years of Apprenticeship

In spite of his efforts Henry failed to convince his father that he would be able to make a stable income as an artist and with some reluctance he agreed to prepare himself for a trade which would provide a good livelihood. Accordingly on 20 May 1844, he went to Richard Jones – printer, stationer and bookseller – of 5, Broad Street, Ludlow, to study the trades of printing and bookselling.

After the required trial period he was indentured to Richard Jones on his birthday, 9 July, aged fourteen, for five years. He made the following entry in his diary: 'And long years they are too working from seven in the morning till nine at night is nothing but slavery and I shall hail the morning of the 9 July, 1849, with the greatest joy.' It must have been purgatory at first after his year of freedom following the pursuits he enjoyed most.

Richard Jones's premises were on the south side of the yard of the Angel Hotel in Broad Street. Recent excavations have shown that extensive medieval remains have survived.[17] The printing shop must have been a drab, dark place in which to spend the bright warm days of summer.

Robinson always made the best of any situation in which he found himself:

Now I cannot say I did not enjoy my apprenticeship, for the employment soon became congenial, and I added to my knowledge enormously, chiefly on the literary side, and my rapid mental growth surprised myself. By good fortune the head printer [Francis Page] was a curious old man, full of out-of-the-way knowledge, which he delighted to impart. But what slavery the work was! The hours would astonish a present-day apprentice [1897] who beside late opening and early closing, must have his weekly half holiday. In summer we went to work at 7 o'clock in the morning and left at nine at night; in winter an hour was knocked off each end. There were no holidays from year end to year end. Perhaps two or three half days in summer to play cricket, could be begged, but were as often refused . . . In my case I circumvented

the early hours of business by rising still earlier, and in the summer was in the little attic studio, in which I took great pride, by 4.30, or to an occasional cricket practice on Whitcliff . . . Then there was always half of the dinner hour available, as well as an hour or two at night for reading.[18]

As a protest against these long working hours Henry Robinson and forty-two other young men sent a 'requisition' to the mayor of Ludlow 'to take into consideration the best means of effecting the early closing system now so generally carried on throughout the towns of England'. They signed their petition on 22 May 1849. The mayor refused to intervene on their behalf.

A wealthy patron of the arts occasionally visited Ludlow. On one of these occasions, in the summer of 1845, he saw Henry Robinson sitting on the river bank sketching during his lunch hour. He joined him for 'a friendly chat', and looked through the portfolio alongside, which contained recent drawings, including single figure studies. He was obviously impressed as, after talking to John and Eliza Robinson and obtaining their agreement, he offered Richard Jones (to whom Henry was indentured) 'a good round sum' to cancel his indentures so that he could take the young artist to London to devote himself to drawing and painting. The offer was refused, to Robinson's bitter disappointment. 'I was crushed for a time, and no work or play of any kind could be got out of me, but I eventually recovered.'[19]

In fact what Robinson learnt in Richard Jones's establishment stood him in good stead throughout his life. He studied all aspects of printing including the reproduction of illustrations by wood and metal engraving. He had to make his own tools at a blacksmith's forge and scrape and polish old plates and wood blocks. He also experimented with a process of colour printing with combination blocks but 'there was no encouragement in that office except for old methods'. This knowledge of the processes and their practice greatly facilitated his understanding of requirements in the reproduction of photographs at a later date.

His time was alternated between the printing works and the bookselling side of Jones's business. Although he applied himself to learning the commercial aspects of bookselling, he was much more interested in the books themselves. He became acquainted with classical sculpture through the *Penny* magazine, in which were reproduced the *Apollo Belvedere*, the *Laocoon* and the *Dying Gladiator*. The cartoons of Raphael were also reproduced in this remarkable magazine. He invested most of his pocket money in the *Art Union Journal*. The editor, S. C. Hall, and his accomplished wife became his close friends in later years when he was an eminent photographer.

Although his practice of drawing and painting was necessarily curtailed during the years of apprenticeship, he managed to produce a certain amount of work to show to Richard Penwarne and some of his sketches were published, including a view of Ludlow Castle with verbal description in the *Illustrated London News* in November 1845 and a sketch and description of Wigmore Castle in the same journal on 3 March 1849. In December 1848 he began a painting of Ludlow Castle for Miss Thomas of the Criftin (finished in April 1849), for which he charged £1 10s; and he finished a watercolour sketch of Castle Street for Mr S. Stead for 12s. This was the start of his commissioned work. What he lacked in time to devote to the practice of art was compensated for by his study of art theory and criticism. in 1844 a 'kind friend' gave him a copy of John Ruskin's *Modern Painters*, volume 1. In writing some fifty years later about his reactions at that time to Ruskin's ideas on art Henry Robinson said:

In that volume Ruskin had created an epoch in art criticism. The ideas were new, and the language in which they were given such as had never before been applied to art. There was no amateurism about it, it was the work of a master in poetical prose. I have read this volume for more than fifty years and it does not lie quietly on its shelf even now. The author makes the youthful mistake of confounding nature with art, and in stating that art can be learned from nature. Art is not spontaneous, it is the slow growth of centuries. That is why a photograph pure and simple can never be a work of art.[20]

Another book which had a profound influence on Robinson as an artist and photographer, at this early age and thereafter, was *Burnet on Composition*. He said that Ruskin 'sent me direct to nature for everything' but that Burnet 'taught me that nature was only the foundation of art. The one corrected the other.' Robinson held the view that if Burnet had been wrong then artists of all ages have been wrong, as his opinions were built on a study of their works.

During Henry Robinson's apprenticeship Thomas Wright's *History of Ludlow* was printed. Wright had been apprenticed to Richard Jones some ten years earlier, then went to college, took

a Master of Arts degree and became a prominent member of the Archaeological Association and other learned societies and the author of many historical and archaeological works. His example encouraged Robinson in his literary endeavours, and he practised writing assiduously. He was schooled in the art by Francis Page, the head printer, who urged him on to publication. His literary labours appeared from time to time in the *Hereford Times* and as accompaniments to his sketches of historical architecture.

In spite of his studious nature, thirst for knowledge and industrious pursuits, there was a strong fun-loving side to Robinson's nature, coupled with high spirits, and he enjoyed the company of many friends. Several incidents which occurred during his last year of apprenticeship and later are recorded in his Diary and throw an interesting light on certain customs, transport, entertainments, and social mores of those days.[21]

Henry Robinson enjoyed many an adventure with Frederick Herbert Gossage, who in 1847, aged fifteen, was apprenticed to a chemist and druggist in Ludlow, J. R. Marston. The following year, whilst Henry kept a 'look-out', Fred courted Clara Robinson when her parents were out by using the coal-hole of their house as entrance and exit. Fred's father, William Gossage, broke the apprenticeship in 1850 and took his son to Widnes, Lancashire, 'to labour in the Gossage soap works' which he had founded.[22]

January 1849 was filled with social events, especially balls. Henry Robinson loved dancing, as the following entries in his Diary for 1849 show:

January 4. Went to the family ball over New Buildings. At the supper Master A. Rocke threw a leg bone of a turkey at Mr Prothero, the provider of the supper. For this Walker gave him a public reproof in his report of the ball in the *Hereford Times.*

January 9. Ball given by Mr T. Jones and held at Mr R. Jones'. I attended.

January 10. Attended the Gypsy Ball over the Market Hall. Kept it up till half past six [in the morning].

January 12. Went to ball given by Mr R. Jones.

January 17. Began to make arrangements for forming a Corresponding Society to correspond annually and give lectures now and then.

January 18. Went to ball at the Crown Inn, Tenbury, in Robert's Trap along with Lizzie, Maria [probably his cousin Maria Jennings], Jane Robinson, William Robinson and Miss Ellis. This ball was chiefly attended by country people. I was very much delighted with the different styles of dancing. The supper was excellent.

January 19. Returned home from Tenbury at half past eight in the morning of January 20. [He had to make up for the time lost so he went to the printing works at 9 o'clock in the evening of January 20 and worked there till 9 o'clock the following morning – Sunday – at a pamphlet by Dr Bryce on *Workhouse Industrial Training.*]

Old customs in Ludlow town were sacrosanct. Robinson recalled one Fifth of November when the celebration of the discovery of the Gunpowder Plot came to a bad end. He and his friends were cutting down a fir plantation to make a bonfire in the Castle Square, for the Corporation had denied them 'the usual ton of coal which from time immemorial had been allowed for this patriotic purpose'. The police intervened and a baton blow was aimed at Robinson's head but he ducked and it landed on John Shepperd next to him, who died from the effects some weeks afterwards.

One of the oldest customs practised in Ludlow was that of Rope Pulling on Shrove Tuesday. The Corporation provided a Rope three inches in circumference and thirty-six yards in length which was given out of one of the windows in the Market House as the clock struck four. The two rival parties, one contending for the Castle Street and Broad Street Wards and the other for Old Street and Corve Street Wards, commenced an arduous struggle. As soon as either party gained the victory by pulling the Rope beyond the prescribed limits, the pulling ceased. This was followed by a second and sometimes a third contest, the rope being purchased by subscription from the victorious party and given out again.[23] The practice was stopped in 1851 because of the disorderly scenes and dangerous accidents which frequently occurred.

Henry Robinson's favourite sport was cricket. He was a member of the Ludlow Junior Cricket Club and records several matches in his Diary for 1849 including one at Leominster on 15 August to which the team were conveyed on Crane's Horse-drawn Omnibus, hired for the occasion. 'We all crowded on the top and were often very nearly over. The omnibus is licensed to take seven outside but we managed to cram fifteen on the roof. We kicked up a most horrible row both going and coming.'

Henry Robinson's great love of natural beauty and empathy with the countryside and rural life developed in his youth from the pleasure he took

in walking. Transport in those days was mainly confined to horse-drawn vehicles, donkey carts for children and horseback riding. It was very early days for rail travel. The only alternative was to walk. Robinson, his family and friends walked for miles. They thought nothing of walking to Leominster from Ludlow and back in a day (twenty-four miles), and frequently walked to Brampton Bryan via Leintwardine (twelve miles) to visit their cousins, the Messers.

A Diary entry for 11 February 1849 refers to a walk with Henry Bedford (the youngest brother of the landscape/architectural photographer Francis Bedford) to a hill near Caynham Camp. After the midday meal in Ludlow he walked up the Whitcliffe coppice and 'after tea over the hill so that I had plenty of walking for one day'. On

5 April 1850 he went shooting in Brampton Bryan Park in the morning and shot two squirrels. In the evening he walked to Presteigne with J. Messer, a cousin, a distance of ten miles there and back. 'There is scarcely twenty yards of level walking between the two places.' Whilst in Presteigne he made a sketch of the Haynes's house and saw his sweetheart, Marianne Bibby, who was staying with her friend Jane Haynes for the holidays.

A most spectacular view of Ludlow, its Castle and Dinham Bridge, which spans the River Teme, can be obtained from the Whitcliffe, a favourite haunt of Robinson and his friends. In his day the steep slope was grass-covered common land whereas today most of it is shrouded in trees. One of Henry Robinson's

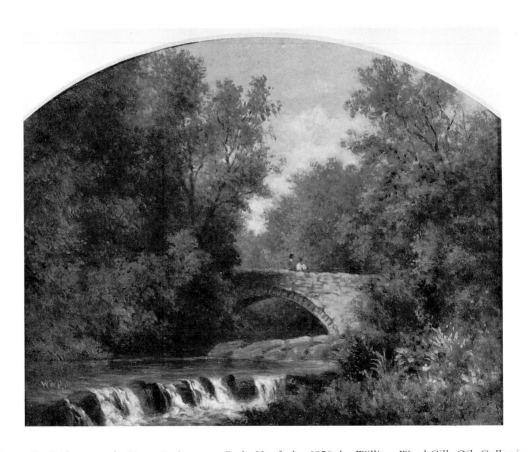

Figure 3 *Bridge across the Stream in Armstrong Park, Hereford, c.1850,* by William Ward Gill. Oil. Collection: Hereford Museum and Art Gallery

Figure 4 *The River at Hereford*, *c*.1850, by George Reynolds Gill. Pencil and wash. Collection: Hereford Museum and Art Gallery

earliest photographs on collodion plates was taken from the Bread Walk on the Whitcliffe,[24] looking down on Dinham Bridge, which forms a sinuous diagonal line across the river (plate 28). This Gilpinesque view must have greatly appealed to him. The Whitcliffe, in addition to affording him splendid views of the town and countryside also provided the backdrop for several of his early genre figure studies (plates 32, 30).

Painters, Painting and Sculpture

One of the major influences on Henry Robinson as an artist was his friendship with William Ward Gill (1823–94) and his younger brother George Reynolds Gill, who were members of a family of landscape painters. Their elder brother, Edmund, was nicknamed 'Waterfall' Gill because of his great skill in the painting of those subjects.

The family lived, variously, in Ludlow and Hereford.[25]

Although William Gill was seven years older than Henry Robinson, they were constant companions during the very limited spare time of Henry's bondage and the more leisured fifteen months which followed. They shared the same passionate interests: love of nature, landscape and painting. Henry Robinson's style and subject selection is akin to that of William Gill and his use of the pencil is closely related to that employed by George Gill, with whom Henry also enjoyed a very amicable friendship (figures 3, 4, 5; plates 21, 22). There are several references in the Diary to the times they enjoyed together. On 1 July 1849 the threesome, after the midday meal, started a walk to the top of Titterstone through Bitterley. They arrived at the top 'at 5 o'clock and were amply compensated for the trouble we had taken in reaching it by the

Figure 5 *Robin Hood and Maid Marion in Sherwood Forest*, 1850, by H. P. Robinson. Pencil drawing in the Bibby album. A. H. Slade collection

splendid view that appeared before us'. One of their favourite walks was to Downton Castle and the water mills, where William and Henry played Welsh harps to the accompanying sound of the rushing river at Hay Mill. It had 'a curiously wild effect. One year we spent a couple of months at that romantic spot, the picturesque beauty of which is known to many photographers,' reminisced Robinson in 1897.[26]

Robinson made interesting reference to the production of landscape paintings in the 1840s and 1850s: 'One great fault of landscape painters at that time was that they seldom or never painted direct from nature. Every picture was reproduced from a sketch or sketches: sometimes slightly tinted with water-colours; at others with the colours written on them or marked with hieroglyphics to which there was a key.'[27] Also he referred to the 'practice of "remembering nature", and what is now called visualization. We would examine a view carefully in every detail, log it down in the memory, and at a future time . . . make a sketch at home of what we remembered, afterwards taking the sketch to the view for correction. This not only practised the memory, but led us to look into nature more minutely.'[28]

Robinson followed similar procedures when he practised photography some ten years later. Furthermore he observed that after becoming a photographer he rarely saw colour any more when memorizing and recalling a scene (photography was monochromatic in his day).

Henry Robinson was at times accident-prone and suffered from bouts of ill-health. For instance he fell down and 'cut the skin off the capsular ligament of his left knee' on 22 January 1849. On 23 March he fell over a ladder in Broad Street and broke a front tooth, hurting his nose and chin as well. Half an hour later he fainted whilst at work. 'This was the worst fainting I ever had,' he wrote in his Diary, which suggests that it was not an unusual experience for him. On 19 June he had to retire to bed at ten in the morning as he was so very weak in the back and suffered much pain in his back and legs. His face 'swelled to an enormous size' and he had to stay in bed for a few days. (He supposed he had caught cold standing in the Castle doorway the previous night.) On 25 January 1851 he fainted as he read an article in the *People's Medical Journal* and was obliged to retire to bed. It is hardly surprising that he succumbed to the toxic effects of the ingredients used in processing photographs fifteen years later.

In February 1849 Henry Robinson met the architect Richard Kyrke Penson in Ludlow Church, where both were making drawings of the medieval reredos recently discovered when the oak screen was removed. Robinson was invited to Dinham House to see some of Penson's pictures. 'I never thought watercolours could be brought to such perfection,' he wrote in his Diary. He sent his drawing with a letter to Thomas Wright, the Ludlow historian, and a letter to the *Hereford Times* about the reredos, suggesting a subscription for its restoration. Wright acted promptly. On 21 April the *Literary Gazette* reported a meeting of the British Archaeological Association at which Prince Albert was present. It was said that:

Mr Wright exhibited a coloured drawing by Mr Robinson of a newly discovered reredos in Ludlow Church . . . and not withstanding the injuries it has received from religious zealots is still in fine preservation and as a work of art worthy of restoration. Mr Wright described the upper portion as nearly perfect . . . but the sculpted stone figures beneath had been either damaged or completely destroyed by the desecrators.[29]

Robinson was rebuked by some of the influential Ludlovins for taking this action. He commented in his autobiography:

The upper classes although very kind and ready to patronise were very strongly imbued with the notion that every one should keep his place 'in that state of life' to which they firmly believed 'God had called him' . . . It must be remembered that the town at that time was quite fifty years behind the rest of the world, therefore they had a sort of prescriptive right to eighteenth century opinions.[30]

In spite of this local censorial opinion subscriptions were raised; Lord Dungannon was particularly generous and the reredos was restored.

Henry Robinson played a minor role in its restoration in the interval between the end of his apprenticeship and his first employment. He spent a good deal of that time practising stone carving under the tutelage of the sculptor – Mr Blackburn – who was employed to carve new statues for the reredos. At last Henry thought he could also carve a figure. Blackburn allowed him to 'try his hand on a full size block of Caen Stone' advising him to '*see* your figure in the stone and cut away all you do not want'. As a result Robinson's contribution to the reredos is to be seen in the statue of St Paul, with sword over shoulder, to the right of the altar. 'But I

must not claim all; the sculptor went over it after me. I had the misfortune to break St Paul's sword twice, and it will be found to be cemented together.'[31]

Release from Bondage

When the day of 9 July 1849 dawned, Henry Robinson was in jubilant mood. At last he was to be released from his apprenticeship. It was his nineteenth birthday and Bob, his brother, was four years of age on the same day. He gave a supper that evening to his companions and friends. Afterwards there were songs and speeches and the handing over of his indentures by the witness, T. Jones. From midnight George Gill, at the piano, kept the company amused by songs, titbits of acting from Shakespeare and ghost stories until two in the morning, when they were 'obliged very reluctantly to go'.

After his apprenticeship, as before it, Henry Robinson was allowed one year in which to further his studies. He spent a good deal of that time in the company of Mr Penwarne, under whose guidance he practised the technique of etching. He learnt the craft of stone carving from Blackburn, the sculptor, and he spent many hours at drawing and painting. Several works were commissioned but others were done to further his artistic ambitions. They were of a narrative kind very popular with artists of the Victorian era, and they were based on a mixture of his acute observation of life and imaginative idealism. These two different forms of artistic expression, which he developed in drawing and painting, were repeated when he took up photography, both as a livelihood and an art form, in 1857.

During this period he produced some delightful watercolours in and around Ludlow (plates 20–3). He seems to have spent many hours making preparatory sketches for a narrative group picture (figure 6), followed by the painting itself of *The English Farmer's Fireside* which was 68.5 cm × 91.5 cm, the largest he had attempted. This painting was, for many years, situated in a fireside alcove in his eldest daughter's home in Tunbridge Wells, but all trace of it has vanished. He returned time and again to similar themes in his exhibition photographs: *A Cottage Home*, 1859 (plate 54), *When the Day's Work is Done*, 1877 (plate 79), *Dawn and Sunset*, 1885 (plate 80).

Henry Robinson's mother was an excellent dressmaker in addition to her other accomplishments. He became interested in historical costume design between 1849 and 1851 and produced the designs from which his mother made up the garments for the seemingly endless costume balls given in Ludlow in the winter months. For one such occasion, the Balmasque at Oakley Park on 6 January 1851, he prepared designs for the Grecian dresses which his mother made for the Davies family. William Gill made sketches of them, including one of Bob Robinson in Grecian costume.

Figure 6 *The English Farmer's Fireside*, 1850, by H. P. Robinson. Preliminary pencil sketch for oil painting. Collection: Helmut Gernsheim, Harry Ransom Humanities Research Center (henceforth HRHRC), University of Texas at Austin

On 15 March 1850 a costume ball was held at the Misses Powell's school for young ladies, to which no gentlemen were invited. Henry was determined to obtain a view of it, so he crept into the garden of the house and onto a high wall, which afforded him an excellent view into the schoolroom through a skylight. He described Miss Rhodes, dressed as a North American Indian playing a tambourine for a quadrille, Miss Ada Sheppard dressed as an Opera Dancer, dancing the Cachenca, and Marianne Bibby dressed as a Gipsy in a straw hat and red cloak, 'her black hair hanging down her back'. He saw several dances, watching from the wall for nearly an hour. However he had a more enjoyable evening on 27 March: 'At Miss Powell's School dancing I enjoyed myself exceedingly as the young ladies were allowed to do as they like, being near the

Easter holidays.' At a costume ball at the Misses Powell's on 10 October he went dressed as an Albanian and Clara was dressed as a Court Lady of the time of George II. He said: 'She far surpassed all the other dresses there.'

The Romance of Ludlow Castle

Ludlow Castle never ceased to attract Robinson. It made a tremendous appeal to his lively imagination. He returned to it time and time again. It was the subject of many of his earliest drawings, etchings and watercolours (see figure 7) and it provided the scene for his first attempts at photography when he tried his hand at calotypy and experimented with the collodion process in the 1850s. Although few of his stereoscopic views have survived, those that have were taken in the Castle grounds (plate 6).

The Castle was built on dominating high land between 1086 when Roger de Lacy built the inner bailey and the late twelfth century when the large outer bailey was completed. After several changes of hands it became Crown property under Edward IV. His sons (the 'Princes in the Tower') spent their youth there. Many a battle was waged for possession of the castle. Owing to its condition in 1772 demolition was considered, but it was bought by the Earl of Powis, who carried out essential repairs, and it is still in the ownership of the Powis family.[32]

One of Henry Peach Robinson's early narrative portrait photographs is titled *Mariana* (1857–8) and was probably based on the Fitzwarine Romance, a tale of the early fourteenth century, relating

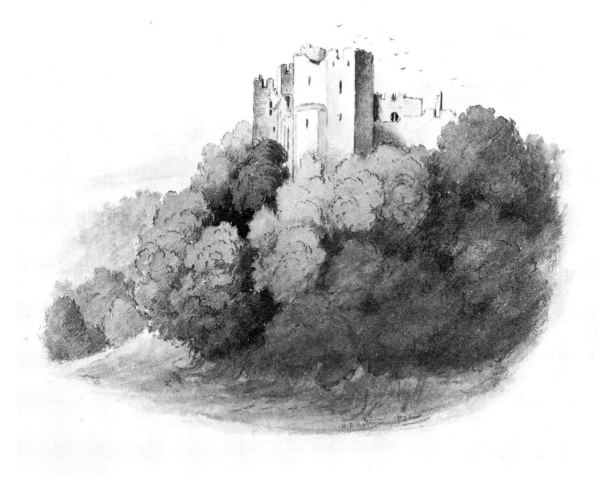

Figure 7 *Ludlow Castle from the Whitcliffe*, 1850, by H. P. Robinson. Pencil and wash drawing in the Bibby album. A. H. Slade collection

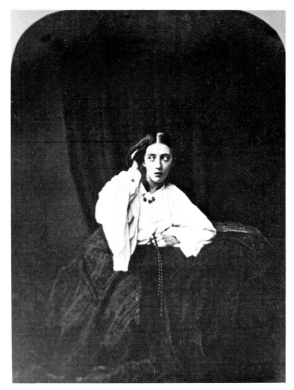

Figure 8 *Mariana*, 1857–8, by H. P. Robinson.
Albumen Print. Private Collection

events which were supposed to have occurred in the 1140s when the Castle was held by Joce de Dinan, an enemy of the Lacys. (Thomas Wright popularized this story in his *History of Ludlow*, 1852.) Mariana de Bruere admitted Sir Arnold de Lis to her bed after he had gained entry to the castle by guile. When she awoke she found that the castle had been seized by his supporters. Learning of his treachery, she thrust a sword through her lover's body and threw herself out of the window.

In 1857–9 Henry Robinson took photographs to illustrate a range of emotions, which he called 'Passions', some of which were based on literary characters portrayed by Tennyson and by other contemporaries, including prose writers. He concentrated on pose and facial expression, in which he painstakingly instructed his model before taking the photographs. Into this category came *Mariana* (figure 8).

Reference to this photograph, when it was exhibited in 1858/9 along with others, was made in a review of the Photographic Society's exhibi-

tion published in the *Daily Telegraph* of 10 January 1859: 'We are quite certain that it will not suggest to any-one the "Mariana" of Tennyson: it is simply the portrait of a young lady trying to look like "Mariana" and not succeeding.' This critic mistook Robinson's intention, which was to illustrate the passion of a Romantic historical episode of long ago by pose and facial expression. It was not intended to portray Tennyson's heroine and her hopeless death wish.

The fascination of *Mariana* for Robinson is evident several years earlier. On the back of one of his watercolour paintings of the Teme with two fishermen, *c*.1850, is written several times: *To my dear Mariana* (plate 22). It is probable he was referring to his childhood sweetheart, Mary Annie Bibby, known as Marianne to family and close friends, whom he had met when she was attending the Misses Powell's School in Ludlow in 1850 (plate 17). She was the model for *Night* in his large oil painting of *Night and Day* (Jane Haynes acting as model for *Day* had fair hair); the present whereabouts of the painting are not known.[33]

It was in Marianne's autograph album that Henry Robinson wrote verse and made a number of pencil and wash drawings which he signed and dated 'H. P. Robinson, 1850' or, more covertly, identified with his secret emblem, a violet, a flower of which he was particularly fond (plate 27). He used to pick small bunches of them from the walk beneath the Castle in the springtime and his mother sent little boxes of violets to him in the following year in Bromsgrove in the hope of reducing his homesickness. A poem called 'Perseverance (Nil est desperandum)' in Marianne's album, 'signed' with the Robinson violet, indicates his determination to succeed in his courtship:

> Persevere and you will conquer;
> Never think of giving in;
> 'Faint heart never won fair lady,'
> Persevere and you will win.

But Marianne was not prepared for marriage. A poem from her album, of which the following is an extract, signed B (for Bibby), clearly indicates her mother's intentions for her daughter's future. Henry Robinson would not have been considered a suitable match at all, as he would have belonged to a lower social order in her eyes:

Besides, Colonel Connor's a frightful old man,
And young Captain King cannot handle a fan;
The Squire's too faze,[34] the Doctor's too poor,
And the Nabob – oh! him, I could never endure;
I'd rather be single mamma, if you please,
Indeed I can't wed, so pray do not tease.[35]

In 1856 Marianne Bibby married Henry Asterley and went to live on a remote farm in Montgomeryshire.[36]

Marianne maintained a lifelong friendship with one of her school friends, Selina Grieves (daughter of John E. Grieves, chemist), who was to marry Henry Peach Robinson in 1859.

PUBLISHERS AND BOOKSHOPS

When a youth leaves home for the first time it often depends on the hands he gets into whether he goes to the good or the bad. He often has no choice and must take what comes. Here again fortune favoured me.

H. P. Robinson, 'Autobiographical Sketches'

In 1850 John Robinson received a letter written in Bromsgrove, dated 23 November:

Sir,

I shall be glad to see your son as soon as conveniently he can come should you think proper. To begin with I would give him a guinea a week, and he will have no difficulty in providing himself with respectable board and lodging at a moderate cost.

I remain,
Sir,
Yrs respectfully,
Benjamin Maund.[1]

Bygone Bromsgrove

For several months prior to this, Henry's father and other well-wishers had been making tentative enquiries of publishers and booksellers on his behalf. For the second time he was unable to persuade his parents that he could make a satisfactory livelihood as an artist. So it was that on 27 November 1850 he arrived in Bromsgrove, Worcestershire to take up his first employment. Henry Robinson was indeed fortunate in that his employer, Benjamin Maund, Fellow of the Linnean Society, was a distinguished, internationally renowned scholar and author who, for twenty-five years, published *The Botanic Garden*,

an expensive monthly periodical with excellent quality plates coloured by hand. In addition to other publications he produced one of the most beautiful books on the flowers of Britain in the nineteenth century.

Robinson found lodgings in Worcester Street in the house of Mr Nowell, at 12 shillings a week, board included. After he had been there a week he made arrangements with his landlady to have the use of a sitting-room with a fire in it after he came home at eight o'clock at night. He paid one shilling extra for this comfort and confided in his diary that it was very much better than sitting in a kitchen.

Maund was the proprietor of a printing and bookselling business. The shop where Robinson was employed, as a bookseller's assistant, was in the High Street (the main thoroughfare) next to the Crown Inn, which was considered the most important coaching house in the town as the majority of the thirty coaches which passed daily through Bromsgrove stopped there and the horses of the coaches between Birmingham and Worcester were changed there. There was a well used subscription library, in front of the shop. Mr Maund's botanic garden was in the adjacent Crown Close and most of the illustrations for his much prized books were painted by his sisters and daughter in their house in Church Street.[2]

Robinson was miserably unhappy for three weeks or so after his arrival as he passionately loved Ludlow, his family, home and friends. He thought Bromsgrove a cold, uncharitable place, lacking in interests and entertainment. 'I cannot

bear the thought of passing Christmas Day away from home. I believe this is the first I have been absent.' He felt a little better when he received a Christmas box from home containing 'two bottles of wine, sixteen mince pies, a large cake, a hare, two jars of pickled walnuts, a lamp, clothes, sketches etc. . . . they seem determined at home to make me as comfortable as possible this Christmastime.'[3] However, his elation did not last long for his Diary entry for New Year's Day, 1851, contains a complaint: 'What a dull, miserable place this Bromsgrove is, not a ball or party to be heard of, They do not even *acknowledge* New Year's Eve. I was out last night as the New Year approached and *not a person was to be seen.* I could forgive everything but the silence of the bells.'

Benjamin Maund was a kind and sympathetic employer. He and his family did all in their power to overcome Henry Robinson's home-sickness and frequently invited him to their home where he stayed to supper, being treated as one of the family. As his spirits revived he joined the Bromsgrove Literary and Scientific Institution and attended the meetings. He made friends, amongst whom was Alfred Palmer, the senior assistant in the bookshop (who became Maund's partner), with whom he went for long walks. After a walk to Droitwich on Sunday, 30 March, they returned home by the mail train, which to Robinson's delight travelled seven miles in nine minutes, a very fast speed when compared with travel by horse-drawn coaches.[4]

Robinson described one aspect of his duties in the bookshop thus:

The Botanic Garden came into the shop at a quarter to nine on Saturday night. We had made out the invoices and packed them up by half past twelve. The next day being Sunday of course occasioned a delay. On Sunday night they were sent off by mail train and arrived in London at the wholesale houses and were distributed by means of collectors to other wholesale houses, by one o'clock on Monday; by four o'clock they are sent to the railway station and early the next morning they are in the hands of the readers![5]

He practised drawing and painting whenever possible and sold a view of Bromsgrove Church to a man who returned the next day requesting it be changed for a summer view. Robinson was puzzled but quickly realized that his customer had confused the 'plain' (pencil) drawing with a winter view and that he must want a watercolour sketch!

Whilst Robinson was at Bromsgrove a daguer-reotypist stayed in the town for a few weeks and took his portrait. Robinson was fascinated and learnt the process from him.[6] In the following year he acquired a 'set of daguerreotype materials' and experimented with them but the daguerreotypes have not survived.

Exhibitions and Publishers in London

It is impossible to imagine in this day and age the intense excitement generated by the opening of the Great Industrial Exhibition at the Crystal Palace in Hyde Park, London on 1 May 1851. Nothing like the great glass construction, or the extraordinary assembly of exhibits from all over the world, had ever been seen before. Henry Robinson's imagination was captured and he resolved to see the Exhibition as soon as possible.

He left his employer, Benjamin Maund, on 22 August 1851 as it was considered necessary for him to have further experience in the business of publishing. After three enjoyable days in his beloved Ludlow, Henry Peach Robinson left with his mother for London, travelling on the Birmingham Coach drawn by horses. They enjoyed a week of sightseeing together before he started work.

They went twice to the Great Exhibition but of the photography exhibits he remembered only the two or three show-cases of daguerreotypes. They also visited the Greenwich Museum, Northumberland House, the National Gallery, the Vernon Gallery and Prince's Theatre. Eliza Robinson returned to Ludlow after a week in London.[7]

On 1 September 1851 Henry Robinson joined Whittaker & Company, Booksellers and Publishers, at 13–16, Ave Maria Lane, and Stationers' Hall Court, Paternoster Row, London, to extend his experience of publishing. He was engaged as a collector, delivering books from the publishers to the distributors, who sent them to retailers or individual subscribers, his area being the West End of London. On 1 October his friend Charles Jones (son of R. Jones, to whom he had been indentured in Ludlow) joined the company as a collector.[8] (He was previously employed in a booksellers/stationers' warehouse in Liverpool.) It was certainly not an intellectually demanding job, neither did it employ the craft skills which Robinson had acquired while indentured, but he said that he soon possessed an abnormal knowledge of book titles and authors. Fortunately he had enough physical and mental energy left over

to make the most of his time in the capital, the geography of which he got to know very well.

As Henry Robinson passed the National Gallery every day on his rounds he often entered and in a short time had visually memorized all the paintings. In those days it was a small institution containing no more than between three and four hundred paintings. He saw all the exhibitions at all the West End galleries, stating his preference for that of the Royal Academy, which in 1852 displayed an unusual number of the works of the artists of the Pre-Raphaelite Movement. He was particularly impressed by Millais's *Huguenot* and *Ophelia*, and the latter must have influenced the production of his composite photograph *The Lady of Shalott* in 1861 (plate 52). He also commented on paintings by Madox Brown, Holman Hunt and Collins.

It was in this same annual exhibition of the Royal Academy that one of Robinson's own paintings, *On the Teme near Ludlow*, was exhibited.[9] It was a small oil painting of Ludford Mill and Bridge over the river, in preparation for which he had made a pencil and watercolour sketch (plate 20). Robinson recalled: 'I was spending the evening with two young artists and we each agreed to begin a picture and send it in. When I got home I painted nearly all night and all the next day. We sent the pictures in, and mine was the only one accepted.'[10] The oil painting was acquired by Helmut Gernsheim, along with other paintings and photographs, in 1952, and is now in the Gernsheim Collection, Harry Ransom Humanities Research Center, in Austin, Texas, USA.

Robinson left London in mid-November 1852 and went home for the winter, as his objective had been to gain experience rather than find a permanent job in London.

The last entry in Robinson's diary is dated 8 November 1852 and is a young man's comment on the fashion of the period: 'Saw a Bloomer for the first time in the Strand, she looked most magnificent and nothing like so vulgar as the long petticoated dames who are obliged to pull up their dresses an indecent height on crossing the streets. I hope this dress will become general.'

In the spring of 1853 he took a job with a bookseller in Brighton but it was a complete failure, for he spent his time reading the books he should have been trying to sell. His employer recommended him to a former partner of his in Leamington who wanted an assistant. Accordingly he left Brighton and returned to the Midlands.

Life and Work in Leamington Priors

Henry Robinson found his employment in Leamington to be very congenial and he was on the best of terms with his employer. Although unstated, this was likely to have been Joseph Glover of 1, Victoria Terrace, Leamington Priors (later changed to Spa), who had a thriving bookselling and publishing business and who, in 1855, founded the local newspaper the *Leamington Courier*. When Robinson opened his photography studio the *Courier* provided him with very desirable publicity.

It was Joseph Glover who, in 1854, published 'Etchings of Leamington and its Neighbourhood by an Amateur' (H. P. Robinson). The etchings were signed in the plate by 'H.P.R.' and dated 1854,[11] and there were twelve local views in the set. If Robinson's employer was a publisher it seems fairly obvious that he would have had his work published by that house. In the previous year (1853) a little booklet was published, *Sketches of Ludlow Church and Castle, drawn and etched by Henry P. Robinson*. The publisher is not named.

Henry Robinson worked for his employer in Leamington between mid-1853 and mid-1856. It was during this period that he became very enthused by photography. He subscribed to the *Journal of the Photographic Society* from its commencement in 1853 and successfully practised the calotype process, working from Dr Hugh Welch Diamond's directions in the *Journal* (No. 11, 21 November 1853) and made 'dozens of negatives by that process'.[12] Two years earlier, in 1851, he had made his first experiments with photography on paper, initially without a camera, obtaining images of flat objects such as leaves and feathers. He then made a very rudimentary camera and exposed 'my first piece of sensitised paper in a cigar box and spectacle lens camera in 1851, and I have a very clear recollection of the astonishing result'.[13]

It was not long before he directed his efforts to mastering the wet collodion process[14] after reading the 'very practical paper by Comte de Montizon' published in the second number of the *Journal of the Photographic Society*. 'From that excellent paper I worked with success, sometimes making my own collodion, but oftener getting it a few ounces at a time from Horne and Thornethwaite. Then I bought a 6″ × 5″ collapsible calotype camera which had to be altered and got ready for a lens when I could

afford one.'[15] From then onwards his other interests took second place to photography. 'It was soon evident in my lodgings that I had become a dangerous lunatic, and there would be nothing left to destroy if strong measures were not taken. So I was turned out of the house, but it was only into the garden, where I was allowed to build a small darkroom of oilcloth' (plate 1). Robinson tried the majority of the photographic processes known in 1853–4 and made up most of the solutions from his own chemical formulae.[16]

Robinson was now twenty-four years old and it was high time he decided what to do with his life. He did not care for the trades of printing, publishing and bookselling, and he had suffered so much disappointment as a painter that he was discouraged. It was at this moment that fortune smiled on him in the form of Dr Hugh Welch Diamond, then on a visit to Leamington, who had his attention drawn to some photographs of small groups of children taken by H. P. Robinson. Diamond sought him out, told him that enthusiasts of his calibre were needed in professional photography and encouraged him to make a career of it. He advised Robinson to prepare himself carefully from all points of view without hurry and if he decided on this course of action he, Diamond, would give him every possible help. Henry Robinson looked on his new friend as his guide, philosopher and photographic father. He said: 'From that day my life has been devoted to photography as a business and as an art; a hobby and a devotion.'

For the next two years (1854–6) Robinson read all that he could on the subject of photography, practised on every possible occasion and spent all the time he could afford at the weekends at Dr Diamond's residence in Wandsworth, London, learning a great deal about photography from Diamond and his friends and receiving critical appraisals of his work.[17] At that time Dr Hugh Welch Diamond was the superintendent of the Surrey County Asylum at Wandsworth and to his residence came a weekly gathering of literary, artistic and antiquarian friends, including photographers. It was this group that was mainly instrumental in forming the Photographic Society of London in 1853.[18] For ten years Diamond was Secretary of the Society and editor of its *Journal*. Attending those gatherings were many of the best known early photographers, such as Roger Fenton, Francis Bedford, Benjamin Brecknell Turner, George Shadbolt and Frederick Scott Archer (who invented the collodion process with

considerable assistance from Diamond). When Diamond retired from his post at the Asylum the meetings were continued at his new residence, Twickenham House, a delightful old mansion near Richmond, Surrey.

An event which affected his life at this time was the death of his father on 7 February 1855. Henry assumed responsibilities as head of the household, taking care of his mother, sister and young brother. The family moved home to a house in Castle Street, Ludlow, at which Eliza and Clara Robinson maintained a ladies' boarding school for two years to supplement the family income.[19] Henry paid frequent visits to Ludlow from Leamington for the next two years, which enabled him, in addition to keeping an eye on his family, to photograph the Castle, Church and scenic views from the Whitcliffe.

In June–July 1855 members of the Robinson and Gossage families went on an adventurous Grand Tour of North Wales. Henry thought the change of scene would be good for his bereaved

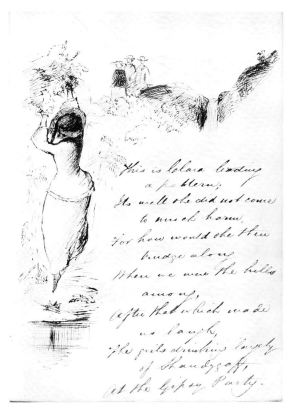

Figure 9 *Clara clinging to a slope at the Gipsy Party on Stretton Hills*, 1856, by H. P. Robinson. Pen and ink sketch. Private collection

mother. A narrative record of the holiday, with typical Robinson illustrations in pencil, is with other documents relating to his life.

Henry Peach Robinson became a member of the Photographic Exchange Club, a prestigious association of photographers which included Diamond, Fenton, Bedford, Comte de Montizon. Each member circulated to the others one of his photographs per annum. Henry Robinson, and presumably other members likewise, placed all these photographs into albums. In 1856 Robinson's photograph was an exterior view of Guy's Cliffe, a historic mansion in Warwickshire, in its parkland setting (plate 8).

H. P. Robinson's habit of making quick 'reference' sketches never deserted him. A little gem still exists, in the form of a leather-bound pocket book with quality paper pages. *On Stretton Hills, Wednesday August 13, 1856* records the 'Gipsy Party', which he and his friends enjoyed, in verse and pen and ink sketches (figure 9). Although Henry took his plate camera and tripod with him on this outing, the rain prevented him from using it. According to the verse the girls quenched their thirst with shandy gaff.

Robinson made a 'trial run' at professional photography in 1856 by publishing a set of whole plate size photographic views he had taken in Leamington and the locality, using the collodion process, which sold well at 4s each (plates 5, 8).

THE STUDIO IN LEAMINGTON

Professional photography is not all art and poetry. The syren must not always sing, or the mariner gets no chance.

H. P. Robinson, 'Autobiographical Sketches'

By the middle of 1856 Henry Robinson felt sufficiently well prepared in the practice of photography to open a professional establishment. The number of professional photographers was increasing rapidly in London and other large cities, where the studio 'glass house' was at the top of a building, often as an extension of the roof, and more slowly in the country districts where the 'glass house' was in the garden. The popular form of portrait photograph at that time was the collodion positive, usually referred to as 'ambrotype' today.[1] Paper prints were the exception.

The only drawback was that Robinson's income from his employment in the bookshop was modest and he was unable to save the money with which to rent premises, and to build a studio and darkroom. Most of his friends thought him mad to give up a good job for what many considered a very dubious method of making a living. He was even offered a loan to start up other businesses for which he had been trained but not a penny towards photography. However, again he encountered a slice of good fortune when one of his former Ludlow patrons, hearing of his difficulty, quite unexpectedly lent him £100.

On the strength of this comparatively modest sum and the little he had managed to save, Robinson wisely decided to take premises in a fashionable part of the town. On finding that 15, Upper Parade, Leamington, was vacant he rented the house at £80 a year, built a studio in the garden at the rear, made a darkroom and 'finishing' rooms in the house and allocated space near the front door for a reception and display area. He had to spend a proportion of the money available on photographic equipment and furniture for the studio. The upper floors in the house provided living quarters. When the house was ready for occupation he brought his mother Eliza, his sister Clara and his young brother Bob from Ludlow to live with him. They employed a domestic servant who 'lived in'. Upper Parade is a long sloping street, no. 15 being at the lower end of the slope on the left side looking north (plate 10).[2] The Regent Hotel was on the opposite side of the road. About five minutes' walk away was the Leamington Royal Pump Room and Spa Waters, which attracted a regular clientele throughout the year and additional visitors in the summer months.

The Practice of Photography

The *Leamington Courier* of 13 December 1856 carried the following announcement:

Photographic Institution, 15, Upper Parade, Leamington.
H. P. Robinson begs to announce that he intends opening the above Establishment early in January, on his return from London, where he is now studying the

latest improvements in photography in one of the most celebrated studios.

This studio belonged to O. G. Rejlander, an artist who had practised painting in Rome and became a portrait photographer. It seems likely that Rejlander introduced Robinson to combination printing on this occasion. The two photographers became firm friends.

Robinson opened his studio to the public on 12 January 1857, at a time when there was only one other professional photographer in Leamington, but in spite of good publicity it was some while before there were sufficient clients for the business to prosper. The services offered by Robinson to the public, as advertised, were impressive (figure 10).[3]

Robinson's emphasis was on the production of portraits on paper. Most of his competitors in the Warwickshire towns favoured 'Positive Portraits on glass' (ambrotypes). It is clear from the advertisement that he also conducted a retail business in apparatus and chemicals for photography and was prepared to give lessons 'in every branch of the art'.

Although many people came to look at the photographs displayed in the window, which consisted of salted paper and albumen prints of local views and portraits taken out of doors, no one, except close friends, came into the studio for a week. At last a family arrived to have a group portrait taken. Robinson recalled the strange thing which happened to him: 'I was struck with what I can only call studio fright, I was "sitter shy". I could not face them. I ran away and took some time to recover my nerves. However, after a time, I pulled myself together and managed to succeed in making a satisfactory group.'[4] He was able to overcome this problem quite soon although on rare occasions in the future he was troubled by sitters 'I would give the world to avoid'.

His first winter in business was a hard one, in terms of the elements as well as finance. There was a great frost, processing baths froze, bottles burst and the collodion would not work or was very slow when prepared in a nitrate of silver bath near freezing point. The studio was heated by a coke stove and when he had a particularly important sitter, John Laird the famous shipbuilder of Birkenhead,[5] who had come 'for an expensive coloured portrait' to be taken, Robinson stoked up the fire. Unfortunately he was called away and on his return found the

PHOTOGRAPHIC INSTITUTION,
15, UPPER PARADE, LEAMINGTON,

Established for the production of the best kind of

PORTRAITS and Prints of all dimensions, from a brooch size up to 20 by 16 inches,—on paper, glass, or ivory, plain or coloured, taken by a process exclusively used by the first London and Paris Operators, by which pleasing likenesses are guaranteed.

Paintings, Drawings, and Works of Art copied, and coloured in fac-simile of the originals.

Landscapes, Public Buildings, Residences, Engineers' and Builders' Works in progress, photographed. Competent artists sent to any part of the country.

Printing done from amateurs' own negatives. Photographs carefully mounted. A great variety of Mounts and Frames.

Lessons given in every branch of the art.

Apparatus by the best makers.

Photographic Chemicals by the best manufactures, and of perfect purity, supplied.

A large Collection of Local Views and Stereoscopic Pictures, many of which are in the present Exhibition of the London Photographic Society.

TERMS:

	£	s.	d.
Plain Paper Photographs, mounted on Bristol Board, any size not exceeding 8 by 6 inches	0	10	6
Ditto, with Two Figures in the same picture	0	15	0
Ditto, with Three	1	1	0

Stereoscopic Portraits at the same charges.

	£	s.	d.
Copy from a Print, Drawing, or Painting	0	10	6

Duplicate Copies, 3s. 6d. each ; a less charge if a quantity be required.

Coloring (additional).

	£	s.	d.
Tinting Face and Hands	0	10	6
For each additional Figure, if more than one	0	5	0
Highly wrought as a miniature drawing	1	1	0
Ditto, for each additional Figure	0	10	6

Photographic Miniatures on Ivory at proportionate prices.

The Portraits on paper have very great advantages over every other kind of Photograph, as they are capable of a much higher and more artistic finish when coloured, they may be kept in Portfolios or Scrap Books, and after the first impression any number may be printed at a trifling cost, without the trouble of another sitting.

Positive Portraits on glass executed in the best manner, and embracing several recent improvements at the following prices :—

	Plain.	Colored.
3¼ inches by 2¼ and under, in frame	4s. 0d.	5s. 0d.
4¼ „ „ 3¼ in frame	5s. 6d.	7s. 0d.
6¼ „ „ 4¼ „	10s. 6d.	15s. 0d.

Remarks on Dress.

Dark Silks and Satins are most suitable for Ladies' Dresses, Black Velvet is somewhat objectionable. White and Light Blue should be avoided if possible.

H. P. ROBINSON, Proprietor.

Figure 10 The first advertisement for H. P. Robinson's Studio in Leamington, January 1857. Courtesy the *Leamington Courier*

whole place alight. Luckily the camera escaped with a scorching and although the studio was converted 'into a beautiful grotto of icicles' he managed to obtain a good negative of his sitter. Robinson said that John Laird was one of his earliest and best patrons, who returned to his studio on several occasions (figure 11).

From the outset Henry Robinson employed his cousin Walter Vickerstaff Messer, aged nineteen, as his photographic assistant, and there would have been at least one junior assistant to clean the glasses for negative making, prepare the studio for sittings and mount the prints. It seems likely that his mother, who was a good artist, coloured photographs by hand when sitters requested their portraits in colour.[6] Walter Messer was known to have been a student of chemistry,[7] and was

Figure 11 *Portrait of John Laird, the shipping magnate of Birkenhead*, 1861, by H. P. Robinson. Carte-de-visite. Courtesy Miss M. Laird

probably trained by Robinson in the processes of photography. It is likely that he did the routine darkroom work and the printing. Robinson wrote:

One of the difficulties of photography in the early collodion days was getting any two samples of material to act alike. Collodion was peculiarly liable to depart from uniformity. It was difficult to obtain a collodion that would give a vigorous image; then it was decided by the chemists that their aim should be a collodion that would develop in the highlights as 'black as your hat, sir!' It was useless for an artist to protest that he would prefer soft pictures, what did he know about it, did *he* invent photography? This idea was unfortunately fostered by the greatest chemist who occupied himself with art, J. F. Hardwich. He advocated the use of iodized collodion to the exclusion of bromide, and thereby got dense negatives.[8]

Robinson also complained about the camera makers who insisted on using the heaviest materials and solid workmanship: Spanish mahogany for cameras and strong oak for printing frames. He had some 51 × 41 cm printing frames made of pine by a local carpenter and others made of oak by the best maker. He said in 1897 that both were still in use but that the ones made of pine were in the best condition and by far the most convenient to use.[9]

The weight of the equipment and the glass plates as well as the inconvenience of the wet collodion process for landscape work were enormous. The photographic world was hard at work inventing dry processes which would enable the photographer to be free of the encumbrance of a 'field' darkroom. Robinson himself greatly simplified the collodio-albumen process and wrote a paper on the subject.[10] He took a series of local views by this process.[11] One of these views, *On the Avon, Stoneleigh* (plate 7), he sent to fellow members of the Photographic Exchange Club in 1857. Nine of the photographs, in the form of albumen prints, were published in 1858 in *Warwickshire Illustrated, a History of some of the most remarkable places in the County of Warwick*. Descriptive essays on each place were illustrated by a single photograph: Royal Leamington Spa (plate 10); the Jephson Monument; Warwick Castle; the Beauchamp Chapel, Warwick; Stoneleigh Abbey (plate 9); Kenilworth Castle; Guy's Cliffe; Church of the Holy Trinity, Stratford-on-Avon; and the Three Spires, Coventry.

The publication received a two-column review in a leading journal:

That stone mushroom Leamington, 'city of waters', loungers, heiress hunters and fox hunters . . . From a mere cluster of miserable inns and lodging-houses, Leamington has spread out its walks and streets, reared its Pump Room and Parades . . . got together its Music Hall and Assembly Rooms, obtained its two railways, established its banks . . . 'on a scale of unparalleled splendour'. Here, in the softest tints of a summer morning, Mr. Robinson shows us Leamington, with its brand-new Palladian houses, mottled pleasantly with the moving shadows of green trees, the balustrades and balconies, and lamp-posts and pilasters . . . retreating pleasantly . . . all up the broad road, lined with wheel-tracks.[12]

The book sold well and the individual views were sold by Robinson in his shop and in the bookshop of his friend and former employer Joseph Glover. In the following year, when there was more money coming in to the business, Robinson bought a pony and van and made 'a fine collection of negatives of the lovely scenery round Leamington' by the wet collodion process (figure 12).

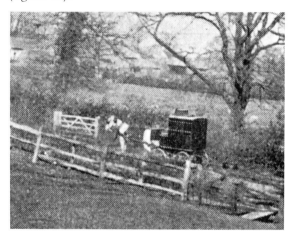

Figure 12 H. P. Robinson's travelling darkroom: his pony and van, 1859

During the first year the portrait side of the business did not flourish and in one of the summer months there were no sittings at all. He kept going by the sale of local views and stereoscopic slides and cards.

On 5 September he altered his usual advertisement and introduced a novelty: '*Vignette Photography*, this new method now first introduced to Leamington',[13] and displayed examples in his shop window (plate 29). He next informed potential clients that: 'H. P. Robinson has peculiar conveniences for making Portraits of Invalids, the process requiring a very short sitting, and the studio being on the ground floor; Prices from six shillings to five guineas.'[14] This was designed to attract the large number of people in bath chairs who attended the nearby Pump Rooms and partook of the spa water.

On 30 January 1858 he announced in the *Leamington Courier* a 'New Discovery in Photography' which was that he had perfected the process, originally discovered by himself after two years of experiments, by which he was able 'to catch the most fleeting expression on the face of children, the Pictures requiring only an instant's sitting'.[15] Robinson found he had a particular aptitude for photographing children (figure 13). They responded well to his kindliness and humour. He retained this ability to the end of his days (plates 41, 53, 73). He also announced that he had improved his coloured portraits as they: 'now resemble fine miniature drawings, with the advantages of a perfect and pleasing likeness, which a really good Photograph always gives.'

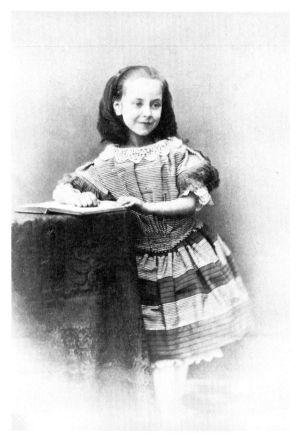

Figure 13 *Fleeting expression on the face of a child,* 1857–8, by H. P. Robinson. Albumen print vignette. Collection: The Royal Photographic Society

In spite of his enterprising advertisements people were slow in coming forward to have their portraits taken and in despair he offered the business for sale in the spring of 1858.[16] Fortunately there were no potential buyers so he kept it alive and within a year the introduction of carte-de-visite photographs brought at first a trickle and then a flood of sitters to his studio.

Before this event there were other noteworthy happenings. Henry Peach Robinson had been elected a member of the Photographic Society of London in the spring of 1857,[17] and attended meetings whenever possible in addition to contributing articles to the *Journal*. He still found time to visit Dr Diamond at his new residence, Twickenham House, near Richmond, Surrey, where the doctor had established a private asylum for female mental patients in 1858. Through these activities he maintained contact with the leading photographers of the period and was soon to be recognized as one of them.

Photographic Art

In addition to making a living, Robinson's objective in taking up photography was to use it as a picture making medium. His knowledge of art theory, as well as his sensitivity to the effects of light, were great assets and from the beginning his photographs showed his artistic skill (plates 2, 3, 4). His commercial portraiture and scenic views provided him and his family with a livelihood and although he worked hard and enjoyed his business, his heart was in the practice of photography as an art, which was consistent with his devotion to drawing and painting during adolescence. He practised the art of photography whenever he could spend time away from his business.

In March of 1857 he made three pictures of a theatrical subject, *Mr Werner as Richelieu*, which were exhibited at the Manchester Art Treasures Exhibition (plate 33). In later years Robinson regarded his *Richelieu* as 'desperately bad', not because of the photographic qualities but because the costume was not authentic, a mistake he was careful to avoid thereafter. Robinson said that the Manchester Art Treasures Exhibition contained 'one of the finest exhibitions of paintings which has ever been seen in this country'. Also displayed were six hundred photographs, a tribute to the growing recognition of photography as a medium for artistic expression.

It was in this exhibition that Oscar G.

Rejlander's major composite photograph, *The Two Ways of Life*, was seen for the first time. It caused a sensation. Victorian sensibilities were such that there was some unfavourable reaction to the extrovert portrayal of nakedness by the camera, in spite of artistic posing, as it was such a realistic medium. Although there was some censorious criticism other critics were amazed by this ambitious attempt to take photography into a region which was previously regarded as the domain of painters, and it was much admired.[18] It was a composite photograph, thirty individual negatives having been printed, one after the other, onto one of two sheets of albumen paper, and the two sheets were mounted together to form the unified picture.[19]

There had been one or two earlier successes at allegorical and narrative picture making by photography, notably by the watercolour artist turned photographer Willam Lake Price, who exhibited *Don Quixote in His Study* (figure 14) and *The Baron's Feast* in 1855,[20] photographs on similar themes to the historical genre subjects favoured by George Cattermole and Daniel Maclise.[21]

Figure 14 *Don Quixote in His Study*, 1855, by William Lake Price. Photogalvanograph. Collection: The Royal Photographic Society

The earliest mention of 'double printing' was published in the Photographic Society's *Journal* for September 1855.[22] The first picture exhibited to the public in which this technique had been employed was a fine seascape *Brig Upon the Water* by Gustav le Gray. It was shown in the Photographic Society's Exhibition in 1856, having been printed from two negatives: one for the sky and one for the water and foreground.

It was in 1857 that Robinson made his first attempts at double printing, producing the photograph *Jenny*, from a negative of a young girl wearing a sun bonnet and country clothes taken in his garden studio with foreground of grasses and plants.[23] He used a negative taken in the countryside near Leamington for the background, masking out the unwanted areas from each negative. The 'group of trees' at the top of the picture and 'sky' were added in sepia colour wash by hand (plate 44).

Towards the end of 1857 Robinson embarked on a series of illustrative studies, the first being *Juliet*, with the phial of poison. This was followed by a set of four on the emotions which he called *The Passions*: *Fear*, *Devotion*, *The Miniature* and *Vanity* (plate 31) which he exhibited in one frame together with a portrait of the model (figure 15).

He chose little Miss Cundall to model for this series (she had first modelled for him as a child of eleven) because she responded so remarkably well to his directions in posing and expression (plate 1). Moreover she was very versatile and could alter her appearance and semblance of age by changes in stance, the manner of wearing a dress and arranging her hair and, most important of all to Robinson, the facility with which she could alter her facial expression. She was 'a fine healthy girl of about fourteen' when Robinson photographed her as a young lady dying of consumption in *Fading Away* (plates 46, 47). She became his favourite model, being the grief-stricken girl in *She Never Told Her Love* (plate 45), the solitary *Elaine* (plate 55), the lady in the *Lady of Shalott* (plate 52), the principal gleaner in *Autumn* (plate 60), the older girl in *Somebody Coming* (plate 59), as well as being featured in several other genre and narrative pictures. Robinson said she had 'the rare merit for never making the slightest suggestion'. Her one weakness, according to a contemporary critic, was that her bust was insufficiently developed to portray a young lady of twenty!

The Passions photographs were delightful and received favourable notices in the reviews of the exhibitions in which they were displayed; for instance: 'Henry Peach Robinson is a photographer of the school in which careful thought is of more importance than the mere production of a "pretty" picture. His frame, no. 159, containing four studies of the passions, together with a portrait of the model (and what a jewel of a model she must be), displays a large amount of artistic feeling, and a pure love for art.'[24] Another reviewer said that the photographs 'would rise in estimation' when examined carefully and more than once.[25]

Fading Away

In April 1856 Robinson embarked on the construction of a picture which was to have a profound effect on his reputation as a photographic artist and which was also instrumental in promoting his business. He conceived the idea for a photograph of a subject which was currently the cause for great concern as there were so many fatalities among the young at the time. The subject was the dreaded wasting disease of tuberculosis, or consumption as it was then called, personified by a young lady lying on a couch in the last stages of the illness with members of her family gathered round her. The picture was to illustrate a verse by Percy Bysshe Shelley, the poet, and was called *Fading Away* (plates 46, 47).

It was an impossible conception to realize by photography at that time in a single exposure owing to technical difficulties including the length of time required to photograph a group indoors adequately. Robinson decided to employ combination printing which would enable him to ensure that each individual photographed expressed exactly what he required. The picture was printed from five negatives onto one sheet of paper. The materials he used were all of his own preparation and in 1897 the three original prints which Robinson retained were 'as perfect and fresh as they were thirty nine years ago'.

After *Fading Away* had been shown to his friends at Dr Diamond's house and at 'Our Club' (an arts and literary club instituted by Douglas Jerrold), it was first exhibited at the Crystal Palace in the autumn of 1858 and then at the Leeds Exhibition in connection with the British Association.

Figure 15 *The Model (Miss Cundall)*, 1858, by H. P. Robinson. Courtesy Sotheby's

Figure 16 *The Dead Lady*, 1854, by Sir Joseph Noel Paton. Oil. Courtesy Neil Cross

Fading Away met with a mixed reception. Some critics were fulsome in their praise of Robinson's achievement but dismayed by the realization of such a subject. It touched a raw place in the experience of so many viewers. One critic summed it up very neatly: 'The photograph "*Fading Away*" is an exquisite picture of a painful subject.' Wonderment was expressed at the emotive power aroused by 'a merely mechanical process'.[26] Another critic made the comment: 'The conception is such a one as Noel Paton might not disdain to own, and indeed has much in common with that of his famous painting of the *Dead Lady*' (figure 16).[27] Yet another was less complimentary: '*Fading Away* is a subject which I do not like, and I wonder Mr Robinson should have allowed his fancy to fix on it; it is a picture no one could hang up in a room, and revert to with pleasure.'[28] Nevertheless copies of the photograph were displayed in the shop windows of print sellers throughout the country and must have provided Robinson with a very welcome income.

The photographic community was not allowed to forget *Fading Away* for a very long time. H. P. Robinson read a paper, 'On Printing Photo-graphic Pictures from Several Negatives', at a meeting of the Photographic Society of Scotland on 13 March 1860.[29] He said he had frequently been asked to give some information on the method he employed to produce photographic prints from two or more negatives. After dealing with the simpler procedures as in *Here They Come!* (plate 32), he spoke of how he had made *Fading Away*. Once the negatives had been made and then prepared for printing (wherein lay the skill), the actual printing was done by his youthful assistants. He said, ruefully, that 'the negatives, after giving about two hundred impressions, were injured by damp, through the carelessness of an assistant.'

The publication of his methods provoked a storm of protest from those who felt they had been deceived, as they thought the print was made from a single negative. The columns of the *British Journal of Photography* were filled with reactions to Robinson's disclosure throughout June and July 1860, including articles by A. H. Wall on ' "Composition" versus "Patchwork" ' in which he condemned the photographer's ideas and techniques,[30] and 'Composition NOT Patch-work' by H. P. Robinson in which he said: 'I am

sorry Mr Wall objects to Composition. He is a gentleman for whom I have the greatest respect . . . I do not expect him to admire my works: I am well aware they are full of faults, but they must be put down to my want of skill . . . I maintain that I can get nearer the truth for certain subjects with several negatives than with one.'[31] The editor, in the same issue of the journal (2 July 1860), in trying to reconcile the two opponents said: 'Absolute truthfulness of representation is not a necessity of photography' and referred to Mr Wall's own occupation: 'by his artistic skill and talent as a colourist he adds a new charm to the best productions of the camera, for by so doing he destroys the assumed absolute truthfulness of the original.'

Robinson was sadder but wiser after this confrontation:

It is a great indiscretion for a photographer to show his model, his scenery, or his methods . . . he may make a heap of earth and a few stones in a back garden look like the top of a mountain; he may throw the glamour of light and shade equal to Rembrandt's over his group, but he gives himself away body and soul if he takes credit for them. Better be content with the applause he is sure to get for the completed work, rather than expose all the mean little dodges that go towards building up a complete whole, that shows not only nature, but that nature has been filtered through the brain and fingers of an artist.[32]

In the same year Henry Robinson exhibited a set of four photographs to illustrate the children's tale *Little Red Riding Hood*, accompanied by appropriate story lines. They were, in all probability, the first attempt at a Photo Essay (plates 48–51). Robinson went to great pains to ensure the authenticity of the characters, their dress and the two cottages. The photographs are delightful in all but one respect: Robinson failed to counter the 'realism' of the medium in the photograph of the 'wolf' in grandmother's bed; nevertheless the photographs received good notices.[33]

In the autumn of 1858 Henry Robinson invited Roger Fenton, a contemporary photographer some years older than himself and already well known for the photographs he took in the Crimean War, to join him in a combined picture, one to do the figures, the other the landscape. Fenton's reply was courteous but cautious:

My dear Robinson,
* I shall be glad to join in the proposed work . . . It is time that a stop were put to the cry that a photographer is a*

mechanic . . . *I have to thank you for some beautiful things which you sent me before I left town . . . To return to our subject, it is not easy to find ready to your hand a view that will serve as a background for figures. They ought to be made, with especial reference to the figure with the sentiment of which they are intended to harmonise, and must be subordinate to it. Now, most of my views are so taken that figures introduced into them can only be as subordinate to the landscape. I have some views of distances which might be used where you want a head to stand out in relief against a bright sky. I have taken also this year some interiors of cathedrals, among which we might find a background for the head which is enclosed in your note, and which I cannot enough admire. To produce however, a first rate result, the subject should be studied by both parties, and the general arrangement of the composition agreed upon before any negatives are taken. If you select any poem for illustration please bring it up so that I may look it over.*
* Yours truly,*
* Roger Fenton.*[34]

So far as it known no further action was taken.

Royal Patronage

Meanwhile business was improving, and in June 1858 Queen Victoria visited Leamington and stayed at Stoneleigh Abbey. Robinson was able to announce that he was receiving Royal patronage: 'Now Ready. A series of views of Stoneleigh Abbey and Park photographed by command of the Queen, June 16 1858 by Henry P. Robinson (Member of the Photographic Society).'[35] He made a more fulsome statement on the subject of patronage in October. 'Patronised by the Queen and the Nobility and Gentry of Warwickshire and the neighbouring counties . . . Mr Robinson is well known as an artistic photographer, and his pictures bear witness of both his artistic and photographic skill.'[36] In addition to the Royal Command, Prince Albert, an enthusiastic collector of photographs, purchased a copy of *Fading Away* and invited Robinson to submit each year one of his exhibition photographs for addition to the Royal Collection of Art.

To meet the expansion in demand for his photographs and the interest being taken in his work in high places, Robinson employed an expert colourist at the end of October. This was his boyhood friend, George Reynolds Gill, whom he described as 'the eminent miniature painter', employed to finish his studio portraits in colour, 'whose exquisite miniatures are well known to connoisseurs of the Fine Arts'.[37]

Family Affairs and Personal Matters

A great misfortune struck in November 1858, probably due to overwork and stress, in that Robinson suffered from an attack of partial blindness. He managed to recover in time to resume full business activities in December.[38] A probable cause of tension in the Robinson household in the last weeks of 1858 was Eliza Robinson's illness, which was to prove fatal in the following year. Henry was very attached to his mother and her suffering must have been very grievous to him. However, he was greatly consoled by his close attachment to one of the former pupils at the School of the Misses Powell in Ludlow, Selina Grieves, daughter of John E. Grieves, the chemist.

Henry Peach Robinson married Selina Grieves in February 1859. He referred to 'this dip into the proverbial lottery from which, good fortune still following me, I drew a prize'. Selina later recalled that when they were married Henry gravely told her that it must be 'photography first, wife afterwards'. She was probably not the first and certainly not the last photographer's wife to be so informed! Nevertheless it was a very happy marriage which lasted until Henry's death in 1901.

The wedding was a quiet one because of Henry's previous ill-health and his mother's terminal illness. His good friend and former employer in Bromsgrove, Benjamin Maund, wrote to congratulate him from Hastings, sending a wedding gift of a butter-dish:

Many congratulations to you and your kind wife. I say kind, because although unknown to her, I am sure you would choose none other . . . I sadly want, too, to have account of your mother – your last information was unfavourable . . . I saw 'Fading Away' in London a week or two before your Review, and incog, was pleased to have such a splendid description of it by the person selling it . . . I hope that my little present may not be unacceptable nor inappropriate inasmuch as its intended contents may well represent the anticipated smoothness of a happy life.[39]

A shadow descended on the household when Eliza Robinson died on 25 June. Her will, which had been made on 31 January, left her entire estate to her elder son Henry, making him the sole executor.[40] As the Robinsons were such a devoted family this settlement must have been made to avoid death duties, hasten Probate or have been for the benefit of all concerned in some other way.

From the time he became a member Henry Robinson actively participated in the affairs of the Photographic Society and in 1859 was elected to serve on the Collodion Committee.[41] An ingenious portable tent and perambulator for outdoor work with wet collodion, which he had constructed and used in previous years, was described by him in a communication to the *Journal of the Photographic Society*.[42] It consisted of a box 12 × 10 × 8 inches (30.5 × 25.4 × 20.3 cm) for plates 10 × 8 inches (25.4 × 20.3 cm) with a lid which was unfolded in front, forming a developing table. When using a camera larger than 10 × 8 inches he used a kind of perambulator with the tent placed at the back. He recommended the Ross Orthographic lens for photographing groups of figures in landscape as exposure times could be reduced to a few seconds and the depth of focus was greater than with portrait lenses.

The *Leamington Courier* carried a publicity notice on 16 July which informed the public: 'Mr Robinson has made arrangements for taking instantaneous portraits of animals, in the best style and of any size.' This was deliberately timed to coincide with the Royal Agricultural Society's show at Warwick.

The threat of competition in 1860 from a German photographer, a well-known colourist, who had said he would 'smash up Robinson' and built a studio a few doors away from him, spurred Henry on to improve the appearance of his premises. The whole place was renovated, he accepted the services offered by another German colourist bitterly opposed to his competitor, and made a most impressive display of large photographs and miniatures on the walls and in the window of 15, Upper Parade.[43] This stimulated business beyond expectations. In addition he had anticipated the cartes-de-visite craze and during the latter part of 1859 re-equipped his studio for their production. Speaking in general terms he said 'The earliest cartes-de-visite were full-length portraits and were pictorial gems.'[44] The fee was 1 guinea for a sitting and twenty cartes.[45] However, he charged high fees for the work which was coloured by hand: 5 to 30 guineas for miniatures and 50 to 100 guineas for a portrait in oils.[46]

H. P. Robinson began his career determined to take the negatives of every photograph which bore his signature himself and he kept up this practice 'with rare exceptions' to the end. At this stage he took every sitter himself, even to preparing and developing the plate. Fifteen sitters in a morning

was considered a good day's work, although in the summer he often photographed between twenty and twenty-five. When he was not available clients were given the option of being photographed by one of his assistants. The resulting photograph was not signed by H. P. Robinson.[47]

A Holiday in the Wood

Although business greatly improved in 1859–60 Robinson was disappointed with his lack of inspiration as far as the production of photographic art was concerned. As this was his first year of marriage his energies and creativity found other outlets; a first child was born to Selina and Henry in the early months of 1860 and baptized Edith. Although he got good press notices he was not satisfied and spent the winter working on drawings and sketches, collecting costumes and materials, selecting models and the scene and preparing the foreground for a composite photograph which he proposed for the spring (plate 38).

Robinson explained the problems he had in the production of this picture as follows:

The year 1860 was the wettest, or one of the wettest, years of the century . . . It nearly prevented me bringing out the one picture I determined to produce for the exhibition. This was called *A Holiday in the Wood* . . . The picture was produced under great difficulties. The figures were done on the only two fine days of April. Then everything was kept ready to drive to Kenilworth for the Woodland background, on the first fine day – which did not occur until 12 September. I had to wait five months.[48]

During the waiting period Robinson made a trial print of the figures which formed the composition and painted in the background to gain an impression of what the completed picture would look like (plate 37). He was never quite satisfied with the final result but received paeans of praise in the press. The *Daily News*, on 14 January 1861, declared: 'We think, without exception this is the choicest and most beautiful photograph we have ever seen.' The *Morning Chronicle* of the same date announced: 'We cannot call to mind any figure study that is equal to the one which worthily holds the place of honour in the present exhibition: *A Holiday in the Wood*.' The *Daily Telegraph* on 17 January raised a question: 'We may decidedly pronounce this to be the most successful attempt at ideal treatment in photography that we have ever seen . . . We grant all

this and still we ask whether such perfection of arrangement is worthy to be accounted a triumph of art.'

On 18 January the *Athenaeum* journal commented '*A Holiday in the Wood* has a sunniness almost beyond Art. As a photograph it is most successful and effective.' The *Court Circular* on 9 February was very complimentary: 'The picture abounds in all the necessary qualities of a good photograph . . . Mr Robinson seems to have distanced all others who have attempted this branch of the art; and has been most successful in overcoming the great mechanical difficulties which must necessarily lie in his way.'

The photographic press devoted many columns to reviewing Robinson's photograph. The *Photographic Journal* in one of the first reviews published (15 December 1860) commenced with the simple statement 'Art in photography is progressing' and continued for three columns with such compliments as '*A Holiday in the Woods* demands our warmest congratulations' and 'The effect is altogether so pleasing and satisfactory, that we feel perfectly indifferent as to what implements have been employed, or what particular method adopted in the execution of this chef-d'oeuvre of photographic ingenuity, for, in our opinion, so far as all artistic operations are concerned, the end always justifies the means.'

In so far as publicity was concerned this composite photograph must have been very successful in promoting photography as an art coupled with the name of H. P. Robinson.

In spite of the lavishness of the praise from reviewers it was one of Robinson's small 'group' portraits which 'stole the show'. *Here They Come!* (plate 32) brought Robinson his first silver medal for an exhibition picture. (It was the second year only that a medal had been offered for photography in Britain. The judge, Horatio Ross, who made the award, preferred the simple figure study to the large group composite.)

Business Pressures

Towards the end of 1860 hard work and business pressures took their toll. Walter Messer, Robinson's cousin and chief photographic assistant for three years, since the start of the business in 1857, left his employer in December, complaining of ill-health caused by the fumes of the chemicals used in coating and processing the glass plates. It has been said that he sailed for New

Zealand in January 1861, but was shipwrecked and returned home to Brampton Bryan, in Shropshire, whereupon he took employment as a gamekeeper on the Brampton Bryan estate, married late in life and died in 1922.[49] Henry himself became sick. Selina took matters into her own hands and ensured that her husband worked each day until 2.30 p.m. only, at which time a pony carriage was waiting to take him away to the farmhouse which the family had rented for a few months, or for a drive.

In 1861 the Robinson ménage consisted of H. P. Robinson, photographer, his wife Selina (also described as 'photographer'), his daughter Edith, aged one year, and his brother Herbert,

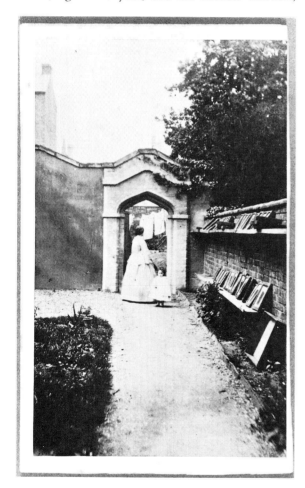

Figure 17 Selina Robinson with small daughter Edith in garden of 15, Upper Parade, Leamington Spa. Photographic print making evident on right of picture, *c*.1862. Carte-de-visite. Albumen print. Collection: Helmut Gernsheim, HRHRC, University of Texas at Austin

aged fifteen, who was classified as an assistant. There were two other assistants: Adelade Hewett, aged twenty-seven, and Margaret Christian, aged twenty. There were also two house servants: Emma Woodruff, aged twenty, of Birmingham and Elizabeth Gumbley, aged sixteen, of Claverdon, Warwick.[50] Robinson must have greatly missed Walter Messer at this stage, as Herbert would have been too young to photograph clients and the two women assistants would not have been trained to do so. There is little doubt that Selina participated in the business. A carte-de-visite, taken 1862–3, shows the wall at the rear of 15, Upper Parade, Leamington, where the prints were made with Selina, accompanied by her little daughter Edith, in control of the printing (figure 17). It is more than likely that she also received clients, advised on dress, maintained supplies and kept the accounts.

Pre-Raphaelite Influences

On the artisitc side of Robinson's life the publicity given to his photographs *Fading Away* and *A Holiday in the Wood* brought him many new friends. He received a large number of interesting letters from the Rev. E. Bradley (pseudonym: Cuthbert Bede), author of the popular book *Verdant Green* and the amusing *Photographic Pleasures* illustrated by his caricatures of photographers, which made fun of photography. He also gained the friendship of Alexander Munro, a renowned sculptor, at whose London studio he met 'many of the young and promising painters, especially the pre-Raphaelite brethren', and Henry Moore, RA (brother of the well-known artist, Albert Moore, RA), a painter who became one of Henry Robinson's closest friends, and who was included in the North Wales house parties in the 1880s.

The art circles in which Robinson moved, especially members of the Pre-Raphaelite Brotherhood, had a demonstrable effect on his photographic imagery in the 1860s. In the first instance he painted a picture in the mode of the Brotherhood 'in which every leaf of a wall of ivy was painfully studied'.[51]

Following this his major composite photograph of 1861, *The Lady of Shalott*, and that of 1862, *Bringing Home the May*, reveal these influences (plates 52, 58). In the forefront of his mind was the illustrative power of photography when

associated with poetry and narrative prose, thus combining his two passionate artistic pursuits: literature and photography. Pre-Raphaelite 'realism' and concentration on detail as well as the static qualities, as in a tableau or frieze, of the work of several of these artists had a great appeal for Henry Peach Robinson. He was prepared to admit there were many things which should not be attempted by photography but he thought that Pre-Raphaelite ideas and concepts could be applied through this medium because of its very nature to give a semblance of 'reality' and faithfully reproduce detail. The only thing lacking was colour.

It is interesting to compare Robinson's *The Lady of Shalott* (plate 52) with the John William Waterhouse painting of *The Lady of Shalott*, *c*.1878 (figure 18), and the Sir John Everett Millais painting of *Ophelia*, 1852 (figure 19). Robinson thought the latter one of the great paintings of the century and in 1896 commented

that he still had great pleasure in sitting in the gallery in which it was displayed, 'never weary of its wondrous beauty'. The two paintings are reproduced here in monochrome deliberately to make the comparisons more effective. The Robinson photograph comes somewhere between the two paintings in concept, illustration and picture construction.

Robinson reproduced five verses of the Tennyson poem on the matt enclosing the photograph but concentrated on illustrating the first two lines of this verse:

> And at the closing of the day
> She loosed the chain, and down she lay;
> The broad stream bore her far away,
> The Lady of Shalott.

His first dilemma would have been in the choice of a suitable craft. It had to be shallow in depth to permit a camera angle which would reveal the 'Lady' 'Lying robed in snowy white

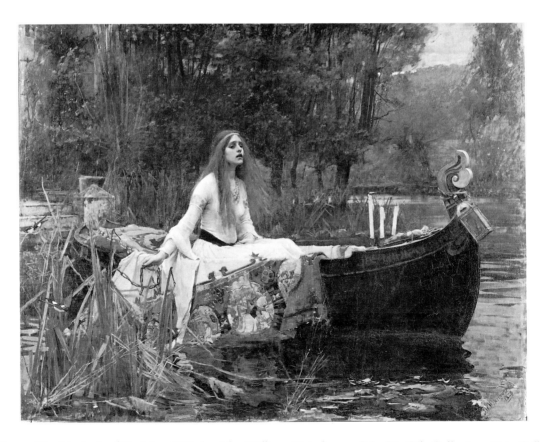

Figure 18 *The Lady of Shalott*, *c*.1878, by John William Waterhouse, RA, RI. Oil. Collection: Tate Gallery

that loosely flowed to left and right'. He chose a punt, which was good for this purpose but lacked a prow round about which to write 'the Lady of Shalott'. This was overcome by inscribing it on the side of the punt. The Waterhouse painting reveals the 'Lady' before she lies down in a boat with an attractive prow. Millais' *Ophelia* portrays her afloat on the current, which provided him with the opportunity to demonstrate his magnificent painterly skills in the portrayal of a body upheld in the water by the air trapped in the gossamer-like garment. The selection of ambience by each of the three artists is also interesting. The willowy banks beside the clear running water of a shallow stream, with reeds beneath the surface, provided a solution in each instance.

Reviews of Robinson's *The Lady of Shalott* were mixed: some were critical of the attempt at such a difficult task; others were over-effusive. Robinson himself said, many years later, that it was 'a ghastly mistake'.[52] Today we would be right in thinking this to be an over-harsh self-

judgement and the photograph could be said to be an interesting stage in the development of photography as an art.

On 11 September 1861 an important event occurred in the Robinson house. This was the birth of Henry's elder son and second child (figure 20). He was baptized Ralph Winwood.[53] It became a matter of honour with the Robinson family to reinstate the name Winwood, which had been paired with Robinson through the female line in 1776 by the marriage of Richard Robinson with Elizabeth Winwood, Henry Peach Robinson's great grandmother.[54] Ralph was destined to take over the business and become a fine photographer in his own right.

1862 was a year of especial achievements for Henry Robinson, who was elected to the Council of the Photographic Society and served on that body for thirty years. It was also the year of the second Great International Exhibition held at the Crystal Palace, Sydenham, and he was invited to be a member of the Committee for receiving

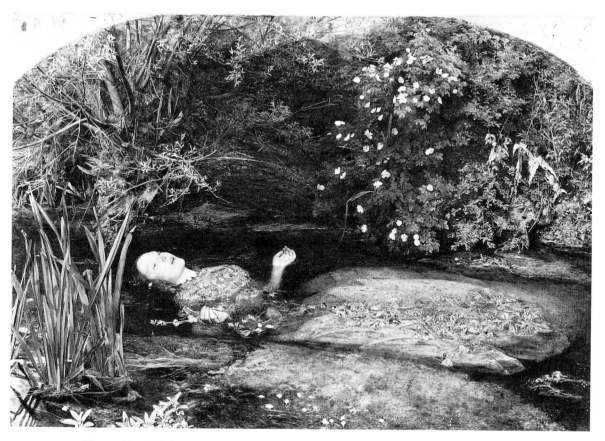

Figure 19 *Ophelia*, 1852, by Sir John Everett Millais, PRA. Oil. Collection: Tate Gallery

Figure 20 *Selina Robinson with baby Ralph*, 1861, by H. P. Robinson. Albumen print. Private collection

which measured 38.8 × 100.3 cm and was composed from nine negatives printed one at a time onto a sheet of paper (plate 58). It was a greater undertaking than any he had previously attempted. The idea was born in the winter of 1861–2 following his purchase of a rare edition of Spenser's poems which he opened at random at 'May' in *The Shepheard's Calendar*. As he read the lines of the poem, written in Olde English, he visualized the scene 'almost as plainly as if it had been already photographed'. In his youth he had frequently participated in the ancient country custom of gathering may blossom and taking huge branches of it home on May Day. Immediately, he commenced the preliminary sketches and made a full-size drawing. (Unfortunately he destroyed these in 1897.)

Robinson painstakingly described the procedures:[55]

It requires consideration to decide how much should go on a plate, and where would be the best places for the joins; these have all to be marked on a full-sized sketch; then the models, costumes and accessories have

awards. The other photographers on that committee were Dr Hugh Diamond, Roger Fenton, Thurston Thompson, Henry White and T. R. Williams (figure 21). Robinson recollected that photography was tucked away at the top of a damp tower. An album in the possession of the Victoria and Albert Museum, compiled by Arthur Robinson (not a relative of H. P. Robinson), records the names of the Jury accompanied by a photograph of each and includes examples of their exhibits. There is also a complete list of the exhibits in the Photography Section. Robinson's photographs included *Early Spring*, *The Lady of Shalott*, *Elaine Watching the Shield of Lancelot* and *A Holiday in the Wood*.

Bringing Home the May

It was in this year that Robinson produced his most ambitious picture, *Bringing Home the May*,

Figure 21 *The Photography Committee for receiving Awards, Second Great International Exhibition*, 1862. *Left to right:* C. Thurston Thompson, Henry White, Roger Fenton, Henry Peach Robinson, T. R. Williams, Dr Hugh Welch Diamond. Albumen print.
Private collection

to be selected and prepared; and minute directions written on the sketch so that the photographer should have as little to think of as possible when the important moment arrived. During the wet days the trouble and difficulty were much greater than they would be now. There was the waiting for the preparation of each plate, for a wet plate would not keep good for more than a few minutes, giving short grace for arranging the poses, some of which were extremely difficult; the exposure of each plate was about fifty seconds, making the stability of the figures anything but certain, and a slight movement of white flowers is usually very conspicuous. In the case of the two central figures, one of which has a great bundle of May on her head, besides the use of several rests of the usual kind, quite a formidable wooden scaffolding was built behind them. Another great hindrance, making the whole thing very doubtful indeed, was the weather. The negatives, naturally, could only be made when the May was in blossom, and it does not last above a fortnight. It was decided that the effect should be that of pale misty morning sunshine. I could easily manage for the figures without the mist, but I was bound to have sunlight. For nine consecutive evenings a pony carriage load of May was gathered in the Warwickshire lanes and brought into the house, and the next morning was cloudy, but on the tenth morning several of the negatives were successfully taken, the three next days were dull, and on the fourth the others were accomplished, but with rather faded samples of May . . . The paper had to be specially made as there was none on the market of that size. Thinking I should only want a very few [prints] I did not have a printing frame made of the size, but used a 24 by 18 [61 × 46 cm], and rolled up the paper at each end in black velvet, while the other part printed; each complete print took several days' exposure, and some were spoilt by time. It took a good deal of enthusiasm to carry this picture to

anything like a successful end, and there is now, I believe, only one moderately good copy existing, that in my own possession.[56] [Figure 22 a–j].

Bringing Home the May met with a rapturous reception from the photographic press. It was given a very fulsome review in the *Photographic Journal* of 16 February 1863, following an announcement made by the adjudicators of the Photographic Society's 1862 Exhibition that the photograph was 'unhesitatingly pronounced to be the best composition-picture photographed from life'. Not all reviews were so enthusiastic, especially in the art journals.

Robinson's picture construction of *Bringing Home the May* was in keeping with the frieze-like qualities of several of the Pre-Raphaelite painters, with the same sharpness and attention to detail. The representation of such a scene by the medium of photography bears a striking resemblance to the painting by J. E. Millais titled *Spring (Apple Blossom)* (figure 23) when the latter is reproduced in monochrome.

The publication price of the photograph was 20 guineas and in spite of this unprecedented sum for a photograph Robinson received a large number of orders which his business commitments did not permit him to fulfil. To avoid disappointing many supporters he decided to issue the picture on a smaller scale, the size being 20.3 × 51 cm and the price 1 guinea. He presented the negatives and copyright for this issue to the Photographic Society. Each member of the Society in that year received a mounted copy with india-tinted margins and a statement

Figure 22a *Bringing Home the May*, 1862. Print of the completed composite photograph.
Collection: The Royal Photographic Society

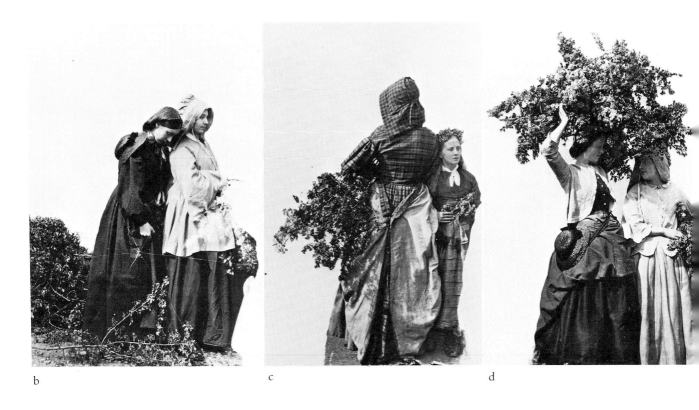

b c d

Figure 22b–j *Bringing Home the May*, 1862. Prints of
the nine separate negatives used to form the composite.
The 'figure' images here associated with the masked
landscape negatives as follows: b and c with g; d with g
and h; e with h, i and j; f with i and j

g

e

f

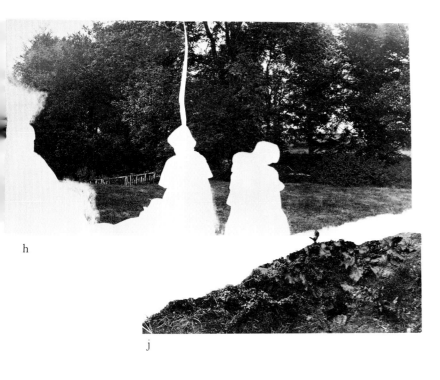

h

j

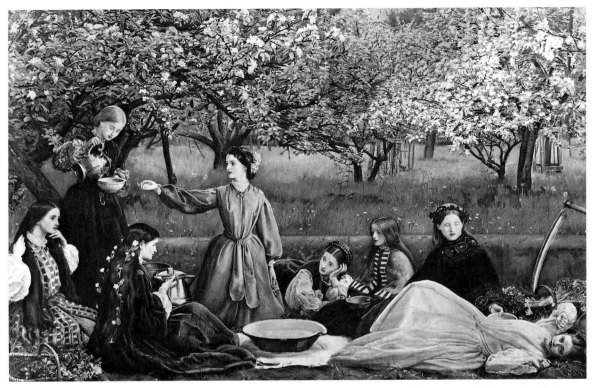

Figure 23 *Spring (Apple Blossom)*, 1856/9, by Sir John Everett Millais, PRA. Collection: Lady Lever Art Gallery, Port Sunlight, Merseyside

to the effect that the photograph would not be published in any other form, so that members would have 'the exclusive possession of this picture'.[57]

The Move to 16, Upper Parade

Robinson's thriving business and ambitious artistic projects made larger premises imperative. Fortunately the occupier of the adjoining premises which were twice the size of 15, Upper Parade, wanted to be rid of them. On 4 October 1862 it was announced in the *Leamington Courier* that 15, Upper Parade was to let. On 29 November the newspaper carried a notice which informed the public: 'In removing from No. 15, to No. 16, Upper Parade, Mr Robinson has availed himself of the opportunity to build one of the most complex suites of rooms for photographic purposes in the Kingdom . . . Open from Nine till Six.' At the bottom of the garden, which opened onto a back street, was a well constructed small building which was most

convenient as a 'printing house' and which provided storage for negatives. There was also a stable and every accommodation for photographing horses (figure 24).

As a grand finale to this momentous year there was another addition to the Robinson family with the birth of a second daughter (the third child), who was baptized Maud on 4 January 1863.[58] Robinson's friend G. Wharton Simpson, editor of *Photographic News*, answered Robinson's joyous announcement of the birth with one of his sketches, in jocular vein:

18, Canonbury Park South, N. Dec. 15, 1862
Dear Robinson,

Mrs Simpson says that you are a provoking tiresome fellow. You promised us news of Mrs Robinson, and then leave it all to assumption on our part. You do not say one word about her health; but proceed to tell us about a little girl – a mermaid, I presume, since she is introduced brushing her hair – who calls herself Maud. What do you mean by it, Sir? We wished to hear how Mrs Robinson was, whom we do know, and you tell us of one, Maud Robinson, whom we don't know, nor indeed ever heard of before. We are glad to assume, however, that no news is good news, and that the

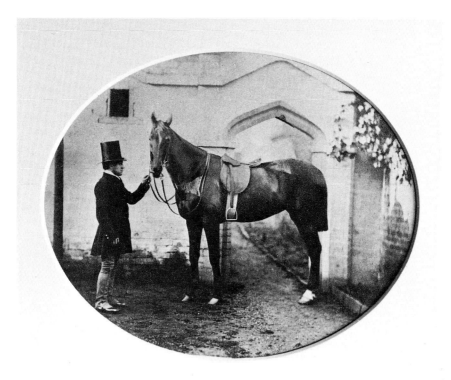

Figure 24 *Horse and Groom*, 1863, by H. P. Robinson. Courtesy Keith and Usha Taylor

said Maud's mama is 'doing as well', or better, than can be expected. Give her Mrs Simpson's best wishes, and do the same good office for me; and do not neglect it, Sir!

Well, my dear fellow three is the most perfect number in every sense, and is symbolical of completeness: don't go and spoil it. If you do you will have to go on to seven, which although more than twice as many, is less than half as perfect. The arrangement is as perfect as the number: one boy and two girls, more will spoil the balance and harmony ...[59]

In fact two further children were born to Henry and Selina, so they ignored Simpson's advice!

During 1863 there was no sign of abatement in the demand for cartes-de-visite and there was an increased demand for high-priced coloured portraits. Robinson sent his pictures to a larger number of exhibitions and was in receipt of many medals for his photographs.

His major composite photograph of the year was *Autumn*, which measured 36.8 × 57.8 cm, the theme being gleaners resting on their way home after a day's work in the fields (plate 60). It received a very long review in *Photographic News* as well as other complimentary notices.[60]

Gleaners, gleaning and country stiles were popular subjects with Victorian painters and illustrators. *Young Gleaners Resting by a Stile* by Myles Birket Foster (figure 25) makes an interesting comparison with *Autumn* by H. P. Robinson (plate 60). Robinson greatly admired the work of this popular nineteenth-century illustrator. They clearly had similar ideas about picture construction, tonal arrangement, lighting effects and rendition of detail, each in his chosen medium. It should be noted that Birket Foster painted this picture in 1886, and it could be useful to compare it with his later work, especially plates 77 and 89.

In his preliminary studies for *Autumn* Robinson made a charming photograph, which he named *Somebody Coming*, and exhibited it in its own right (plate 59). The landscape in *Autumn* was a photograph he had taken in Stoneleigh Deer Park.[61] The *Journal of the Photographic Society* carried a long notice on this picture in which Robinson was praised for his attempts to make good the claims of photography 'to a place in the sisterhood of the Fine Arts'.[62]

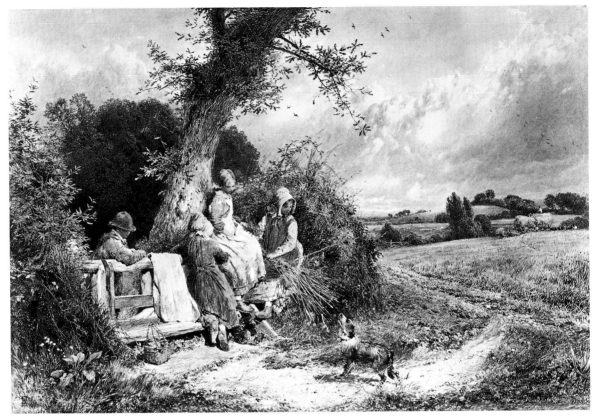

Figure 25 *Young Gleaners Resting by a Stile*, 1886, by Myles Birket Foster, RWS. Watercolour. Collection: Victoria and Albert Museum

On 25 May 1864 a fourth and youngest daughter was born to Henry and Selina Robinson and baptized Ethel May. This child referred to herself as 'Bouncing Baby' and was known to family and friends as B.

Early Retirement

During 1864 it became clear to the Robinson family that the hard work and intensive strain involved in running his business and keeping up his artistic output of photographs was altogether too much for Henry. In addition the constant inhalation of the fumes from the collodion and other chemicals had induced a nervous condition. He had had no holiday, except for the occasional day or two in London, for six years. He eased up and took more rest but it failed to restore his shattered reserves of energy. He was faced with the fateful decision of selling the business and retiring from the professional practice of photo-

graphy in the autumn of 1864.

In the *Leamington Courier* on 17 December 1864 he informed his

Patrons and friends that in consequence of ill-health he [Mr Robinson] has been obliged to relinquish his duties as a photographer. In returning thanks for the great amount of support he has received Mr Robinson is happy to state that he has been particularly fortunate in finding in his successor, Mr Netterville Briggs, a gentleman to whom he has no hesitation in entrusting the reputation he feels he has been fortunate enough to make in this profession.

This thoughtful introduction of his successor to his clients was a kindly and typical gesture. Robinson had sold the goodwill of the business along with his vast accumulation of portrait negatives. He, of course, retained his exhibition pictures (negatives and prints) as well as the cameras and other equipment required to continue producing photographic art.

4

PICTORIAL EFFECT

It is an old canon of art, that every scene worth painting must have something of the sublime, the beautiful, or the picturesque. By its nature, photography can make no pretensions to represent the first, but beauty can be represented by its means and picturesqueness has never had so perfect an interpreter.

H. P. Robinson, *Pictorial Effect in Photography*

The Move to London

It must have been a bitter blow to be forced into retirement at the early age of thirty-four. It is not clear how Henry Robinson managed to support his growing family during the next three and a half years (1865–8), as the personal records he kept virtually ceased for that period, or were subsequently destroyed. What is known is that he went to live in London near to his friend G. Wharton Simpson (figure 26) and that his address was 68, Canonbury Park South in north London.[1]

It is reasonable to conjecture that with such a prosperous business in Leamington between 1862 and 1865 he was able to save money, and that that, combined with the proceeds of the sale, enabled the family to live modestly for three years or so on a reduced income. Also he must have continued to receive income from the sale of views and exhibition pictures through print sellers and other outlets.

In spite of an enforced rest from running a busy photographic portrait practice Henry Peach Robinson took full advantage of this time, using his waking hours to good effect. It was a comparatively easy journey between north London and Twickenham House, Middlesex, and he was able to join the company of painters, photographers and literary folk more frequently than before. He could also spend more time at meetings of the Photographic Society. But it was not socializing that occupied most of his time. This he spent in writing. He lectured and wrote extensively on photography, his articles being published by the photographic press,[2] and he assisted G. Wharton Simpson on the editorial side of *Photographic News* 'as a recreation'.

In 1866, as his health began to improve, Robinson set up what he called a 'private studio' at 68, Canonbury Park South. He continued with the production of pictures for exhibition, and there were times when he took photographs for cartes-de-visite, as the occasional carte with his London address on the back reveals. He concentrated on genre portraits of girls in country costume photographed in his studio against appropriate backdrops. These are some of his most delightful pictures and although he had several imitators his photographs are distinguished by the ease and natural pose of the models he employed and by their expressions, at which he always excelled. *Down to the Well* (plate 61), *Load of Ferns* (plate 62), *Waiting for the Boat* (plate 63), and *On the Way to Market* (plate 64), are representative of his work during this period.

Robinson at this time was convinced of the need to obtain a degree of softness in a portrait photograph which would, he felt sure, enhance its aesthetic appeal. Accordingly he collaborated

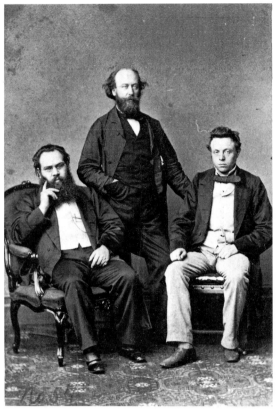

Figure 26 *G. Wharton Simpson, T. R. Williams and J. H. Dallmeyer, c.1866*, by H. P. Robinson. Carte-de-visite. Collection: The Smithsonian Institution

with the leading lens designer/manufacturer, J. H. Dallmeyer, (figure 26) in demonstrating the effectiveness of a lens designed for this purpose. *Waiting for the Boat* and *On the Way to Market* were taken by means of Dallmeyer's new Portrait Triple Lens, the special object of which was to get rid of excessively hard lines in one plane only, distribute the focus and provide depth of focus. Robinson exhibited the photographs at a meeting of the Photographic Society in the spring.[3] He then displayed *Waiting for the Boat* before the North London Photographic Association on 3 October at Middleton Hall, Islington, when G. Wharton Simpson was in the chair.

Robinson was also in collaboration with Sir Joseph Wilson Swan, the inventor, who introduced carbon printing on a commercial basis in February 1866. His firm, Mawson & Swan, made an edition of carbon prints from Robinson's negative of *Waiting for the Boat* in the summer. (The photograph had already been published in the form of albumen silver prints at 12*s* 6*d* each

by Marion Son & Company, and distributed to print sellers earlier in the year.)

Robinson and Swan made it possible for each member of the North London Photographic Association to be presented with one of these carbon prints (said to be the first actual issue to the public of prints made by Swan's process) as part of their subscription to the Association.[4]

The Solar Club

H. P. Robinson was an enthusiastic socializer and supporter of clubs and societies all his life, and was not infrequently a founder member.

After approaching one or two friends he invited seven 'gentlemen connected with photography' to meet together with him on 12 February 1866 to dine at Blanchard's, Beak Street, after which they adjourned to the studio of the distinguished portrait photographer T. R. Williams, to form the Solar Club.[5] Membership was open to 'an unlimited number of members and a Chancellor, who shall be gentlemen interested in photography or other branches of the Fine Arts'. Members were elected by ballot, having been nominated at the previous meeting.[6]

The Solar Club was essentially social in intent and was a dining-club, meetings being held at the Café Royal, Regent Street, London. 'Whereas the object of this Club is Social Enjoyment and whereas it is clearly great and virtuous to dine, therefore be it enacted that we be great and virtuous.' The club met once a month and smoking, far from being prohibited, was strictly enforced! The presiding member for the evening (having been nominated at the previous month's meeting) was addressed as 'Lord Uriel' (Regent of the Sun which was the symbol of the club) and members were Brother Rays. The Chancellor (H. P. Robinson) organized the meetings.

The psychological need for clubs of this kind is a deep-seated one, going back to the early days of man's social consciousness. Without an association of one kind or another many individuals suffer from a lack of identity. They require a community of like-minded individuals with whom to share experiences and solve problems and who will provide the necessary stimulus to engender creative thought. Photographers are no exception and although these associations are manifested in more diverse forms today the need is as strong as it was in the latter part of the nineteenth century.

Sleep

In 1867 Henry Robinson exhibited a major composite picture: *Sleep*, which he had made the previous year using his two eldest children, Edith and Ralph, as models (plate 71). It was conceived to illustrate a verse from the poem 'Tristan and Iseult' by Matthew Arnold:

> They sleep in sheltered rest,
> Like helpless birds in the warm nest,
> On the castle's southern side,
> Where feebly comes the mournful roar
> Of buffeting wind and surging tide
> Through many a room and corridor.
> Full on their window the moon's ray
> Makes their chamber as bright as day,
> It on the snowy pillow falls,
> And on two angel heads doth play.
> Through the soft-opened lips the air
> Scarcely moves the coverlet
> One little wandering arm is thrown
> At random on the counterpane,
> And often the fingers close in haste
> As if their baby owner chased
> The butterflies again.
> This stir they have, and this alone;
> But else they are so still.

The photograph is one of his best. It has a mystical, dream-like quality and more aesthetic appeal than most of his previous composite pictures.

Robinson visualized the poem in considerable detail, interpreting the mood by means of the concentration of light and dark tones, and the vulnerability of the two children by their positions in relation to the surrounding space. He reinforced the menacing undertones of the poem by the positioning of heavy draperies over the heads of the little sleepers and the use of barely discernible wall tapestry on the right, with its image of a war horse and ancient soldiers preparing for battle, calculated to kindle the boy's dreams to nightmare proportions.

To appreciate Robinson's interpretation fully the picture should be read in conjunction with the poem as printed and *not* the first two lines only. The boy's restlessness is well expressed by the little wandering arm 'thrown at random on the counterpane' and 'the soft-opened lips'. The 'moon's ray' falls 'full on their window' and bathes the sleepers in light, and through the window can be seen 'the surging tide'.

Similar themes were popular with painters of the period and Robinson was making the point

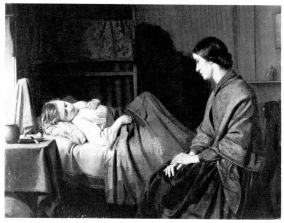

Figure 27 *An Anxious Hour*, 1865, by Mrs Alexander Farmer. Oil. Collection: Victoria and Albert Museum

that it was possible to use light, lens and paper as an alternative to paint, brush and canvas to depict powerful narratives of this kind (figure 27). One contemporary reviewer made the point that *Sleep* was

a picture of singular and daring chiaroscuro, with a rare Rembrandtesque effect: the chief interest being concentrated on one small intense light, whilst the greater portion of the picture is in shadow or deep mezzotint . . . It has almost ceased to be necessary to justify this kind of work. At one time the fitness of photography for such attempts was honestly doubted by some who held in equal reverence the beauty of art and the truth of photography. The satisfactory answer has been the actual production of photographic pictures embodying both.[7]

Photographic Art Theory

It was during his years in London that Robinson embarked on his major literary work *Pictorial Effect in Photography, Being Hints on Composition and Chiaroscuro for Photographers*. It was the result of over twenty years of thought about aesthetics, the principles governing art and theories of the Picturesque applied to painting, drawing and photography, as well as his own practical experience. The text was first published as a series in 1868 in *Photographic News* and then in 1869 as the first edition of a book with illustrations and with a chapter added on 'Combination Printing'.[8] There were seven subsequent editions in the nineteenth century.[9]

Robinson dedicated *Pictorial Effect in Photography* to his friend and mentor Hugh Welch Diamond, 'one of the fathers of photography . . .

as a tribute of the sincerest and warmest respect and esteem'. Diamond was very touched by this gesture and wrote to Robinson on 19 September 1869: 'I cannot tell you with what astonishment I saw the dedication, it quite upset me and I could not see plainly – a gentleman put out his cigar as he saw the smoke affecting my eyes but it is very kind of you to think me worthy of such a compliment and I can only thank you in sincerity.'[10] In the introduction to a modern reprint of the book it was stated that

Henry Peach Robinson was perhaps the most influential voice in nineteenth century photography. No other photographer so consistently produced major works of art, was bestowed with so many commendations and medals and was so much a proselytizer of a coherent theory of photographic art . . . Even more important than his pictures, however, Robinson's writings stand as the first complete photographic art theory in the English language.[11]

H. P. Robinson's theories on photographic art were built on a sound foundation: the aesthetics of the Picturesque movement in the arts, in particular the association between landscape and painting on the one hand and the relationship between poetry and painting on the other. His boyhood study of the writings of Ruskin and Burnet had long since been synthesized in his own mind to a harmonious unity by a process of acceptance of some ideas and rejection of others. As chapter headings in *Pictorial Effect* he quoted from both authors.

The pronouncements of the Rev. William Gilpin, the great nature lover and advocate of the Picturesque in landscape, were very close to his own ideas of the relationships between Truth, Beauty and Nature, and he fully accepted Gilpin's orginal dictum: 'We must ever recollect that nature is most defective in composition; and *must* be a little assisted. Her ideas are too vast for picturesque use, without the restraint of rules.' Robinson had no difficulty in applying this concept to drawing and painting, along with many other artists of his day but, realizing the exacting and uncompromising nature of photography, he devoted many pages of *Pictorial Effect in Photography* to a clear and uncomplicated account of how the real and the ideal could be associated in one photograph.

The Picturesque, as a concept, had emerged in the mid-eighteenth century, although it had existed in a more restricted form for many years before. J. H. Polt, in his 'Essay on Landscape Painting' (1782), said: 'the meanest object in nature, a stone, the stump of a tree, a piece of broken ground, if imitated most exactly, will immediately affect the mind with pleasure.' Robinson applied this concept to photography when he reminded his readers how a simple subject will serve to make a picture. Photography

is not possessed of unlimited power; the sublime cannot be reached by it; its power is greatest when it attempts the simplest things [a basket, stone, logs of wood, or barrel] . . . all or any of these may be made valuable when a foreground presents nothing of especial interest in itself and how, by their presence, they at once give tenderness to the distance and space to the picture.[12]

By 1797 an aesthetic in how to treat the subject had become all-important. This was perpetuated by artists in the nineteenth century. There were visual delights to be revealed by pencil and paint (and the action of light on sensitized paper, according to Robinson) of, for example, the rough textures and broken surfaces of a building in ruins in a manner which provided a romantic and visually pleasing interpretation of the subject rather than the sadness of past glories, death and decay. This association of ideas could be reinforced by coupling appropriate verse or lines of prose with painting or photograph.

Robinson was well aware of the value of the association of the verbal with the visual narrative as practised by many of the great painters whose work he so much admired. He had spent hours studying the works of artists such as J. M. W. Turner whose imaginative painting *Childe Harold's Pilgrimage: Italy* (figure 28) possessed all the important ingredients, including the human action, of a picturesque interpretation of landscape and was exhibited in 1832 with lines from Canto 4 by Lord Byron alongside; these aptly expressed Turner's own feelings:

> And now, fair Italy,
> Thou art the garden of the world.
> Even in thy desert what is like to thee?
> Thy very weeds are beautiful, thy waste
> More rich than other climes' fertility.

Robinson used this picture to illustrate the chapter on 'Light and Shade' in another of his books, *Picture Making by Photography*, in which he said:

It will be found that the beauty of effective light and shade consists chiefly in wedge-shaped masses . . . Turner's pictures are often composed on this principle. In *Childe Harold's Pilgrimage: Italy* a simple mass of

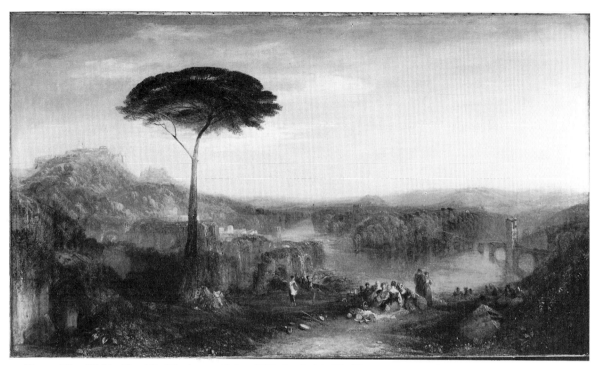

Figure 28 *Childe Harold's Pilgrimage: Italy*, 1832, by J. M. W. Turner, RA. Oil. Collection: Tate Gallery

extreme dark of an agreeable form – the stone pine – is relieved against a light sky; and some bits of extreme light are introduced into the foreground, while the rest of the picture is composed of gradations within the extremes of darkest and lightest; in this arrangement Turner imitated Claude.[13]

Robinson's admiration for Turner and his works is made very clear in *Pictorial Effect*, as there are frequent references to this great artist.[14] In the first instance he advised students of the art of photography to: 'Go to the National Gallery, and make a careful examination of the Turner collection' [now in the Clore Gallery of the Tate Gallery] and to observe in his picture construction that 'Turner strictly obeyed the simple rules of composition' and that they did not in any way inhibit the richness of his imagination. In the chapter which deals with skies in photographs he referred to Turner's paintings in which the skies are

'drawn from the retentive stores of his memory; they are adapted to the picture in hand by the different qualities required. If the subject is indifferent, he trusts to the richness and composition of the sky to give it interest; and if the scene is complicated, and consists of many parts, he makes use of the sky as the seat of repose' . . . It must be remembered that nature is not

all alike equally beautiful, but it is the artist's part to represent it in the most beautiful manner possible.[15]

In applying this dictum to photography he referred to the technical difficulty, during the nineteenth century, of securing a good rendition of sky and subject on the same negative. He advised the photographer to make a range of 'sky' negatives from which one suited to the mood of the subject in hand and lit from the same direction could be combined in printing onto one sheet of paper. He frequently employed this method for his own photographs (plates 65, 67, 94, 96).

In his chapter on 'The Faculty of Artistic Sight' Robinson implores his students to train their eyes to see beauty:

However much a man might love beautiful scenery, his love for it would be greatly enhanced if he looked at it with the eye of an artist, and knew *why* it was beautiful. A new world is open to him who has learnt to distinguish and feel the effect of the beautiful and subtle harmonies that nature presents in all her varied aspects. Men usually see little of what is before their eyes unless they are trained to use them in a special manner.[16]

Beauty to Robinson and his peers was an essential quality which, if missing from a work of

art, degraded it beyond recognition. One of our problems today, in evaluating Robinson's theories on photographic art as well as his own photographs, is that Beauty, for better or worse, is an irrelevant idea in modern thought about art. In Robinson's day it was paramount.

While admitting that photography had its limitations, Robinson made the point that it was much more than a merely mechanical craft skill:

It must be admitted, by the most determined opponent of photography as a fine art, that the same object represented by different photographers will produce different pictorial results, and this invariably, not only because the one man uses different lenses and chemicals to the other, but because there is something different in each man's mind, which, somehow, gets communicated to his fingers' ends, and thence to his pictures.[17]

Again and again Robinson emphasized the importance of the trained eye rather than rigid adherence to the rules, which if pursued without visual awareness and perception were sterile:

I must warn you against a too close study of art to the exclusion of nature and the suppression of original thought . . . Art rules should be a guide only to the study of nature, and not a set of fetters to confine the ideas or to depress the faculty of original interpretation in the artist, whether he be painter or photographer; and a knowledge of the technicalities of art [or photography] will be found the best guide . . . The object [of rules] is to train his mind so that he may select with ease, and, when he does select, know why one aspect of a subject is better than another.[18]

On the subject of the limitations of photography as a medium for artistic expression Robinson said, amongst other things:

It is a too common occurrence with photographers to overlook the inadaptability of a scene to artistic treatment, merely because they think it lends itself to the facility, which their art possesses, of rendering, with wondrous truth, minutiae and unimportant details. To many this rendering of detail, and the obtaining of sharp pictures, is all that is considered necessary to constitute perfection; and the reason for this is, that they have no knowledge of, and therefore can take no interest in, the representation of nature as she presents herself to the eye of a well-trained painter, or of one who has studied her with reverence and love.[19]

One of the most important principles of picture construction about which Robinson expressed his thoughts was Unity:

Unity is so simple that it is often overlooked; but no success in any other qualities desirable in a picture, as I have already said, will compensate for its absence. In photographs, where there is no colour to distract the attention from the design, it is especially necessary. It is the absence of unity in the arrangement of the figures in a photographic landscape that so frequently mars the beauty of an otherwise effective picture. It is too often the practice to scatter figures, dressed inharmoniously within the scene, over the foreground of a landscape, without any reference to one another, or the propriety of their being there at all, and so unity is disregarded and lost . . . I must impress thus early upon you this dominant idea: that if a picture is to be successful, it must have a oneness of purpose or intention, a oneness of story, a oneness of thought, a oneness of lines, a oneness of light and shade. Everything must have a meaning, and the meaning must be *the object* of the picture.[20]

He put this principle into practice in his own photographs, as can be seen from a study of the main illustrations to this book.

The photography of groups which represented an activity or formed the nucleus of a narrative statement was of especial interest to Robinson. His major composite photographs were about such subjects, which presented a marked challenge to the photographic artist. It is hardly surprising that he wrote about this challenge in *Pictorial Effect*, using works by the painter David Wilkie as exemplars:

As regards composition, the pictures of Wilkie may be taken as safe guides by the student. Artists of every shade of opinion unite in regarding them in this one respect as perfect. The 'Blind Fiddler' [figure 29] as far as the arrangement of its materials is concerned, would have been possible in photography; it is, therefore, a picture of which a long study and analysis will much benefit the photographer.

The composition consists of a series of pyramids built up on, and combined with, one another. The fiddler himself forms a pyramid, and being the motive of the picture, he is more isolated than any other figure, which gives him great prominence, although he is not the chief mass of light; so that what Ruskin rather fantastically calls the 'law of principality' is observed. But he is not left quite alone, but is connected with the principle group by the figures of his wife and child, and the basket at his feet. This basket is made light, to strike the eye, partly to unite the two groups, but chiefly because it is the supporting point of the angle of which the old grandfather's head in the centre is the apex, and which is led up to by the boy in shadow warming his hands at the fire. The two little girls form a pyramid, and so do the mother and child, supported by the dog, which is again continued by the man snapping his fingers, again by the old man, who caps and perfects the whole group. Notice

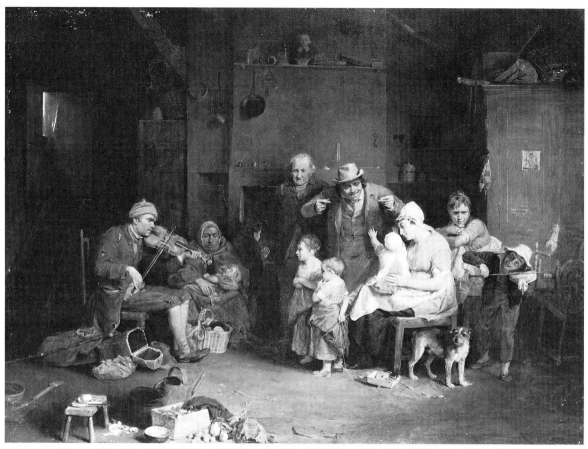

Figure 29 *The Blind Fiddler*, 1806, by Sir David Wilkie, RA. Oil. Collection: Tate Gallery

particularly how the line of one side of the pyramid formed by the mother and child is carried on by the stick in the little girl's hand. All the figures are connected together in one grand pyramid by the dark and light spots formed by the cooking utensils over the fire-place; and the diagonal line is still further carried on by the slanting beam to the left, which, again, is balanced by the steps leading to the door. The perpendicular lines of the wall give stability to the composition, and the group of kitchen utensils and vegetables in the foreground, being darker than any other part, give delicacy and distance, as well as scale, to the rest of the picture, and, by contrast, perfect balance to the group . . . What could be more formal, regular, and artificial than this group, and yet what more entirely natural? If art – art regulated by laws – were antagonistic to nature, this would not have been the most popular picture of its year, 1806; nor would it have retained its popularity, and become, as it perhaps is, the best known picture ever painted in England.[21]

Another painter he singled out for attention was William Mulready:

Perhaps nothing in the whole range of art can be brought into comparison with the works of Mulready for *technical* perfection. In truth of drawing, elaborate finish, and exquisite colour, he excelled long before the works of the modern pre-Raphaelites made these qualities indispensable in pictures, and to these perfections he added most supreme skill in composition. Painted in his best period, 'Choosing the Wedding Gown' [figure 30] is one of the finest creations, and is an admirable example for the student to have constantly before his eyes.[22]

With reference to *The Swing* by Frederick Goodall, which was 'one of the most charming groups of children's portraits that have ever been painted', Robinson admitted the difficulty in photographing such a subject but said that it was not impossible.

Although he put considerable emphasis on the importance of good design in picture construction, Robinson was also greatly concerned with content. On this subject he had very important

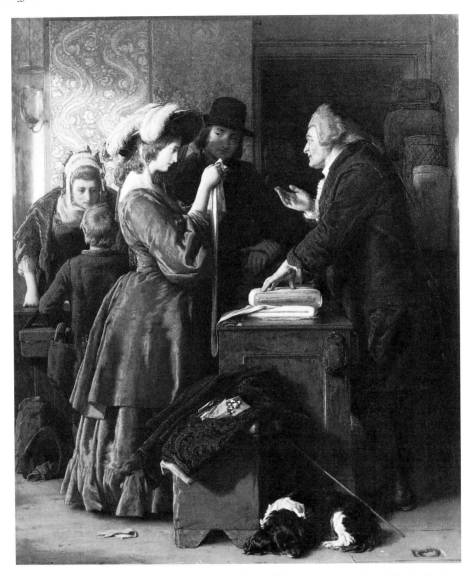

Figure 30 *Choosing the Wedding Gown*, 1846, by William Mulready, RA. Oil. Collection:
Victoria and Albert Museum

things to say which were manifest in his own pictures. With references to figures in landscape he said:

It is not open to the photographer to produce his effects by departing from the *facts* of nature, as has been the practice with the painter for ages; but he may use all legitimate means of presenting the story he has to tell in the most agreeable manner, and it is his imperative duty to avoid the mean, the base, and the ugly; and to aim to elevate his subject, to avoid awkward forms, and to correct the unpicturesque . . .

The figures and the landscape should never be quite equal in interest or pictorial value. The one should be subordinate to the other. The picture should consist of figures with a landscape background (if they are represented in the open air), or of a landscape in which figures are introduced merely for the sake of impressing a point or adding a life to the more important scene.[23]

And in another chapter he expresses the same values but in more general terms:

I am far from saying that a photograph must be an actual, literal, and absolute *fact*; that would deny all I have written; but it must represent *truth*. Truth is

conformity to fact or reality – absence of falsehood. So that truth in art may exist without an absolute observance of facts . . . The photographer must not let his invention tempt him to represent, by any trick, any scene that does not occur in nature; if he does, he does violence to his art, because it is known that his finished result represents some object or thing that has existed for a space of time before his camera. But any 'dodge, trick, or conjuration' of any kind is open to the photographer's use, *so that it belongs to his art, and is not false to nature.*[24]

On the subjects of portraiture and genre he had this to say: 'A great deal can be done, and very beautiful pictures made, by the mixture of the real and artificial in a picture. Although, for choice, I should prefer everything in a photograph being from nature, I admit a picture to be right when the "effect" is natural, however obtained.' *On the Hill-Top* (plate 30) was used to illustrate this point. The model was photographed in his studio, the 'foreground' was made up of turf, ferns and heather, placed on a platform which moved on large castors, for the convenience of rolling it about the studio, and the background was a painted screen.

It is not the fact of reality that is required, but the truth of imitation that constitutes a veracious picture. Cultivated minds do not require to believe that they are deceived, and that they look on actual nature, when they behold a pictorial representation of it . . . Art is not the science of deception, but that of giving pleasure . . . If the background be well painted, it will be found to unite very naturally with the foreground. Care must be taken that linear perspective be avoided, and that the light fall on the figures in the same direction as it does on the painted screen.[25]

Nearly all photographic art critics used Robinson's form of picture analysis from the time of the publication of *Pictorial Effect in Photography* until the 1940s and beyond. His teachings on pictorial design and picture construction were absorbed and passed on to succeeding generations of students by teachers of photography and were faithfully followed by adjudicators of pictorial photography the world over. To today's older generation of photographers they have a very familiar ring. In some instances Robinson's advice on composition and other aspects of picture making were interpreted too narrowly, and promulgated in the form of dogmatic rules which were in contradiction to his own precepts, which were that rules could and should be broken on occasion by those who knew what they were doing.

By the 1950s Robinson's art teachings had long since been absorbed into the practice of photographic art whereas the originator of photographic art theory was forgotten and his pictures regarded as quaint and old-fashioned.

5

LIFE IN TUNBRIDGE WELLS

A sitter will sometimes want to be taken 'naturally'. His idea of being natural 'just as I am, you know' is to sprawl over the furniture. Perhaps he will put his hands in his pockets, sink low in the chair, and expect you to make a good head and shoulders of him. This is an awkward customer to manage. Possibly the best plan is to recommend him to go to the worst photographer he can find . . . or to the peripatetic on the sands or common, who will let him have his own way entirely, so that he pays his sixpence in advance.

H. P. Robinson, *The Photographic Studio,*
and What to Do in It

Henry Peach Robinson's recovery from his debilitating illness was complete in the summer of 1867. As he was ready to become fully engaged in professional photography again, he began to look round for a suitable location to acquire premises for a studio. He longed for the country, where his young family could enjoy the fresh air and play in green fields and woodland, and the county of Kent had its attractions for him. The climate in the south was kinder than in the Midlands and he wanted to live within reasonable distance of London. It was Tunbridge Wells which met his requirements, so in the autumn of 1867 he acquired domestic property at 5, Belvedere Terrace, later redesignated 21, Church Road, in the lower part of the town.[1]

The Spa Town of Tunbridge Wells

The town was pleasant, with interesting architecture and distinct character. Not least of the attractions was the fair land of Kent that comes right up to the doorstep. Culverden Down, Rusthall Common and High Rocks were within easy walking distance from the centre and were ideal for children's outings and looked promising subjects for the camera. Although the prefix 'Royal' was not bestowed on Tunbridge Wells until 1909, many members of the nobility and wealthy middle classes lived in the district. The townsfolk were prosperous and shops displayed the best of wares. Moreover there was a railway station situated within easy reach of the Pantiles and the shopping centre. This brought visitors in droves to the town in the summer months.

When Henry Peach Robinson arrived in Tunbrige Wells in 1868 relatively small changes had occurred since the Census return of 1851, which showed that eight in ten of the working population were in service industries of one kind or another. Domestic servants accounted for 13.4 per cent of the whole population. It was the largest group in the town, in a period when domestic service was the principal form of employment for women. Most people worked long hours with only Sundays free. Over 8 per cent of the population were of independent means, unemployed or retired.[2]

In 1869 people still drank at the spring, where the basins had been renewed in 1865. One raconteur was 'amused at seeing folks drink their glasses and then diligently scrub their teeth over with sage leaves to remove the marks of iron'. Towards the end of 1870, a Pump Room was built which contained a fountain from which the

spa water gushed forth. Development of the town had proceeded rapidly and it was not long before the High Street was filled with shops and business premises. The Pantiles became the fashionable nucleus of the town where Pelton had his bookshop and Tunbridge Ware was displayed and sold. 'Quite notable toilettes' were to be seen in the precincts any day between the select hours of eleven and one, reported a local paper, the *Fashionable Visitor*, in 1888.

Tunbridge Ware, the town's oldest industry, flourished in the nineteenth century and examples were probably photographed by Robinson. It was a highly skilled process in the new form of end-grain mosaic and marquetry which superseded the earlier inlaid work. More than a hundred different woods were used to make up the pictures, which then had to be polished or varnished.[3]

There were two other notable industries in the town when Robinson took up residence: mineral water made by Lyle and others and Tunbridge Wells biscuits, made since 1862 by Romary of Church Road, which were counterparts to Bath Olivers.

The guidebooks extolled the attractions and amenities of the town: the softness of the air, filled with the aroma of broom and gorse (which grew prolifically on the common land beside the town on the west side), and iron (from the springs); the delightful scenery; local excursions to the High Rocks and the country estates of the local gentry. As far as amusements were concerned, there were concerts, lectures, an annual ball (which must have pleased Robinson) and all the usual outdoor sports of the period, including cricket on the Upper Ground of the Common, a sport in which Robinson took a lifelong interest.

A visitor to the town in 1879 commented on 'pony carts with invalids, the broughams of medical men, ladies and gentlemen on horseback, barouches bearing ineffable dowagers . . . these were signs we were entering Tunbridge Wells the Fashionable, the Cheerful, the Salubrious . . . The good things of life are enjoyed there in a placid, undemonstrative and equable manner.'[4]

With a growing community there were problems of water and gas supply as well as drainage and sewage. All these must have affected a business such as Robinson's. The water shortages in the dry summers of the 1880s must have caused him many anxious hours as clean running water is vital to the processes of photography. In 1889 gas was still the only supplied source of illumination in Tunbridge Wells. In the taking of photographs Robinson remained an ardent advocate of the use of natural lighting all his working life, as did the majority of portrait photographers in the nineteenth century, but artificial light must have been a necessity in the work-rooms. On occasion he made brief reference to the use of flashlight for work away from the studio.[5]

In 1889 mechanically propelled vehicles were forbidden to go at more than four miles an hour in the streets and a man with a red flag had to walk in front. Omnibuses were drawn by horses and the conveyance of goods between the town and adjacent villages was by carrier's cart. The train service was comparatively slow and travelling in winter necessitated the carrying of a rug (steam-heated trains being described as 'a modern luxury' in 1939). The telephone was not generally available, but Richard Pelton had one installed between his shop and his printing works and 'visitors inspected [it] as a curiosity'.[6]

On Taking a Partner

Selina Robinson, ever mindful of their previous business experience and the near ruination of Henry's health and sanity, pursuaded her husband to think about taking a partner. Unwilling at first, as Henry Robinson preferred to be his own master in everything, he reluctantly came round to her viewpoint and considered possible candidates.

Through his Photographic Society activities in London in 1865–7, Robinson had become friendly with Nelson King Cherrill, a young photographer for whom he had a high regard, who was living at Belmont Lodge, Lee, south of England in 1866–7. They had much in common in that they both desired to promote the art of photography, albeit in somewhat different ways. They each enjoyed solving technical problems and were both articulate and lectured on photography as well as writing on the subject for the photographic press. In other respects they were complementary. Robinson was impulsive, intuitive, relied on inspiration and imagination, and was inclined to nervous tension, being easily drawn into argument. Cherrill was cool, precise and factual. He had trained as a civil engineer and had a good grasp of the sciences, whereas Robinson's skills were in the visual arts and literature. Cherrill's proven ability in photography was in landscape; Robinson preferred portraiture, figures in landscape and genre subjects.

Robinson was not alone in his assessment of N. K. Cherrill, whose *Views of the English Lake Scenery* were reviewed in 1866. The reviewer had concluded that the photographer possessed not only considerable technical knowledge but also a high degree of manipulative skill. He said:

Several views of Borrowdale are remarkable for their delicacy of gradation and perfect harmony . . . One espccial feature in these pictures is the presence of atmosphere and of cloud effects. In many cases these are obtained on one negative, at the same time as the landscape; but in many others the clouds are introduced by skilful double printing. [He also praised his] very fine photographs of machinery, especially some of the interior of the engine works of 'Messrs Penn and Co' of Greenwich, shown at some of the public exhibitions.[7]

It is not surprising that both Henry and Selina Robinson were delighted when Nelson Cherrill agreed to Henry's proposal that they should enter into a business partnership. Together H. P. Robinson and N. K. Cherrill set up a photography establishment at 1, Grove Villas, Upper Grosvenor Road, Tunbridge Wells, and commenced business there in 1868.[8] Meanwhile Cherrill acquired household property at 1, Fern Villas, Queen's Road.

Soon they were very busy and Robinson photographed two very important personalities in the world of photography, one within months of opening the studio. M. Antoine Adam-Salomon of Paris, the internationally renowned portrait photographer, came to visit their studio in 1868. Robinson photographed him in the manner of Salomon's own style of portraiture. The photographs received good press notices.[9] The following year Dr Hugh Welch Diamond visited the studio on 28 September and Robinson took his photograph (plate 72).

Cherrill was tireless in experimenting with new processes, just as Robinson had been in earlier days. As soon as Joseph Wilson Swan had made his carbon tissue available to photographers in February 1866 Cherrill made tests and was soon producing some excellent prints by this process,[10] including several from the negatives of Robinson's former exhibition pictures which they displayed in their studio gallery. They became expert at the transfer of the carbon tissue to silk and at a later date to porcelain and enamel. In fact the latter became one of their specialities and Robinson and Cherrill became renowned for photographs on enamel plaques, the process being carried out at their new premises, the Great

Hall Studio, in the early 1870s.[11] The plaques could be displayed on a wall, mantelshelf or piano and, if in the form of miniatures, could be worn as jewellery in pendants, brooches, rings or bracelets (plate 42).

Watching the Lark, Borrowdale

Nelson King Cherrill and Henry Peach Robinson became partners in photography in all respects in that they did not confine this activity to their portrait business alone. Cherrill was very interested in combination printing and from the start of their friendship had questioned Robinson on the manner and methods of the production of his composite pictures. He experimented for himself and thought he could improve on the manner whereby images from separate negatives are associated together in printing. They worked on this together and perfected the method of using L registration marks on the negatives as detailed in the chapter on 'Combination Printing' in Robinson's book *Pictorial Effect in Photography* (appendix II). To prove the efficiency of this method they used it to print *Watching the Lark, Borrowdale* (plate 69), a composition based on Robinson's design and constructed from two negatives: a landscape photograph taken by Cherrill in the Lake District of England and a portrait of Maud, Robinson's second daughter, aged five. Robinson took the portrait in their outdoor studio with Maud seated on a 'mossy bank' behind which a white background was erected. The negative when printed contained the image of the child in the foreground, with basket and hat, and a uniform density over the rest of the negative which printed to a light tone. The negative of the landscape was to provide the middle and far distance in the picture.

Although both Robinson and Cherrill described this improved method of combination printing for the benefit of fellow photographers,[12] it was really in the interpretation of ideas through photography that Robinson was most interested. From boyhood he had found the song of the birds to be most uplifting, not least the ethereal call of the skylark. In seeking an apt illustration for William Wordsworth's joyous poem 'The Skylark', what could be better than the rapturous expression on the upturned face of a little girl resting on a knoll and surrounded by the plants and flowers of the field in Wordsworth's countryside of Borrowdale?

When the negatives had been prepared

Robinson and Cherrill were able to 'rattle off the two hundred copies' which they had decided to make for members of the Photographic Society of London 'at the usual rate of about four or five a day, with very few failures, and with still fewer bad joins'. *Watching the Lark, Borrowdale* signed by 'H. P. Robinson and N. K. Cherrill' was much admired by members of the Photographic Society, each of whom received a print, as a supplement, issued with the journal of the Photographic Society for November/December 1868. It was also enthusiastically reviewed elsewhere in the photographic press.[13]

Seascapes

Cherrill had developed a passion for seascapes. It was a subject with which Robinson was not familiar but as soon as they got to work along the Kent and Sussex coastlines he enjoyed the challenge such subjects presented in those days. The results of their labours were crowned with success and they were able to achieve the spontaneity of effect necessary to portray the restless motion of the sea (plate 74).[14] Their photograph *Seagulls* received several notices in the photographic press, including the reference to 'a magnificent flight of about fifty sea-gulls . . . a splendid instance of rapidity' and 'a wonderfully charming and harmonious piece of instantaneous photography . . . what especial device has been employed to secure this difficult but effective picture, or whether any device beyond the skilful use of well-known appliances, we cannot say.'[15] However, Mr J. H. Johnson of the Vicarage, Tilshead, was not deceived. He said that 'the secret [device] must be a very valuable one . . . and no doubt will soon be covered by a patent'. He then referred to one enthusiast, 'the Old Photographer', as having been '*gulled*'. Johnson's supposition was that the gulls had been '*painted upon the negative*, the whites having been laid upon the film, the blacks scraped out'. He confessed to being 'quite proud of the discovery'.[16] Robinson and Cherrill replied:

It was very cruel of Mr J. H. Johnson to publish the secret of our seagull picture . . . If he had only written to us privately, assuring us he had found us out, we confess he would have compelled us, in self-defence, to bribe him to silence by the offer of a license [sic] under the proposed patent, which would enable him to paint in or scratch out 'gulls and other birds' in his negatives at pleasure. As it is, he has forestalled us. We are human, but we freely forgive him.[17]

There was no acrimony in the published correspondence; it was all in light-hearted vein.

Family Life

Robinson was a great family man and there was nothing he enjoyed better in the early days in Tunbridge Wells than to take his young family and friends out after church on Sundays and on summer evenings after work to Rusthall Common and Culverden Down. There were times when Henry took his camera equipment with him, as he couldn't resist photographing his children in those lovely surroundings.

He was also a religious man in that he regularly attended St John's Church with his wife and children. The Robinson home after 1871 was in that parish. The vicar at this time was very popular and drew large crowds to the services.[18] It was at St John's Church that Maud Robinson, his second daughter, who frequently posed before his camera as a child, was married to Dr George Craigie Bell on 28 August 1888.[19] Henry Peach Robinson's own funeral service was conducted at St John's in 1901.

Robinson regarded 21, Church Road (5, Belvedere Terrace) as a temporary home. He secured a plot of land in Queen's Road, a pleasant residential area in the northern part of the town on higher ground, and a house was constructed on it to his specifications.

Whether Selina Robinson was really actively involved in photography at this stage is not known. In Tunbridge Wells her domestic duties must have taken up most of her time, but she may have helped with the financial side of the business.

In their third year in Tunbridge Wells Henry Robinson was able to install his household in their new home at 2, Queen's Road; he named the house 'Winwood' in honour of the ancestor from whom the Robinson family claimed descent. He carved a stone lintel to go over the front door and a cartouche with the initials H. P. R. within a scroll which included the date of occupancy, 1871 (figure 31). He also carved the bookcases for his library and his desk chair. This residence remained the family home until Ethel May Robinson died in 1932, having lived there alone after her mother died in 1909.

The Robinsons' fifth child and younger son was born *c.*1872 and baptized Leonard Lionel. In adult life he became the Borough Engineer for Hackney and married Kathleen Bell, presumed

Figure 31　The lintel stone carved by H. P. Robinson in 1871 over the porch of Winwood, 2 Queen's Road, Tunbridge Wells, as it was in 1979. Harker collection

younger sister of Dr George Craigie Bell, who had married Leonard's sister Maud.

Of all Robinson's children it was Edith who inherited her father's ability and inclinations as an artist. There is no evidence that she applied it to photography but she developed a reputation as a good amateur artist, especially in painting on china. Her work was exhibited at Howell and James Galleries in Regent Street, London, in June 1879.

Henry and Selina Robinson welcomed members of the family and friends to their home. Henry Baden Pritchard was a frequent visitor. In 1873 he married Mary Evans whom he had first met at their house. He became editor of *Photographic News* on the retirement of G. Wharton Simpson and proprietor a few years later. He died in 1884 at the early age of forty-three.

Henry Moore, the painter, was often to be seen at 'Winwood' and a close friend of Henry's, William Mayland, the Cambridge photographer, was always welcome, and sometimes stayed for long periods.[20]

An important family event occurred in 1876 when Henry's young brother Herbert John (Bob) Robinson married Agnes Esther Tate, who was the youngest daughter and one of the twelve children of Sir Henry Tate.[21] This was the first of the unions between the Robinson and Tate families who, with the Gossage family (into which Henry's sister Clara had married in 1860), became so closely interlinked through marriage. Henry Tate and Henry Robinson, who had similar tastes in paintings, became good friends and it was said in family circles that Henry Robinson advised Henry Tate on his collection of paintings. This magnificent collection was presented to the nation and was kept at the National Gallery until, several years later, it was established in the gallery in London which bears the name of its founder.

The Great Hall Studio

In 1871 the partners moved their business to new premises, the interior of which had been designed and furnished to their specifications. In the previous year Robinson had made the necessary arrangements to secure the lease of the north wing of the New Public Rooms (the Great Hall), the building of which had been commenced in 1868 and which was completed in 1870. This impressive building stood (figure 32) on a prime central site in the town in the Calverley Hotel grounds, Mount Pleasant, directly opposite the entrance to the South Eastern Railway station. The company which had been formed to erect the building for public meetings such as lectures,

Figure 32　Contemporary engraving of Tunbridge Wells' Great Hall buildings, with Robinson and Cherrill's Great Hall studio in the north wing (on left facing) as published in Pelton's *Illustrated Guide to Tunbridge Wells*, 1872/5

concerts, exhibitions and fêtes decided to 'let' the two wings at either extremity of the main body of the building.[22] (The south wing was leased to a firm of caterers, who established refreshment and dining rooms.)

The Great Hall Studio's impressive entrance was on the ground floor. Facing the street were two large plate glass windows behind which were displayed a few large portrait photographs and a frame of 'the most perfect photo-enamels we have ever seen. The unique feature is, however, a large gold frame in each window with a display of medals – gold, silver and bronze – amounting to nearly fifty, obtained at various exhibitions in England, Scotland and Ireland, Continental Europe, India and America.'[23] Passing through spacious reception rooms, the client entered a studio which was lit by a large, steep north skylight as it was on the north-facing side of the building. No sun-rays entered this room. Beyond this were dressing rooms, darkrooms, printing and toning rooms and an open-air studio with access to Calverley Park at the rear of the building. 'Entering the happy compromise between office, shop, and picture gallery which constitutes the reception rooms, we find an unusual display of specimens all in spotless condition of neatness . . . Our attention is soon rivetted on the fine display of pictorial compositions with which Mr Robinson's skill as an artist has long been associated.'[24] A corridor, at first arranged as a fernery but later used for picture display, led into another exhibition room in which was displayed 'every style and size of portraiture, a fine collection of landscapes and combination pictures [familiar to exhibition-goers] some of [which] have been converted into paintings and pleasantly vary the display of effective coloured work to which one side of the room is devoted.'

Robinson, in concert with most other eminent photographers of the day who had good accommodation, was his own print seller. He and Cherrill prepared stocks of prints of all the exhibits which were displayed in the galleries of the Great Hall Studio. The numbers of people who came to view the pictures on display and make a purchase were, at times, greater than those whose purpose was to have a portrait taken!

The studio was so arranged that an invalid's chair could easily be wheeled into it. It was 36 ft long by 14 ft wide (11 × 4.25 m). The eaves were low and the ridge at the apex of the glass roof was high (the former 5 ft 6 in (1.70 m) and the latter 14 ft (4.25 m) from the ground). The north-facing side was of glass panels down to 2 ft (60 cm) from the ground. A complete system of blinds controlled the entry of light. The walls were a green-grey and the floor covered with linoleum of a Maltese cross pattern. 'Hot water pipes maintained the whole establishment at a comfortable temperature.' At either end of the studio was a series of backgrounds with a canopy overhead and a stand to which a curtain could be attached. Chairs and other furniture gave 'an air of elegance and comfort and afford as well great variety of effect in the pictures'. In the studio and dressing rooms were children's toys of all kinds. In the open-air studio were 'banks covered with growing wild flowers and natural rustic accessories in profusion'. This was used for instantaneous groups, portraits of animals, equestrian photography and figure studies for combination printing with landscapes. The prints were made in an enclosed glass structure like a very large cucumber frame at the rear of the premises.

On the two floors above the ground levels were rooms devoted to enamel printing, mounting, retouching and finishing and a painting room where 'Mr Robinson is engaged in painting in the moments he can snatch from the glass room' (studio).

In one account of the Great Hall Studio, it was said that the 'enamels were executed by a process akin to that which has often been described in the journals; and, between you and me, I don't mind whispering that they were really first-rate . . . I do not know how to account for their very perfect character.'[25]

This journalist visitor to the studio gives an interesting sidelight on Robinson's sense of humour. When the guest accepted the offer of a thirst-quenching drink, Robinson opened up the back of the large studio camera and from the dark interior produced a tankard of beer.[26]

The Great Hall Studio was a dream come true for Robinson, for at long last he had been able to realize his ideal. It was a model of good design, being a show-place for exhibiting his work as well as incorporating all the features needed to make possible the most efficient methods of production in the practice of photography. For years he had advised other photographers, both amateur and professional, on studio design, and professionals on studio practice. In this as in many other photographic matters he had achieved a singular reputation. He had been able

to put some of his theories into practice in his first studio in Leamington, his 'private' studio and the studio at 1, Grove Villas – but all suffered from problems of limited space and other structural deficiencies.

Having had the satisfaction of managing a photographic business under ideal circumstances for which he could honourably claim to be responsible, he decided to impart his knowledge to a larger audience through a book, *The Photographic Studio and What to Do in It*. It was a summary of a lifetime of experience in such matters.[27]

Out of twenty-two chapters, ten are devoted to the 'Management of the Sitter' and contain advice on the conventions practised by artists for hundreds of years, adapted to the special requirements of photography.

The Management of the Sitter

Amongst other things Robinson said:

Difficult poses should never be tried with nervous or awkward people. Make your pose very simple . . . avoid the twists and contortions so much affected by some photographers. Try to get the feeling of life and motion. To accomplish this it is sometimes necessary to make your subject walk round the studio and suddenly stop at the point where you wish to photograph her . . .
Before the introduction of photography, which corrected many artistic mistakes, artists used to draw the hands so absurdly small that when the truth was seen in photographs it was not believed. Still there is some truth in the hands being too large in many photographs . . . to prevent this the hands must be in the same plane as the face.

In an article, 'Heads I have Taken Off', published in the *Mirror* on 17 January 1874, Robinson reminisced about some of the sitters in front of his camera, comparing his role as a portrait photographer with that of an executioner because, as he remarks with jocularity: 'I am often looked upon by my victims with almost as much horror as those grim personages . . . However . . . unwilling as they generally appear to be, they come by shoals, offering themselves of their own accord; and in the exercise of my profession I have taken off thousands of heads.' He expressed concern with those very numerous sitters who came to his studio with new clothes bought for the occasion and a boxful of caps, entirely different from garments worn in every-

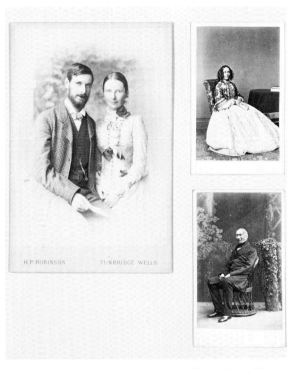

Figure 33 Examples of H. P. Robinson's studio portraiture. *Left:* young couple, 1879; *upper right:* unknown lady, 1864; *lower right:* unknown gentleman, 1862. Courtesy Meir Berk

day life: 'How am I to get a likeness of a person who does not look like herself?'

He then commented on the range of sitters who came to his studio:

The vainest creatures I ever have to deal with I have no hesitation in saying are the men . . . The specimen of vanity beyond all rivalry whom I have met was a revivalist preacher . . . I had requested the preacher to favour me with a sitting for his portrait . . . He consented stipulating for a royalty on each print sold. He had agreed that a background should be painted especially for this picture [carte-de-visite] representing a library full of books of revivalist literature. He had written a few tracts and insisted on having the titles written on the backs of the folio volumes! His appearance was remarkable – his obstinacy equally so. When I got him into a moderately decent position, and was putting the prepared plate into the camera, he started from his place suddenly, and walking up to me said in an awful whisper, 'Are you happy, Mr Photographer?' [Robinson replied that he thought he was, which was not strictly true at that moment.] 'But are you regenerated?' continued he. My reply did not satisfy him, and he pounded away so hard at my wickedness until, on my reminding him that the light

began to fail, we then proceeded to work, and I obtained several good negatives, with which I hoped to repay myself for the trouble and annoyance I had been put to.

But Robinson did not succeed in selling many of the resulting cartes as this wily character had visited every photographer in the town so that the supply of his cartes-de-visite was greater than the demand. About another sitter he said:

The most nervous man I ever had to photograph was a lieutenant-colonel. It required an army of young ladies to persuade him to consent to pay me a visit: he was brought with difficulty to my studio, and then ran away from his first appointment. When he was brought up to the scratch again, after much trouble I succeeded in getting a good negative of him . . . He asked me to give him a written agreement, under penalties, that no one but myself and assistants should see a copy. I, of course, refused to do anything so ridiculous as to give him so singular a bond, but gave him my word to the same effect. I had an opportunity afterwards of showing the colonel that my word was sufficient, for a few months subsequently he became so famous that I could have sold thousands of copies of his portrait, instead of which I broke the negative to keep temptation out of the way.

. . . old ladies and old gentlemen are, as a rule, amongst my most obliging and kindly sitters. They do as requested, sit where they are placed, and when asked to sit quiet for the few seconds necessary, it is sometimes difficult to get them moving again, so anxious are they not to spoil the picture and give trouble. But there are exceptions to all rules.

Robinson then described an elderly marchioness:

. . . the favourite toast of sixty years ago, who was so dilapidated and limp that she had to be shaken occasionally by her attendant. She was so anxious to present a juvenile appearance, that to hide the sinking in of the cheeks, natural to her years, she insisted on keeping a biscuit in her mouth while I exposed the plate.

The young ladies have their whims and fancies, and at their age why should they not? This class [of sitter] embraces many varieties. There is the 'gusher', a difficult variety to manage, and of two kinds – the languid gusher who never seems able to stand upright, but must have something to lean upon, and with whom it seems impossible to more than half open the eyes; and the vivid gusher, who goes in for passionate amiability, and is never seen without a smile, a smile so unnatural, that it does not appear to belong to the face. There is the masculine young lady, who comes in her riding habit, and insists on having a cover-side for a background. This is not a troublesome variety: there is a tone of business about her and a desire to get the matter over, but without haste, that nearly always

insures her a good picture . . . And lastly, there is the average English young lady without any peculiarities, except those which distinguish her from her sisters of any other nation, and of which the country is proud, and who does all in her power to assist the photographer and save him trouble. It is said that young ladies seldom make good photographs; but I maintain they are the best models, and make the best pictures, when properly treated, of any form of living creature – except children, who do almost anything you require.

The most delightful sitters are children . . . a glow of happiness runs through me when I think of some of my little friends. I do not know a more charming occupation than photographing little girls, from the age of four to eight or nine. After that age they lose their beauty for a time . . . I can call to mind many pleasant hours in trying to get the 'counterfeit presentments' of little elves and fairies, who have at the same time driven me nearly mad by moving at the critical moment, or who would take a fancy to waltz when I required them to be immovable . . . yet I never tired of them. The result, when you do get one, is so exquisitely beautiful that it repays you for all your labour. The reason is that children cannot act – they must be natural or nothing.

When in 1872 a controversy arose in professional circles over retouching portraits he joined the fray:

I am not a retoucher myself and I doctor my negatives no more than I did years ago. But if a sitter's complexion was marred with blemishes or freckly, not unpleasant to the eye in nature, they would be emphasised in the print, appearing as dark or even black spots.[28] I do not think I violated the truth by filling the spots on the negative with a black lead point or colour to give the complexion a natural appearance.

The Robinson and Cherrill Partnership

Nelson King Cherrill is an obscure figure in the history of photography. No photographs attributed to him alone have survived other than a few cartes-de-viste and cabinet portraits taken by him during the late 1870s in New Zealand.[29] During the period they were in partnership all exhibited photographs produced were attributed to both partners. In this as in most matters Robinson practised what he preached. It is only possible to conjecture, based on circumstantial evidence, that Robinson was master in the studio and reception room and that Cherrill supervised the printing and allied procedures including the transfer of prints to enamel plaques. (He was acknowledged as having perfected this technique.)[30] However, it is certain that Robinson took the trouble to acquire the skill of enamel printing as he

continued to advertise this form of presentation of photographic imagery long after Cherrill's departure.[31] It is probable that Cherrill deputized for Robinson from time to time at sessions in the studio, especially during Robinson's bouts of illness. The partners' respective roles in the production of their exhibition work is more difficult to determine. There is no direct evidence as to who did what with the exception in 1868 of *Watching the Lark, Borrowdale*, as already indicated. In 1872 they jointly exhibited *A Gleaner* (plate 77), the model being Mrs C. Tattershall Dodd, wife of the artist by that name (1815–78) who lived in Tunbridge Wells.[32]

Both *Watching the Lark, Borrowdale* and *A Gleaner* lack atmospheric perspective to differentiate between the near, middle and far distance. The lighting used gives roundness to the figure in both foreground negatives but there is an unnatural tonal separation between the near and far distance with no obvious middle distance in either case. By contrast an earlier composite picture by Robinson exhibited in 1863, *Autumn*, and also later ones by him alone, *Carolling* (1887) and *Primrose Time* (1891), convey much better differences between the near, middle and far distance, and therefore create a sensation of depth. All five composite photographs were similarly constructed although *Autumn* and *Carolling* were more complex, as Robinson employed four negatives each for these pictures.

The seascape which Robinson and Cherrill exhibited from 1869 to 1871 are not amongst the most interesting of their photographs, although technically very accomplished for the period. Robinson's later seascapes and loch scenes are more attractive and exhibit a naturalism absent from the earlier work, for example: *A Seascape with Headland*, c.1885 (plate 76); *In Kilbrennan Sound*, 1895 (plate 75); and *Atlanta*, 1896 (plate 103). Of course Robinson was able to use gelatine dry plates for these photographs, so that some of the technical problems of earlier days had been resolved.[33]

Preparing Spring Flowers for Market, 1873 (plate 78) signed by both partners, is a composite picture constructed on similar lines to *A Cottage Home*, 1859 (plate 54) by Robinson, and his later interiors: *When the Day's Work is Done*, 1877 (plate 79) and *Dawn and Sunset*, 1885 (plate 80). However, there are very significant differences between *Preparing Spring Flowers for Market* and these others. In no other photograph by Robinson are the figures turned away from each other as though the one was not aware of the presence of the other; indeed there is no apparent relationship between them. The unnatural pose of the girl standing with her gaze fixed on the distance, although within the confines of a small cottage, is most unlike any other Robinson portrayal. The effect of such posing is to create a feeling of unease in the viewer. Another difference between this picture and the others is in the treatment of the dimension of depth. The interior of the cottage in *Preparing Spring Flowers for Market* appears to be shallow owing to the amount of light falling on the walls behind the two girls. In the other three a better impression of depth is given because of the lower lighting levels on the areas behind the figures. These factors lead one to suppose that Cherrill was responsible for the conception, arrangement and lighting of *Preparing Spring Flowers for Market*. If that is so the indications are that Cherrill was very skilled in the techniques of photography but that he lacked Robinson's sensitivity and skill as an artist.

Both Robinson and Cherrill continued to write for the photographic press during their partnership.[34] How well the partnership functioned it is impossible to say, as there are no references whatsoever in the literature to give a clue. It was comparatively short-lived: after seven years, at the end of 1875, they parted company. What caused the break we shall never know; we can only surmise that it was probably for financial reasons. Reports in the local press make it clear that photographic businesses proliferated in Tunbridge Wells during the 1870s. As the number grew it became increasingly difficult for all the photographers to make a living, so many of the less secure and confident ones indulged in price cutting, a practice frowned on by professionals of repute, especially by Robinson to whom it was anathema. He and Cherrill kept up their prices, insisting that by so doing they were able to maintain their high standards of photography. This attitude did not find favour with everyone and they came in for some criticism in the press, with reports on 'the excessively high prices charged for photographs'. Worse still, they lost clients, so that their income was reduced. They were forced to lower their charges for cartes-de-visite to 10*s* 6*d* per dozen. The business was no longer able to support two high salary earners in addition to the several assistants they employed.

The sequence of events indicates that Cherrill

decided to seek his fortune elsewhere. He sailed for Australia aboard the SS *Whampoa* in January 1876,[35] two or three weeks after he and Robinson ended their partnership. His intention was to set up as a landscape photographer in Melbourne,[36] but it must have been uncongenial for he moved to Christchurch, New Zealand in the summer of 1877. He practised photography there until 1881, when he returned to England for domestic reasons. He must have abandoned photography as a profession after that for he accepted the post of Manager to the Swan Electric Lamp Company, Paris, in the spring of 1883.[37] He may have continued to take an amateur interest in photography thereafter.

Assistance, Consultation and Instruction

H. P. Robinson was ready to act as consultant in matters photographic. In the 1860s he was asked by Dr Livingstone to inspect a photographic outfit which had been prepared for him to take to Africa by order of the government. Robinson was horrified by the size and weight of the outfit. What was really required was 'about twenty five pounds weight of apparatus and materials, neatly packed in a small box . . . What was provided was contained in several enormous cases weighing several hundred weights and which cost several hundreds of pounds.' There were 3 lb of ammonia (a small bottle would have sufficed) and only 1 lb of hypo. Robinson told the Doctor's brother, who was to have been the photographer of the expedition, to 'leave the lot at home, and save yourself the trouble of dropping it into the first jungle you come to'. There was no time to make any change except exchange the ammonia for hypo. No information was forthcoming as to what actually happened and, as no pictures were ever sent home, Robinson thought that the outfit met with the fate he had predicted.[38]

Robinson was prepared to print the negatives of other photographers who lacked the necessary facilities or time. Such was the case with Lewis Carroll (Charles L. Dodgson), who wrote to Robinson from Christ Church College, Oxford, on 2 July 1875,[39] commenting 'the photographs have come and are beautifully done' and asking if Robinson ever went to London and could pick up a parcel of negatives to avoid 'the risk of sending by train'. He admired Robinson's work, writing in his diary for 16 April 1858: 'Called on Mr Munro in Belgravia [Alexander Munro, the sculptor, who was one of Robinson's artist

friends] . . . He has a large collection of photographs, many from his own sculpture; one he gave me, a duplicate of an exquisite picture by Robinson in the Photographic Exhibition this year. It is called "Juliet" . . .'

Henry Peach Robinson instructed quite a number of amateurs in the art of photography. One of his most successful tutees was Robert Crawshay of Cyfarthfa Castle, Merthyr Tydfil, Wales, who owned an iron works and took up photography in 1868 at the age of fifty-one when he lost his hearing.

Crawshay and Robinson met at meetings of the Photographic Society of London, of which both were members and of which Robinson became a Vice-President in 1870. Under Robinson's tutelage Crawshay became a very good photographer, concentrating on portraiture and genre studies, employing his daughters and their friends as models. He was elected to the Council of the Photographic Society in 1874. Crawshay persuaded Robinson to take photographs at the wedding of his younger daughter, Henrietta Louise, on 28 April 1871 at Cyfarthfa Castle. Robinson secured an exhibition picture on this occasion. It was a portrait of the bride's elder sister, Rose Harriet, known as Trotty, and was entitled *The Brides-maid*. He exhibited this large picture (made on a plate size 55.7 × 40.5 cm) at the Royal Cornwall Polytechnic Society's exhibition at Falmouth in the summer of 1871, under the pseudonym of Ralph Ludlow. It won the first Silver Medal. The unknown name attracted the curiosity of members of the photographic press, who soon announced the real name of the photographer: 'Ralph Ludlow is H. P. Robinson, who seems to have been anxious to test his work very thoroughly indeed upon its merits . . . it must be admitted that the winner of twenty eight previous medals in something like a dozen years might not unnaturally have a craving for the crucial test of winning as an unknown man, and so enter the lists in a mask.'[40]

In 1873 Robert Crawshay offered five prizes to be awarded by the judges of the Photographic Society's annual exhibition. The conditions governing the awards were designed to stimulate a form of portraiture rarely practised at the time with the very notable exception of Mrs Julia Margaret Cameron. The first prize of £50 was 'for the best collection of three photographs of heads taken direct from life, the size of the picture being not less than twenty by sixteen

inches [51 × 40.7 cm] and the head not less than eight inches [20.3 cm] from the top of the forehead to the bottom of the chin. Heads more than half-an-inch [1.3 cm] less than this will be disqualified.'

These conditions must have presented quite a challenge to photographers used to conventional posing rather than 'close ups' of heads. The first prize was won by H. P. Robinson and N. K. Cherrill (figure 34). Insinuations were made about Robinson's possible influence on both Crawshay and the judges with whom he was friendly. This calumny must have infuriated the generous donor.[41] However, the Society's own *Journal* published an enthusiastic review: 'These studies of heads are certainly the most striking feature of this year's exhibition . . . There can be no doubt the lesson set to photographers by the prize donor cannot but be beneficial by weaning them from portraits of diminutive proportions, and inducing them to produce work of a bolder and freer description.'[42]

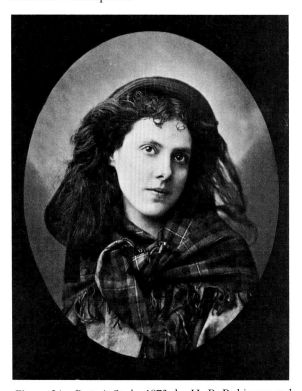

Figure 34 *Portrait Study*, 1873, by H. P. Robinson and N. K. Cherrill. This large-size head and shoulders portrait measured 54 cm × 40.5 cm and was one of the set of three photographs by the partners which won the Crawshay prize in 1873. Albumen print. Collection: Tunbridge Wells Museum

Sole Responsibility

After Cherrill's departure in 1876 Robinson managed the Great Hall Studio on his own, aided by a few loyal and trusted assistants. He did not engage another partner.[43] It is likely that he engaged a reliable printer who operated the processes which were formerly Cherrill's responsibility. As soon as was practicable the name of Cherrill was removed from the frontage of the building, leaving the name of Robinson *in situ*.

As relaxation, during the times when the studio was quiet, he gave time to painting. In 1876 he exhibited a landscape, *A Quiet Evening in October*, in a newly opened gallery at the Westminster Aquarium in London.

As the popularity of cartes-de-visite began to wane Robinson introduced new forms of print presentation to his clients, including panel and promenade portraits, which were particularly suited to full-length standing figures on which were displayed the elegant dress of the period. He also produced carbon prints on opal glass, which could be coloured by hand at the wish of the client. A journalist who reported on a visit to his studio in 1880 made the comment:

Children's portraits are what Mr Robinson delights in, and everywhere those laugh at you from the walls . . . Nor must we omit to mention the beautiful photographic enamels for which the Great Hall Studio has been famous for some years past. We see that the prices asked for enamels vary from fifteen shillings to three guineas . . . A good test of the quality of a man's productions is the price he gets for them. Mr Robinson continues to maintain respectable and 'professional' charges, notwithstanding what many people would consider severe competition, for there is a host of photographers in Tunbridge Wells and of all degrees . . . there is this difference between a true artist, like Mr Robinson, and the ordinary commercial photographer – the latter must make a profit on everything, the former spares no trouble or expense to get the best results. He says it pays in the end and we believe him.[44]

At this time Robinson branched out into a new field of photography when he took a series of theatrical scenes which were said to have been 'exceedingly good'. The photographs presented certain episodes in play and farce which included a lady on a 'verandah' in hysterics with a nervous gentleman trying to soothe her; and a disorderly dinner party. The series number over twenty. They were reported as being 'the funniest, as they are the most perfect, theatrical representations

we have seen reproduced by photography'.[45] They were taken on gelatine dry plates, making short exposure times possible with the artificial lighting then available.[46]

When the Day's Work is Done

This was the last of Robinson's major pictures made by the wet collodion process (plate 79). It was first exhibited in the Photographic Society's Exhibition in 1877 and is considered one of the three most successful composite photographs made by him, both in concept and in execution, the others being *Dawn and Sunset* and *Sleep*. There is a unity, both in the interpretation of the narrative and in the relationship of the constituent parts of the composition. Herein lies an inherent harmony which is an indication of a perfect blend of visualization and realization through the various stages of construction.

When the Day's Work is Done could have been complex and the inclusion of so many accessories a distraction, but the artist has placed the emphasis where he wants it by clever positioning of the two figures and very skilful lighting. The articles in the room contribute to the narrative but do not intrude. The old lady's head against the light-toned wall and the elderly man's snow-white hair against the gloom of the interior provide interesting counter-contrast and instantly command attention.

The original print (53.7 × 76.4 cm) was made from six negatives on albumen paper in three printings. (The negatives, masked as necessary, were associated in pairs on support glass for printing purposes.) The picture was a great success, not only in London but also in Paris where it was exhibited by the Photographic Society of France in 1878. There are more prints of this photograph still in existence than any other Robinson picture. It was printed in a number of different sizes, ranging from the original to a miniature of 3.4 × 4.8 cm and by three printing processes: albumen, carbon and platinum.

Employer and Employees

Henry Peach Robinson was a good employer. He did not expect his assistants to do anything which he himself could not do and he encouraged them to advance themselves by producing their own photographs. With any business built on personal reputation it was imperative that Robinson should photograph his clients even though he himself had confidence in his studio assistants. If one of his assistants introduced a client and was capable, in Robinson's eyes, of taking that sitter's photograph then he was encouraged to do so and was given the credit for it.

The practice amongst many portrait photographers in that day (and this) was to arrange for a number of clients to be photographed by an assistant but the resulting photographs bore the signature of the employer. Robinson deplored this practice, making his views known through the photographic press. In December 1884 he received a letter from H. Jarvis of Derby, one of his former employees, who wrote 'in confidence' as follows:[47]

> You will I trust pardon me for the liberty I am about to take in writing you but as one who has been in your employment (for which I have ever been thankful) I hope you will excuse me.
>
> My object is to ask you to give me your candid opinion regarding a photograph exhibited at the late Pall Mall exhibition by Mr W. W. Winter, my employer of Derby. You doubtless saw it there, if you did not notice it I will endeavour to send you a copy. It is entirely my own production and gained the first silver medal at Cornwall also one at Bedford. I am anxious to get the opinion of one who I have always looked upon as the first photographer in England . . .
>
> I wish I could send you one of each of the 15 × 12 prints I have taken for exhibition purposes, but I am not in a position to do.
>
> Yours obediently,
> H. Jarvis

Robinson's reaction to this letter was predictable. Filled with indignation, he resolved to write a leading column for publication headed 'Who Should Have the Honour?':

It seems almost absurd to ask the question in reference to the taking of a successful photograph, 'who should have the honour?' but it is now a well known and much to be regretted fact that medals are sometimes awarded to men who had nothing to do with the production of the pictures to which the awards were made. I know of one case a year or two ago, in which the taker of the medal first saw the picture to which the honour was awarded in the Exhibition itself. It may be legally honest for an employer to claim the credit for work for which he has paid, but it is artistically a crime for one man to put himself forward as the producer of work which was due to the genius – or to put it more mildly, the persevering talent – of another . . . Can anything be done to remedy the evil? It would be impossible for jurors to enquire into the truth. When a man, otherwise unconvicted of falsehood,

sends a picture to an exhibition with his name on it, the managers of the exhibition are bound to believe that it is his own production, and treat it accordingly. I am afraid redress must be left in the hands of those who are least able to help themselves – the employed.[48]

He qualified this statement by saying that he saw no objections to a photographer accepting assistance in the production of his photographs but that the subject and arrangement should be of his own conception, and he should supervise and guide the rest of the stages in production if he wanted safely and honourably to 'put his name on any photograph and call it his own'.[49]

An interesting slant on this statement is that problems of this kind still exist today. Robinson's criticism is by no means irrelevant in the late twentieth century!

Photography as a Business

Robinson's little book *Photography as a Business* must have been invaluable to those who were considering photography as a career as well as to those who had already embarked on it.[50] Many would-be professional photographers would benefit greatly from Robinson's advice today, as the factors which influence good business management have changed little over the years so far as photography is concerned. The book covers just about all of the important things: the education of a professional photographer; qualifications natural and acquired; the purchase of a business and its locality; the studio and workrooms.

Robinson's consideration for his assistants is revealed in his comments on darkrooms.

Few photographers know the comforts of a well-fitted and lighted darkroom, although they are very familiar with the converse. Health, eyesight and reputation depend in a great measure on this room. For health's sake it must be well warmed and ventilated, for the sake of your eyes it must be properly lighted, while if you want to do good work you must have room to do it in and light to do it by.

When he referred to the reception room he made the very practical point: 'No amount of skill in other departments of the business will compensate for bad management here.'

He wrote of the preferred dress for lady assistants:

It must be borne in mind that the principal attraction in the reception room should be the pictures; that there should be no rivalry between them and any other object. It must also be remembered that the pictures are principally in monochrome, and will not bear distracting colours in their neighbourhood. All this points to the undoubted fact that the attendant should be neatly dressed in black or very quiet tones.

He drew attention to 'the rapacity of photographers and their suicidal tendancy to overreach and destroy one another by under-selling and practices which have done mischief all round'.

Plagiarism

Photography was as vulnerable to plagiarism as painting, if not more so. This was a practice which Robinson abhorred and he hotly pursued an offender, given the opportunity. In one such case letters from him were published in the photographic press in June 1877 under the heading of ' "Conveying" a Photographer's Pictorial Ideas into Paintings'.[51] He recollected 'one of the most glaring instances' which occurred in the Royal Academy three or four years previously, when 'a painting copied "thread for thread" from Rejlander's photograph of a ragged boy on a doorstep, called *Night in London*, was amongst the exhibits . . . I have often had the doubtful honour of having my pictures appropriated by painters, and do not object to artists refreshing their recollection of nature by looking at my photographs, but I strongly object to wholesale copying.' In making this statement he had in mind, amongst others, a painting which had appeared as No. 359 in the Royal Academy's exhibition of 1862, being copied, almost exactly, from his photograph *The Lady of Shalott*.

Of more immediate concern was a watercolour drawing of a seascape, exhibited in the Dudley Art Gallery, London, which was a very obvious copy of one of Robinson and Cherrill's seascape photographs. He informed the gallery officials of the plagiarism but they were not interested: 'How was the committee to know that the drawing of Mr Macbeth's was a copy of yours? [your photograph].' They advised Robinson to take the matter up with the artist, J. Macbeth. Robinson wrote and received the following reply:

I saw the photograph in the house of a friend. I borrowed it to assist me in some of the minor details of the water in the drawing you complain of, supposing it was a photograph of nature done for the use of artists,

who are, as a rule, the only buyers and appreciators of such works. Had I known that the *design, invention, composition, and light and shade* were your own, I should have no more thought of using it than I should think of copying a picture by a brother painter.

This thinly veiled sarcasm must have incensed Robinson, who wrote back:

In reply to yours of the 10th, allow me to say that the mistake you and other artists make is that photographs are as much open to copy as nature herself, just as if they were taken by chance and were common property; whereas the best photographs are almost, if not quite, as much the result of artistic design as paintings . . . Suppose a dozen painters copied the same photograph, whose would have been the original picture?

It was by no means the last incident of its kind and painters continued to copy his photographs even after his death, as an exact copy of his *Carolling* proves. The painting, dated 1911, was found in an antique shop and has been added to my small collection of Robinson memorabilia. It could be said that plagiarism is worse today than it was then, a recent practice being the appropriation of a well-known photograph and its incorporation in association with other media, out of context, thereby changing its meaning. Some photographers, like Robinson, seek protection against the offence by invoking the copyright laws and insisting on reproduction rights.

PICTURE MAKING BY PHOTOGRAPHY

My aim is to induce photographers to think for themselves as artists and to learn to express their artistic thoughts in the grammar of art . . . The materials used by photographers differ only in degree from those employed by the painter and sculptor.

H. P. Robinson, *Picture Making by Photography*

Following the success of *Pictorial Effect in Photography*, Robinson's book *Picture Making by Photography* was published in 1884.[1]

It is hardly surprising that he frequently referred to painters whose work he greatly admired to illustrate his picture analysis. David Cox was second to none other than Turner in his esteem. He said the pleasure to be gained by studying Cox's paintings was the way in which the artist introduced incidents and figures into his landscape so naturally and in a manner appropriate to the place.

The illustrator Myles Birket Foster was another of his favourites, for his 'drawings on wood, as illustrations to books, afford grand lessons in the introduction and composition of groups of figures and incidents and light and shade'.[2] He devoted a chapter to these 'lessons' in his book *The Elements of a Pictorial Photograph*, published in 1896, maintaining that: 'Mr Foster's drawings have been especially worthy of the study of the photographer, his genre and landscape subjects being of the kind very possible in photography . . . and [when] he became a famous painter he never changed his principles of composition.'[3]

In the chapter on 'Light and Shade' he said that light tones should have a focus and referred to *Showery Weather* by F. R. Lee to illustrate the point. In this painting the lightest light is opposed by the darkest dark, the rest of the lights receding from the focus in every gradation of middle tones. The two extremes of black and white create emphasis by contrast and a forcible effect with great breadth.

Sir Augustus W. Callcott's *Dutch Peasants Returning from Market* (figure 35) was used to illustrate a diagonal composition with the balancing spot provided by the girl in front of the group on horseback.

He used photographs by fellow photographers

Figure 35 *Dutch Peasants Returning from Market*, 1834, by Sir Augustus W. Callcott, RA. Oil. Collection: Tate Gallery

to illustrate analysis of picture construction, including ones by his friend William Mayland of Cambridge, of whose work very little remains; and on the choice of models he referred to his friend O. G. Rejlander's *Head of John the Baptist in a Charger*:[4]

Rejlander saw his head on the shoulders of a gentleman in the town in which he then resided. The curious thing is, that he did not so much see the modern gentleman as always the picture which the head suggested. It was some months before the artist ventured to ask the model to lend his head for his purpose, and years before he obtained his consent. The result from an art point of view was splendid, and, considered photographically, a mystery!' [It was in fact a composite, having been printed from two negatives.]

Models

Robinson attached a great deal of importance to the selection and use of models, in both the studio and the field. His favourite model during his Leamington period was undoubtedly Miss Cundall, who must have been a very willing and patient girl. Although Robinson did not photograph her again after he left Leamington, he knew that she was still alive in 1895.[5] The chubby-faced little girl who portrayed *Little Red Riding Hood* (plates 48–51) was 'a charming little model who appeared in several of my pictures'.[6] She was one of the models in *A Holiday in the Wood* (plate 38) and the seated 'gleaner' in *Somebody Coming* (plate 59) and in *Autumn* (plate 60).

It is hardly surprising that H. P. Robinson used members of his family as models. For instance his daughter Edith was the smallest child in *Bringing Home the May*, and all three daughters posed, variously, for *Gossip on the Beach* (figure 43), *What Luck?* (plate 40), *Nor'Easter* (plate 96), *Old Dapple* (plate 98) and other pictures. His daughter-in-law, Janet Robinson, was the mother in *The Gilly Flower* (plate 97), the model in *The Starling's Nest* (plate 99) and was in a large number of the Gelli Gynan 'figures in landscape' series. His son Ralph was the fisherman in *At Sunset Leaps the Lusty Trout* and was included in many other photographs.

When it came to photographing figures in landscape he insisted on the importance of relating content to context. Country folk engaged in country activities in the country would harmonize, whereas town folk in city attire would not. The distinction between the two was far greater in the nineteenth century than it is today, when casual dress is seen in both town and country.

He encountered a major problem in the practical implementation of this policy as farm workers in those days had a minimal education, if any at all; a large percentage were superstitious and a surprising proportion regarded the camera as an 'evil eye' and refused to be photographed. Robinson seldom found suitable models amongst the agricultural communities.

Robinson recalled an occasion in Wales one summer when his painter friends, on returning from a walk, enthused about the beauty of a girl they had seen planting potatoes. The next day he found they had not exaggerated and tried to photograph her, after the gamekeeper who accompanied him had explained what was wanted of her. But 'she looked as frightened as a hunted hare' and finally ran away. Her mother brought her back next day and Robinson posed her beside a pool. 'I got a fine picture in every respect, except in the one essential – the expression . . . I could not succeed in calling up anything better than a scowl.'[7]

Experiences of this kind led Robinson to enlist the services of members of his family and their friends to model for his 'figures in landscape' photographs. 'My models may be called to some extent artificial but they are so near the real thing [when dressed in country clothes] as to be taken for it by the real natives.' He remembered a day when two of his models were walking across a park and were mistaken by a gamekeeper for agricultural workers until he met them 'face to face'. 'This, I think, shows that our imitation is sufficiently like the original for artistic purposes.'[8]

In speaking of his models he said that they were trained to strict obedience and to make no suggestions. They were not always the same persons. 'In fact, I get as much change in that respect as possible, to avoid monotony.' Nevertheless, if he found one to be particularly graceful and responsive to his instructions, he frequently included her in his 'figures in landscape' series, such as 'the dainty young lady' who was transformed into 'a comely country maiden' in his photograph: *In Maiden Meditation, Fancy Free*.[9] This was his first encounter with Janet Spence Reid, his daughter-in-law to be.

He explained that it was almost as difficult to get variety in dress as in persons:

It is not always easy to explain what you really mean

when you meet a girl in a lonely country lane, and you offer to buy her clothes, but a little perseverance and a good offer usually succeed. A country girl's dress is not often worth more than eighteenpence, and if you turn the pence into shillings, and look business like all the time, you may make pretty sure of walking off with the property, or, at all events, getting it sent to you next day.[10]

Robinson stressed the important point that the clothes worn by the models should not be new. 'In my practice I always used old clothes' he said.[11] He complained of the incompetence or carelessness of some photographers who mismanaged 'dressed-up' persons:

For instance, we usually find that when a young lady is dressed as a peasant model she generally looks like one of the chorus in an opera. The clothes are new and very clean, the country clodhopping boots are perhaps represented by patent leather shoes and by some strange dispensation of artistic providence she is only allowed to appear as a milkmaid or gleaner.[12]

Robinson urged photographers to acquire a range of accessories of all descriptions, as well as dresses, cloaks and aprons. 'It is the sun-bonnet which is characteristic of the country.' He must have possessed a large stock of these, judging from the different shapes and styles which were worn by his models. His list of useful accessories included baskets, jugs, sticks, hay-rakes for the country scene, as well as shrimping-nets and lobster pots, for beach and sea pictures.

He said that old people were often very useful in landscapes. With them, as with children, you may take the real native. It is between the age of ten and thirty that the genuine peasant is so difficult to manage.

One of the best models I ever employed was an old man of seventy-four. He was a crossing-sweeper. I should never have accomplished one of my best works if I had not seen him sitting at a table in my studio, waiting, till I could talk to him. I not only saw the old man there, but mentally, the old lady, and the interior of the cottage . . . The old man, by his attitude and expression, gave the germ of the idea; the old lady had to be found, and the cottage built, but they appeared to me then quite visibly and solidly. This was the picture called 'When the Day's Work is Done' [plate 79].[13]

Although the male models were genuine fisher-folk in *A Strange Fish* (figure 36) they 'had much practice in sitting to painters and knew how to obey'.[14]

Robinson's statements on the subject of models sheds light on his character as well as his methods. He was a good-looking man, with a commanding presence, who thoroughly enjoyed the company of young women as well as that of his male artist friends. It is somewhat surprising that he chose such a plain-looking woman as his wife; presumably she had other sterling qualities, including the reticence and tolerance which inhibited her from coming between her husband and photography. It is evident that there was a strong paternalistic streak in Henry Robinson's nature and he expected total obedience to his instructions. It is to be expected that some found him intimidating, although his strong sense of humour and innate kindliness outweighed the awesome impression he sometimes conveyed to people.

Figure 36 *A Strange Fish*, 1890, by H. P. Robinson. Reproduced in *Practical Photographer*, 1895

The Three Families

Family holidays in the summer months of 1880–4 in North Wales provided Henry Robinson with opportunities as well as the inspiration to photograph the scenic beauty which is paramount in the Vale of Clwyd and the mountain range alongside.

Henry, his sister Clara and brother Bob were a close-knit family and maintained this relationship after their respective marriages, in spite of geographical separation. They always welcomed every opportunity for a family reunion. Fortunately their respective spouses had the same inclinations, and the children of the three families spent many happy hours of childhood in each other's company.

The five children of Henry and Selina Robinson,

Edith, Ralph Winwood, Maud, Ethel May and Leonard Lionel, were the eldest cousins and all but Leonard were young adults in the 1880s.

Clara Robinson's marriage to Frederick Herbert Gossage in 1860 resulted in eight children: Mabel, William Winwood, Ernest Frederick, Frederick Herbert, Ralph Howard, Mildred Mary, Guy Winwood and Neil. Clara died in giving birth to Neil in 1874. Henry was deeply grieved at the loss of his sister.

F. H. Gossage had worked his way up to a position of prominence in William Gossage & Sons, the soap manufacturers, by the mid-1970s. He was the third son of the founder. He was married to Amy Perrin, a friend of the family, in 1882. He played an important role in the community as Alderman, the first Mayor of Widnes and was the senior Justice of the Peace in Britain when he died in 1907, leaving £709,393, considered to be a fortune at that time.[15]

Herbert John (Bob) Robinson married Agnes Esther Tate in 1876. She was the youngest daughter of Sir Henry Tate, being the eleventh born, on 2 July 1855, of his twelve children. They produced eight children: Frederick Winwood, Claude, Muriel Clara, Henry Winwood, Brian Winwood, Edwin Winwood, Alan Winwood and Geoffrey Winwood. Claude Robinson became a leading figure in Henry Tate & Sons, Sugar Refiners, and a Managing Director up to the time of the amalgamation with Abraham Lyle & Sons in 1921.[16]

From the genealogical point of view it is interesting to note the use of the name Winwood in all three families to perpetuate the Winwood connection. The genealogical chart (p. ix) shows that Henry Peach Robinson's great grandfather, Richard, married Elizabeth Winwood, whose ancestry can be traced back to Arthur Winwood, the Porter (Prison Governor) of Ludlow Castle *c.*1620. The Robinson family were convinced that the connection went back to Sir Ralph Winwood, Bt, Secretary of State to King James I of England, to whom Arthur Winwood could have been related as a cousin twice removed. However, the estate of Ralph Winwood passed through his daughter Anne to her son and grandson, the Duke of Montagu, a Winwood line which has no connections with the Robinsons.[17] It is claimed by the family that the cap and ring in the collection of family memorabilia belonged to Sir Ralph and were passed down through the Robinson family from Henry Robinson's great grandmother, Elizabeth Winwood (plate 34).

Another interesting aspect of the relationships between these three families is the number of marriages which took place between their members. For instance two sons of Clara and F. H. Gossage, William Winwood and Guy Winwood, married two Tate sisters, Ethel Caroline and Helen Frances respectively (daughters of Sir Henry Tate's eldest son, Sir William Henry Tate, 2nd Baronet, and his wife Caroline), on the same day in 1896 at the same time and place. It was William's second marriage. Mildred Mary Gossage (daughter of Clara and F. H. Gossage) married Sir Ernest William Tate, 3rd Baronet (eldest son of Sir William Henry Tate and his wife Caroline) in 1892. Their daughter, Mildred Clara, married Henry Winwood Robinson (son of 'Bob' Robinson and his wife Agnes, née Tate) in 1922.[18]

Henry Peach Robinson's children married outside the three families. His elder son, Ralph, married Janet Spence Reid, daughter of John Robertson Reid, the Scottish painter of genre, landscape and coastal scenes who made a notable contribution to the development of the Glasgow School of Painting, although resident in England. He was one of Henry's closest artist friends. Both father and daughter were present at the Artists' Parties in North Wales in the 1880s. Henry's two daughters, Edith and Maud, married doctors resident in Tunbrige Wells: George Abbott and George Craigie Bell respectively. His youngest daughter, Ethel May, remained single. Leonard, his younger son, married Kathleen Bell (sister of G. C. Bell). Of Henry Robinson's five children only Ralph and his wife Janet had children, all of whom were girls: Janet May, Margaret Winwood, Flora Kathleen and Vera Noel. The Robinson male line, descending from Henry Peach, came to an end with the death of Ralph Winwood Robinson in 1942.

It could be expected that with Henry Peach Robinson's great enthusiasm for photography other members of these three families would have taken photographs. Other than Ralph and his wife Janet, only one other is known to have exhibited photographs. William Winwood Gossage, by that time an Alderman and Justice of the Peace for Liverpool, had photographs displayed in the Photographic Salon of 1895.

Gwysaney

In June–July 1880 and the three years following, members of the three families assembled at

Gwysaney Hall, near Mold in Flintshire, North Wales. Painter friends of Henry Robinson were included amongst the house guests. The Hall was leased to Frederick H. Gossage, by that time an influential industrialist and Justice of the Peace for Widnes. An old-fashioned stone-built mansion with latticed windows and rough walls, it stood at the top of a green hill 'as if on a pedestal'. It served as a shooting lodge in the autumn, as the game was plentiful in the surrounding woodland and pastures on the·north-east facing side of the Clwyd range. In June the house, set in parkland, was surrounded by rhododendrons in flower and sweet-scented briars and from the windows guests enjoyed an uninterrupted view of stately trees and a lake. The River Dee could be seen in the distance and the little town of Mold could be glimpsed through a gap in the hills.

It is not surprising that Henry Robinson found inspiration in this place. The photographs he took in and around Gwysaney were assembled in three albums, one for each family, and in addition he selected the best pictures for exhibition. He concentrated on studies of figures in landscape but took several interiors, as well as a number of family groups.

The stone steps leading up to the door of the Hall provided an excellent setting for groups (figure 37) and the interior yielded some good pictures. The wainscoting of shining brown oak was in every room and the furniture 'had lived there for centuries'. Ancestral portraits hung on the walls and it was said that King Charles II had slept in the oak four-poster bed on the first floor. The room Robinson chose for his photographs had a big bay window of clear glass, 15 ft (4.5 m) across which, together with a second smaller window, admitted sufficient light to give good illumination and permit reasonable exposure times. One critic likened *Pamela* (plate 70), and others taken in the same room, to the work of Angelica Kaufmann.[19]

Robinson was experiencing the benefit of the availability of gelatine dry plates, which were being manufactured and marketed in 1878 following the invention of the gelatine silver halide emulsion by Richard Leach Maddox in 1871. They had good keeping properties, were ready for immediate use (the photographer no longer had to prepare them himself) and exposure times were greatly reduced. The only problem was that in the first few years they were not always evenly coated, which, on development, gave a greater density where the emulsion was thicker, and near

Figure 37 Henry Moore, RA, with Mabel and Mildred Gossage on the steps of Gwysaney Hall, North Wales, 1882, by H. P. Robinson. Private Collection

transparency where it was thinly coated, resulting in a distortion of tonal reproduction. Lenses had also been considerably improved, reducing exposure times still further. Robinson said that when he was at Gwysaney in June of 1881, with a Dallmeyer Rapid Rectilinear lens on the camera, he exposed forty-six 15 × 12 inch (38 × 30.5 cm) plates in five or six days' work in sessions of one or two hours a day 'and they all turned out good when developed at home'. The outdoor views were exposed from one to five seconds and the interiors from twenty to forty seconds.[20] In spite of these advantages he was as careful as ever in the arrangement of the subject, the dress and poses of his models.

Robinson said that many of his pictures arose in his mind's eye in a most inexplicable manner and remained there until he made sketches of them. He described his progress from the conception of an idea for a picture to its completion, using his photograph *A Merry Tale* for this purpose (figure 39).[21]

In the drawing-room of a country house in North Wales [Gwysaney Hall] five young ladies in evening

Figure 38 Sketch in preparation for the photograph *A Merry Tale*, 1882, by H. P. Robinson. Collection: The Science Museum, London

costume were amusing themselves after dinner. One of them was relating some funny circumstance to the others, who arranged themselves in a picturesque group round the story-teller. Here was the germ of the picture. A few seconds sufficed to make a sketch of the composition . . . [figure 38] Correct drawing is by no means necessary; the 'effect' is what should be noted. To return to the picture. By an easy transition the mind easily changed the young ladies into peasant girls, and suggested suitable surroundings. A sketch was made of the arrangement, and the dress for each figure decided on. In selecting the costumes, the light and shade of the group, and its relation to the landscape, were not forgotten, neither were the accessories – the baskets, jug and stick. The colours were taken into account only as to how they would translate into black and white.

After an interval of several days, due to bad weather, the photographer and his models walked to a quiet lane about a mile away.

The photograph conveys no idea of the picturesque effect of the five girls in their humble but brilliantly-coloured garments . . . The choruses sung on the way had, perhaps, nothing to do with photography; but the foxgloves and other wild flowers the singers gathered came in very useful in the picture. Arrived at the selected spot, the camera was unpacked, and the models placed approximately in their proper places, interfering branches cut away, and everything got ready, so that the last moments might be devoted to the quite final touches, expressions, and other little things . . .

Now for the arrangement of the group. The girl to the left was sitting up at first, as will be seen in the sketch, but being a young hand at the business, she could not control herself, and, enjoying the fun, threw herself back on the bank screaming with laughter. This was a happy accident, which much improved the composition, and was seized immediately. She was at once shouted to, to keep her place, which, being an easy one, required little further thought on the part of the photographer, who could now turn his attention to the other figures. The seated figure, the one in the straw hat, was a steady old stager with plenty of experience and no nerves; she required but a moment's attention. The next figure, always dramatic in pose, and with a charming expression, is, perhaps in consequence of her other good qualities, rather shaky as a sitter. She required a rest of some kind. The stick was useful here, and was of immense value in the composition . . . The figure telling the story was now settled; the pose came easy, the model being an admirable story-teller, and thoroughly up to her business; but it was necessary to give all possible effect to the hand, for the hand, if well placed, would do more towards showing the intention of the picture than anything else in it. It, in a way, leads the chorus of expressions. It emphasizes the situation, – it makes you feel the girl is speaking . . . The standing figure, who could not be expected to keep the pose for above a minute or two, was placed last. The jug, basket, and foxgloves, which form the key-note of the composition in the foreground, had been previously arranged, and all was ready . . . 'Now, girls, let this be our best picture. Mabel, scream; Edith, a steady interest in it only for you; Flo, your happiest laugh; Mary, be sure you don't move your hand, or all the good expressions will go for nothing . . . Steady! Done!' and two seconds' exposure settled the matter. I scarcely expected a successful result, the thing was so difficult; but as the wind was blowing almost a gale, I did not care to try another plate. As it happened, I found, when I developed the plate a fortnight afterwards, I had got a good negative . . .

This seems a long story to tell; but the picture was exposed in under six minutes from the time the models first took their places. This quickness is one of the secrets of success.

Robinson always thought very carefully about the placing of his figures in landscape, having regard to the rule of thirds, whereby the figures were positioned one-third of the distance back into the scene if the landscape was intended to be a harmonious setting, or two-thirds back if the figures were to be subordinate to the landscape. He used the latter procedure whenever he chose to integrate the figures with their surroundings, as in *Rook Shooting* (plate 84), but did not hesitate to change the emphasis by other means when he saw fit to do so. For example, by judicious choice of clothing, which provided tonal contrasts with the scene, the avoidance of a strongly detailed setting, and the exclusion of part of the foreground in favour of more sky, the figures in *The*

Figure 39 *A Merry Tale*, 1882, by H. P. Robinson, from the Gwysaney, North Wales, 'Figures in Landscape' series. Private collection

Skylark (figure 40) do not 'sink' into their surroundings when placed two-thirds back into them but give the required emphasis to the narrative. *The Skylark* is a very effective use of this arrangement. With the group on the right slightly offset, the balancing point is provided by the single figure on the left.

Robinson was a master of the use of gesture to illustrate a theme or title. In not one of his 'figures in landscape' photographs are any two models holding the same pose or giving the same gesture. Each gesture is significant and an aid to illustration, as in *The Skylark* (figure 40), *A Merry Tale* (figure 39) and *The Mushroom Gatherers* (plate 86).

When Robinson wanted to call attention to an object within the landscape he associated a figure(s) with it, as in *The Old Boat* (plate 85). In this photograph he 'added to the atmospheric effect by allowing the mid-distance to be a little out of focus'. This picture was of particular

interest to him, 'being the first landscape I ever exposed on a gelatine plate. I took four plates only to Wales, experimentally, and on developing at home was astonished at the result, and how easy picture making away from home had become.'[22]

Wayside Gossip (plate 87) was one of the most successful of the photographs taken at Gwysaney, probably owing to the perfect placement of the figures and the shimmering effect of the light on the trees. Robinson was experimenting with 'contre-jour' lighting at this time, a form which was to become so popular with the Linked Ring photographers between 1892 and 1910. It was this picture which won the gold medal offered by the Photographic Society of Great Britain for the best outdoor portrait in 1882 and which was selected by Robinson for presentation to members of the Photographic Society in 1883.

On occasion Robinson gave even more prominence to the figures in the North Wales landscape

pictures by placement close to the camera, as in the cameo *Can I Jump It?* (plate 93), where he wanted the emphasis on the human element, with the location in a supportive role.

Gelligynan

'The Artists' Party' (figure 41) in North Wales in the last two weeks of June 1884 was recollected by Henry Peach Robinson in an article published one month after the event.[23] After three or four delightful summer holidays at Gwysaney the venue was changed to Gelligynan, the country residence of Sir Henry Tate, seven miles distant from Mold on the lower slopes of a heather-covered mountain overlooking the Vale of Clwyd. There was an extensive and wild-looking tarn situated halfway up the mountain and two or three miles of the River Alyn graced the sur-

rounding countryside. Robinson said: 'For my purposes the great attraction of this kind of place is its solitude. Here you can do as you like; here your models can dress as they please, and no prying eyes come to disconcert the photographer.'

The party decided to concentrate on one section of countryside at a time and both painters and photographer chose about a mile of the river where they elected to 'pass our time on its banks, leaving the mountain and lake for future use'.

Stepping stones, fords and a 300-year-old mill were subjects they could not resist. Robinson made friends with the miller, who appears in several of the photographs he took at Gelligynan (plate 91).

The Gelligynan house could not boast the attractive features of Gwysaney. Probably built in the 1830s, it presented a plain and somewhat undistinguished facade. However, there was

Figure 40 *The Skylark*, 1882, by H. P. Robinson, from the Gwysaney, North Wales, 'Figures in Landscape' series. Private collection

Figure 41 *Members of the Artists' Party at Gelligynan in 1884*, posed by H. P. Robinson and photographed by R. W. Robinson. H. P. Robinson is standing, seated to his left is Henry Moore, with two other artists seated on his right. Selina Robinson is in the deckchair in the centre of the group

ample and luxurious accommodation, gardens and tennis courts which were well patronized by the young and agile, a trout river and plenty of indoor amusements 'which sometimes carried us so far into the night that we saw the sunrise and heard the village cock do salutation to the morn'.[24]

Henry Robinson took the required group photographs but he found inspiration on the river banks (figure 42) and at the mill (plate 90).

In addition to the miller, who was delighted to participate in the photographic activities, Robinson enlisted the aid of a 'picturesque gamekeeper' who carried his camera. There was also the under-gardener who stood in for the gamekeeper on occasion:

This man was a pictorial treasure . . . He was essentially a happy-looking old man, and full of native wit. I had been looking for a view some way off and, returning, saw my old man sitting upon a railing in the hedge, surrounded by the models who were chaffing him in Welsh and English. They made a picturesque group and I heard one of them say 'He never told his love'. Here were subject and title together and were at once secured [plate 89.][25]

Robinson took a large number of photographs of cattle but did not find them an easy subject as he could not control the cows in the way he controlled his models! However, one or two are rather charming (plate 88).

The three family albums, which contain photographs taken by Robinson at Gelligynan in

1884 vary in content and number of images, although several of the best pictures are the same in all three. Once again Robinson selected the ones he thought most suitable for exhibition and sale to the public and printed them separately.

The hallmark of Robinson's portraits, genre studies and figures in landscape is in the body language of his subjects. Reference has already been made to communication and interpretation through pose, gesture and facial expression. Many of the other photographers at work on similar subjects in this period often failed in this respect, the expression of their sitters and models being lifeless and wooden.

There is another probable explanation for Robinson's use of middle-class people to portray the labouring class other than the reasons he advanced. Henry Peach Robinson's upbringing and the life he lived were in the context of what is sometimes called the Nineteenth-Century

Mind: the acceptance of the stratification of society, and the unquestioning attitude to law and order, which led the majority to accept that 'station' in life to which it had pleased God to call them. The identification of the peasant with ignorance and lack of comprehension and the well-educated with culture and adaptability was another form of fixed idea.

Most members of 'polite' society turned away from the upheavals and traumas wrought by the industrial revolution and sought relief and security in Romantic escapism. This was expressed in several ways including the Victorian passion for dressing up. The 'Tableau Vivant', introduced into Britain from France and Germany, was a popular pastime. It was the reconstruction of historical themes and their enactment in the form of a series of static poses which at a later date took the form of the party game of charades. Queen Victoria and her household, as well as

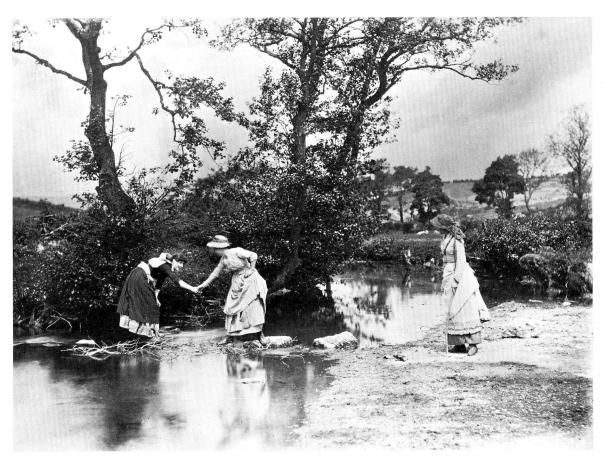

Figure 42 *Come Along!*, 1884, by H. P. Robinson, from the Gelligynan, North Wales, 'Figures in Landscape' series. The stepping stones across the river provided a good setting for this lively incident. Private collection

many of her subjects, delighted in this form of entertainment. An analogy can be drawn between Tableaux Vivants and photographs of the historical and allegorical kind such as Julia Margaret Cameron's illustrations for Tennyson's poem *Idylls of the King*, William Lake Price's *Don Quixote in his Study* (figure 14), Roger Fenton's photographs of younger members of the Royal Family acting out historical plays, O. G. Rejlander's *The Two Ways of Life*, and H. P. Robinson's series on *Little Red Riding Hood* (plates 49–51).

Another popular middle-class pastime which was practised in France as well as in Britain was 'playing at being a rustic' in which the concept of the country 'idyll' was associated with the convention of the Picturesque. The photographs Robinson took whilst on holiday in North Wales were his way of portraying the countryside, country people and country pursuits within the framework of these nineteenth-century beliefs. His 'figures in landscape' photographs belong essentially to this period and must be viewed in that light. They are wholly alien to the late twentieth century in conception and treatment and should not be considered in the context of photographic art of the present day.

THE LAST OF LIFE

It is only by loving nature, and going to her for everything, that good work can be done; but then we must look to her for the materials for pictures, not for pictures themselves. It is nature filtered through the mind and fingers of the artist that produces art, and the quality of the pictures depends on the fineness of that filter.

H. P. Robinson, *Art Photography in Short Chapters*

Photography's History

Henry Peach Robinson took a great interest in the history of photography. He wrote about it with reference to his own personal recollections and experience as a practitioner from 1851.[1]

In 1884 he acquired some very important items in the history of photography at the sale of the effects of J. J. Bennett, FRS.[2] In 1827 Nicéphore Niepce, the French inventor and experimentalist, came to England to read a paper before the Royal Society on the process at which he had been at work for more than ten years.[3] He left a number of examples of his invention with the Secretary of the Royal Society, Francis Bauer, FRS. The three items acquired by H. P. Robinson (the other Niepce relics were acquired by H. Baden Pritchard, then editor of *Photographic News*) were a photographic image on a bitumenized pewter plate, being a direct positive copy of a painting probably made through a camera obscura; a photographic image on a bitumenized pewter plate, being a positive copy of an engraving or lithograph of *Christ Carrying the Cross* made by

contact printing; and a photo-etching of an engraving of *Cardinal d'Amboise*, being the second stage of a process of which stage one was the making of a positive photographic image on a bitumenized pewter plate, by contact printing with the engraving. This was then etched to make it into a plate for printing. The first mentioned, which Robinson displayed on his study wall in his home, could be the earliest photographic image made with a camera (1826 or even earlier).[4] The last mentioned is a very important item in the history of photographic reproduction. Robinson himself made prints from the *Cardinal d'Amboise* plate.

H. P. Robinson and H. B. Pritchard's widow exhibited their treasures at the International Inventions Exhibition in London in 1885 and at the retrospective Photographic Exhibition at the Crystal Palace, London, in 1898.[5] The Niepce relics were donated to the Royal Photographic Society, together with a large number of H. P. Robinson photographs, by Ralph Winwood Robinson in 1924.

Exhibition Pictures

Robinson's major composite photograph for 1884 was *Gossip on the Beach* (figure 43). The technique employed enabled a greater degre of control than would have been possible with a single exposure, and permitted the photographer to organize pose, gesture and expression as he required.

In 1885 Robinson exhibited *Dawn and Sunset*

Figure 43 *Gossip on the Beach*, 1884, by H. P. Robinson. This composite photograph was Robinson's prime exhibition picture of the year. Platinum print

(plate 80). On a par with *When the Day's Work is Done* (plate 79), it is at the peak of achievement in composite picture making by photography and is a delightful interpretation of a simple, homely but idyllic situation. The mother and child relationship is stated with great tenderness and the figure of the old man is particularly expressive. Although the two groups are separated in space they are nevertheless linked by the chiaroscuro effect and well-positioned accessories.

An interesting comparison can be made between Robinson's interpretation of this theme and Thomas Faed's painting *From Dawn to Sunset (The Full Cycle of Life)*, 1861 (figure 44), which is a somewhat more realistic interpretation of a cottager's home, overcrowded, untidy and drab. Robinson, like many photographers and painters, tended to idealize the cottage existence rather than reveal the harsh reality as portrayed by the writer Thomas Hardy during the same period.

In the same year Robinson exhibited *Hope Deferred*.[6] All attempts to locate an original print have failed and what remains is an inferior reproduction. The setting and accessories are the same as in *Dawn and Sunset* but the content less complex. Once again Robinson succeeded remarkably well with subject management, of a boy playing with a dog inside a cottage, the boy's expression and the dog's attitude being perfect.

Two years later, in 1887, Robinson exhibited *Carolling* (plate 82). This composite picture aroused a certain amount of adverse criticism. How could Robinson justify combination printing now that instantaneous exposures were possible for outdoor subjects? A careful scrutiny of the image is needed to find the answer. The accompanying verse is also significant. Robinson is not merely making a factual statement about two pretty girls in a landscape with sheep; he is telling a story of the joys, aspirations and apprehensions of youth. One girl is pensive whilst the other cherishes fond hopes and dreams of what the future may have in store. He had to give undivided attention to the pose and expressions of the two girls. Sheep also require undivided attention if the result is to be successful. In fact Robinson continued to make composite photographs of outdoor scenes for a few more years. The most notable were *Primrose Time*, 1891 (plate 95) and *Coming Boats*, 1893 (plate 100).

Last Years in Business

During 1885 Henry Robinson suffered an illness which resulted in a severe operation from which he took a long time to recover. He was unable to exhibit any of his photographs in 1886 and had to

content himself with interests which made less demand on his energy, such as attending the second annual soirée of the Tunbridge Wells Natural History and Antiquarian Society, to which he contributed oil paintings and etchings.

With great reluctance, as he protested he was better now than he had been for twenty years, he agreed to summon his son Ralph to Tunbridge Wells to join him in the management of the Great Hall Studio and to take over as much as possible of the photographic work. Ralph had already embarked on a career as an analytical chemist in the Gossage soap works at Widnes, Lancashire, under the direction of his Uncle Frederick. Being a dutiful son he relinquished his post and returned home.

Ralph Winwood Robinson is an obscure figure in the history of photography, one who lived under the shadow of his illustrious father. In fact he was an excellent photographer in his own right, becoming a talented portraitist who specialized in children and animals. His best-known photo-

graphs are a series of 'At Home' portraits of Associates and Members of the Royal Academy of Arts which were assembled into presentation albums in 1891, of which one is in the Collection of the Royal Photographic Society (figure 45).

A year after Ralph Robinson joined his father's business he married Janet Reid. They had been close friends for several years. Janet was an enthusiastic photographer and assisted her husband in the practice.

In January 1887 the Tunbridge Wells Amateur Photographic Association was founded. It was said that it owed its beginnings to a lecture given by Ralph Robinson in the autumn of 1886. Both Robinsons were founder members, and supported the Association in many ways.

One of Henry Robinson's last commissions as a practising professional photographer was to photograph several of Tunbridge Wells's most distinguished townsmen. Five leather-bound volumes in the County Library, Tunbridge Wells, are inscribed 'Tunbridge Wells in the

Figure 44 *From Dawn to Sunset (The Full Cycle of Life)*, 1861, by Thomas Faed. Oil. Collection: Tate Gallery

Figure 45 *Sir Frederick Leighton, PRA*, 1891, by Ralph Winwood Robinson. Platinum print. Collection: The Royal Photographic Society

Jubilee Year, portraits of some of the residents in 1887 photographed by H. P. Robinson, Great Hall Studio, in platinotype'. The first photograph is of the Chairman of the Town Council and the last is of H. P. Robinson himself.

In 1888 Henry Peach Robinson decided to retire from the business he had built up so successfully in Tunbridge Wells. He relinquished the Great Hall Studio, which was then acquired by Cox & Durrant, and in 1892 by P. S. Lankester, a distinguished professional photographer and prolific exhibitor.

Meanwhile Ralph Robinson had acquired premises for a studio in Redhill, Surrey. He transferred the business there, named the premises 'The Rembrandt Studio' and practised under the name of H. P. Robinson & Son.

New Developments in the Art of Photography

A newcomer to the photographic scene in the 1880s commanded attention by reason of his exhibition pictures and the address he delivered at the Camera Club in 1886 on 'Photography, a Pictorial Art'. This was Dr Peter Henry Emerson, a writer and enthusiastic photographer of rural life in East Anglia. In 1888 H. P. Robinson defended Emerson in the correspondence columns of *Amateur Photographer*, headed 'Combination Printing': 'Things in a photograph not easily understood do not seem to be believed, and you, yourself, in this same notice, in speaking of Dr Emerson's *Poacher* (which, by the way, was one of the best pictures in the Exhibition), are puzzled by the lighting of parts, although this clever photographer's pictures are all, I understand, done on one plate at one exposure'. Robinson was frequently irritated by the amount of space critics devoted to analysing photographers' methods rather than their powers of expression.

Emerson, an egocentric character, convinced of the novelty and rightness of his ideas on photographic art, challenged Robinson's theories in his book *Naturalistic Photography*, published in 1889, and through the photographic press. He placed emphasis on the aesthetic, ethic and technique of photography as an *independent art* and exhorted fellow photographers to study their own medium rather than be guided by the rules which applied to painting. He denounced Robinson's definition of Truth in the context of Art and his concept that an artistic photograph contains a mixture of the real and the ideal. Instead he promoted Truth to Nature as a principle. He advocated Picture Taking rather than Picture Making (this was the major difference between Emerson and Robinson).

One of Emerson's main arguments for Naturalistic Photography was that of differential focusing, a technique whereby parts of the image are sharply focused and the rest are unsharp to a greater or lesser extent. He said that the eye sees a part only of the subject it is viewing in sharp detail and that all else is softened; that this phenomenon was not automatically produced by the lens, so that photographers were obliged to use their cameras and lenses in such a way that the eye's vision was more correctly stated in the image. Although not scientifically sound the theory worked in practice. He denounced the biting sharpness which, he implied, Robinson and other photographers got in their pictures.[7]

Emerson thought he had introduced an entirely new concept to photography. In fact it was a method which had been employed for many

years by other photographers, including Frank Sutcliffe when photographing Whitby and its inhabitants.

Robinson was mindful of the controversy on diffusion of focus published in the photographic journals of 1866–7. In response to a request which he and Blanchard had made, Dallmeyer, the distinguished designer and maker of lenses, had introduced a lens which distributed the focus and provided depth of focus. Robinson said that there was 'plenty of recommendation to put the image out of focus at that time . . . All we wanted was greater depth of focus and softness without resorting to putting the image out of focus.'[8]

Robinson then referred to his photograph *Waiting for the Boat*, 1866, as having 'a certain amount of softness' without being out of focus (plate 63). He also referred to the concluding chapter of *Picture Making by Photography* (1884), in which he had said that 'excessive definition is not now looked upon as the chief glory of the photographer. I object as much as anybody to the sloppy-smudge order of photography; but when I see my way to getting a more atmospheric effect by sacrificing definition, that sacrifice is made without more ado.'[9]

Robinson realized that there is a fundamental difference *in effect* between 'a certain amount of softness' of definition which is evenly distributed over the image and different degrees of definition from sharp to blurred throughout the image and that the appearance of these two forms of photographic imagery is not the same.

Much to Emerson's dismay his theories led to experimentation which went well beyond the use of differential focusing. He himself always re-tained part of the image in sharp focus but others, notably George Davison, took photographs in which the image was deliberately diffused throughout, based on Robinson's practice rather than Emerson's. The degree and *effect* of diffusion depended on the technique(s) used. Davison started by using a pinhole instead of a lens, subsequently using specially designed soft focus camera lenses and the new rough-surfaced gela-tine silver printing papers. Davison exhibited his first impressionistic photograph *An Old Farmstead* (later renamed *The Onion Field*) in 1890. It was taken with a pinhole in a piece of sheet metal in place of a lens; nowhere was it in sharp focus. It was a sensation and the signal for a surge forward into impressionistic photography.[10]

Robinson, in supporting this New Movement in photography, said:

We got tired of the sameness of the exquisiteness of the photograph . . . [He was referring to the exact rendition of detail which is all-revealing.] Why? Because the photograph told us everything about the facts of nature and left out the mystery. Now, however hard-headed a man may be, he cannot stand too many facts; it is easy to get a surfeit of realities, and he wants a little mystification as a relief . . . Clever writers are now discovering that it is not necessary that photography should make for realism, but indeed, in its higher flights, may tend the other way.[11]

In writing about visual perception he said:

Impressionism has induced the study of what we see and shown us that we all see differently; it has done good to photography by showing that we should represent what we see and not what the lens sees . . . What do we see when we go to Nature? We see exactly what we are trained to see, and, if we are lucky, perhaps a little more but not much . . . We see what we are prepared to see and on that I base a theory that we should be very careful what we learn.[12]

Robinson never went further than introducing 'a certain amount of softness' into his own photographs but he was able to appreciate the radical change wrought in photographic imagery by the vogue for impressionism (in the reduction of photographic detail and increase in the use of broad areas of smooth tones). It opened the door to a greater variety of expression than hitherto.

Although seemingly the battles were fought over the methods employed to obtain different visual effects, the real issue, as Robinson saw it, was the pictorial effectiveness or otherwise of photographs.

Secession from the Photographic Society of Great Britain

In his fight for the recognition of photography as an art, Henry Peach Robinson became increas-ingly exasperated by the influence of the photo-graphic scientists and technologists on the Council of the Photographic Society of Great Britain and the disporportionate amount of time in meetings devoted to photographic techniques. By 1890 the two divisions in the Society – photographic science and technology, and photo-graphic art – had become polarized. Robinson summed up the position thus:

If photography is ever to take up its proper position as an art it must detach itself from science and live a separate existence . . . For years art has been scarcely mentioned . . . [in the proceedings of the Society].

Two or three years ago one of the officials expressed his opinion that papers on art may be tolerated if they could be got and there was nothing better to be had.[13]

The crunch point came during the hanging of the Annual Exhibition in 1891 when the Chairman, Chapman Jones, Robinson and others were overruled by the Honorary Secretary, Captain Mantell and the new Assistant Secretary, H. A. Lawrence, who disqualified the late entry of George Davison. The resulting row in the Council meeting of October 1891 led to a vote of censure passed on Robinson, which was followed by Robinson and Davison walking out of the meeting and subsequently resigning from the Society.[14] In letters to W. S. Bird, the Honorary Treasurer, Robinson accurately forecast the loss of respected members to the Society as a result of this unfortunate incident. In the event twelve resignations from distinguished practitioners of the art of photography were to follow. Robinson, a Vice-President at the time, had been a member for thirty-three years. Conciliatory attempts to get him back or at least to participate in certain Society events met with firm rejections. Robinson was not prepared to risk any further ignominies.[15]

Instead, Henry Peach Robinson and other leading photographers decided to set up an Association through which their ambitions for the development and recognition of photography as a fine art might be realized.

The Linked Ring Brotherhood

Alfred Maskell, cultured and well travelled, was a leading authority on old ivory carvings, and an enthusiastic impressionistic photographer. He initiated the meeting which brought together the group of photographers who had seceded from the Photographic Society of Great Britain with others of a like mind to form a 'small Society, an inner circle, a kind of little Bohemian Club' which the fifteen founders named *The Linked Ring*.[16]

The information sheet given to postulants for admission states: 'The Linked Ring has been constituted as a means of bringing together those who are interested in the development of the highest form of Art of which Photography is capable.'[17]

The major activity was an annual exhibition of photographic art selected from entries made by both members and non-members. Until struck down by a terminal illness Robinson played a prominent part in the selection and display of the exhibits. The exhibition was known as *The Photographic Salon* and new standards were set in bringing together photographic imagery of high quality and greater variety than had ever been seen before.

In a few years' time the Linked Ring had established an international reputation and included on its membership roll were the names of photographers of world renown from the USA and Europe as well as Britain.

H. P. Robinson, who had transferred his allegiance to the Linked Ring, exhibited his work in the Salon each year instead of in the Society's exhibition.

Activity in Retirement

After retirement from business Henry Robinson was able to concentrate on the activities he had come to enjoy most: the production of pictures for exhibitions of photography, involvement in the affairs of the many photographic organizations of which he was a member, writing for the photographic press, judging exhibitions and advising fellow photographers (both amateur and professional).

In his pleasant residence, surrounded with books and pictures, he yet generously gives his attention to answering letters which he receives from all parts of the country every day . . . He is unusually systematic for a man of his calling [and] classifies his manuscripts and papers so that he can put his hand on any given paragraph at a moment's notice. He is a great reader and gets through more than a dozen photographic periodicals every week. His books are arranged systematically on their shelves and though chiefly relating to photography and art, on which subjects he has one of the choicest collections of volumes in this country, there are also other valuable works, and not a few rarities.[18]

Selina Robinson said that her husband was never as thoroughly at home as when in his library. The walls were hung with photographs, including many of his own. Over the mantelpiece was a choice collection of miniatures on porcelain with Nicéphore Niepce's early experiments close to hand.

He had built a little studio at the bottom of his garden, but it was impossible to take a portrait in it; in fact it was more of a laboratory, but it gave him great pleasure.[19] Many of the photographs he exhibited in the 1890s were printed from

Figure 46 *Henry Peach Robinson*, 1890, by R. W. Robinson. Platinum print. Private collection

taught his children to draw before they could read or write. He also made sure that his daughters received the same quality of education as his sons, sending Maud and Ethel to finishing schools in Germany. Henry Peach Robinson was a great family man. Vera remembered that the entire Robinson family assembled at 'Winwood' for Christmas each year and at other times for special celebrations.

Selina Robinson was very quiet and never attempted to assert her own personality. She was obviously devoted to her husband, responding to his every whim. A. H. Slade, grandson of Marianne Asterley (née Bibby), was born in Tunbridge Wells and lived in Queen's Road as a small boy. His family were near neighbours of the Robinsons and visited them frequently. He remembered Selina, by that time widowed, as 'a very kind lady who provided splendid teas for small boys'.

During his life H. P. Robinson maintained contact with friends in Ludlow. In July 1895 he took a party of photographers to the town from Shrewsbury where they were attending the annual meeting of the Photographic Convention, and in 1896 he took a dozen friends, members of the Amateur Photographers' Field Club (the oldest photographic body in the world, according

negatives made in previous years but he still continued to take photographs at the bottom of his garden and when on holiday, until his final illness (plates 75, 97, 98, 99, 103, 104).

He became an enthusiastic supporter of the Tunbridge Wells Society. In June 1889 members took a trip on the River Medway piloted by Henry's future son-in-law, Dr George Abbott. A report of the outing makes special mention of 'H. P. Robinson, on board, with his "quips and cracks", his genial stories and the ladies smiling approval'.[20]

His granddaughter Vera Tomkins recollected Robinson's 'rich sense of humour', which created great merriment in the family. He was a typical Victorian and ruled his household in a very firm but kindly manner. Her father, Ralph Winwood Robinson, maintained that his father 'did not argue, he always asserted'. Vera recalled both her grandparents sitting bolt upright in chairs either side of the hearth at family Sunday afternoons in 'Winwood', Queen's Road, Tunbridge Wells, with HPR 'ruling the roost', giving orders to the staff and also the members of the family. When he gave orders he always complained if they were not carried out to his satisfaction. To a child 'there were times when he appeared to be austere'. He was a most meticulous man who paid great attention to detail. Nothing was out of place so far as he was concerned and nothing was ever left to chance.

Vera greatly admired her grandfather. She thought he was 'ahead of his time' because he

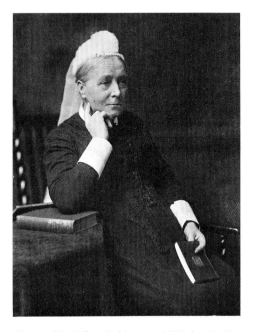

Figure 47 *Selina Robinson*, c.1905, by R. W. Robinson. Platinum print. Private collection

to Robinson), to Ludlow for a few days. 'Their unanimity of admiration was wonderful,' he said, proudly, for he still regarded Ludlow as the most lovely place in the world.

Henry Robinson was greatly sorrowed by the death of his close friend the artist Henry Moore, RA, in 1895:

> Our greatest sea painter, Henry Moore . . . His work was the highest impressionism without the least touch of eccentricity and affectation that so marred the work of the impressionists a few years ago . . . One reason why he gave us the spirit of the sea so faithfully was that he always painted straight from nature, and never asked photography to help him [figure 48] . . . For forty years he was my intimate friend, and took the greatest interest in photography.[21]

In spite of the best endeavours of the Links to gain recognition for photographic art, and a seemingly enthusiastic response from the public, painters of repute were, in many instances, dubious about the merits of photographs.

John Brett, an Associate of the Royal Academy, lectured on 'The Relation of Photography to Pictorial Art' on 24 January 1892.[22] Although he stressed the importance of photography as a means of factually recording nature and history, concluding that it was the greatest of all modern inventions, he did not admit that the medium was capable of being 'a pictorial art'. He said that by rearranging the constituent parts of a scene, without distorting them or changing their natural-ness, the painter could produce a more delightful impression on the spectator than the natural view was capable of making. Lyddell Sawyer, a member of the audience, who was a member of the Linked Ring and a follower of Robinson, challenged Brett to visit some of the photo-

Figure 49 *The Stonebreaker*, 1857/8, by John Brett, ARA. Oil. Collection: Walker Art Gallery, Liverpool

graphic exhibitions 'which he appears to shun' and invited him to 'find *some* specimens (one would prove the possibility) proclaiming the photographer to be an educated artist, and his photograph portraying an artistic achievement in monchrome'.[23]

Brett's painting *The Stonebreaker* (figure 49) makes an interesting comparison with Robinson's photograph *Primrose Time* (plate 95). The picture construction is virtually the same in both, resulting in the unification of carefully selected separate parts. The relationships between the foreground which contains the figure(s), the middle and far distance are similar in both. The rendition of detail in the painting is almost more precise than that in the photograph. The only fundamental difference is that the painting is in colour and the photograph in monochrome. In the sympathetic handling of the picture content Robinson's *Primrose Time* has affinities with Birket Foster's delightful illustrations of children at play.

In the 1890s Henry Robinson was the delighted owner of a Kodak hand camera, which he found particularly useful for taking photographs of the sea and Scottish lochs. He was invited to participate in an annual cruise in a large steam yacht during the Clyde fortnight. He recalled the racing in 1895 at one of the Clyde regattas as unusually interesting and succeeded in photo-graphing three great yachts on one plate: *Ailsa*, *Valkyrie III* and the Prince of Wales's *Britannia*. He stressed the importance of having sufficient knowledge of sailing if a photographer was to succeed with these subjects.

The photographs he took with his hand camera are quite different from the rest of his work in

Figure 48 *Catspaws off the Land*, 1885, by Henry Moore, RA. Oil. Collection: Tate Gallery

that they are straight and the content not preconceived. Nevertheless his personal style is clearly recognizable in the subject selection and photographic qualities of the imagery (plates 75, 103, 104).

With some photographers there is a discernible deterioration in their work during the last phase of their life. This is not so in the case of Henry Peach Robinson. Two of his best photographs were taken only months before his fatal last illness. *Old Dapple*, 1899 (plate 98), is a delightful picture and shows a complete understanding of how a horse should be photographed. It is strange that only one other photograph of a horse by him has come to light. He devoted a chapter to animals in one of his books:

Of all animals taken to the photographer the horse is the most frequent . . . It is fortunate that he is a good sitter. The photographer has nothing to do but to see that the position is easy – for even horses can pose – and the expression is bright . . . I lately refused to photograph a lady on horseback because her groom insisted that the horse should stand with the legs level, and stuck out at both ends of the animal in the fashionable way.[24]

The Starling's Nest, 1900 (plate 99), is surely one of his loveliest pictures, a perfect embodiment of the quality of mystery without which he thought no picture could be quite complete.

A picture should draw you on to admire it, not show you everything at a glance. After a satisfactory general effect, beauty after beauty should unfold itself, and they should not all shout at once . . . This quality [mystery] has never been so much appreciated in photography as it deserved. The object seems to have been always to tell all you know. This is a great mistake. Tell everything to your lawyer, your doctor, and your photographer (especially your defects when you have your portrait taken, that the sympathetic photographer may have a chance of dealing with them), but never to your critic. He much prefers to judge whether that is a boathouse in the shadow of the trees, or only a shepherd's hut. We all like to have a bit left for our imagination to play with. Photography would have been settled a fine art long ago if we had not, in more ways than one, gone so much into detail. We have always been too proud of the detail of our work and the ordinary detail of our processes.[25]

In 1900 H. P. Robinson was unanimously elected an Honorary Fellow of the Royal Photographic Society (the former Photographic Society of Great Britain) 'in consideration of his services to photography and to the Society in the past'. It was one of the first Honorary Fellowships to be

awarded and was bestowed in the nick of time. Later that year he suffered a paralytic seizure and was housebound for many months, a tragedy for one so active and interested in life.

Henry Peach Robinson died on 21 February 1901, aged seventy years, following his paralysis the previous year. He was buried in the Ben Hall Road Cemetery, Tunbridge Wells.[26] The headstone of the grave was designed and carved by him in the style of the lintel carving over the front door of his home 'Winwood', 2, Queen's Road, Tunbridge Wells (figure 50). All the living members of his family attended the funeral as well as other relatives and many friends.

A lengthy obituary notice appeared in the *Tunbridge Wells Advertiser* on Friday 22 February 1901, followed by an 'Obituary by a Friend' published in the *Kent and Sussex Courier* on 6 March 1901. Many tributes to the 'Grand Old Master of Photography' were published in the photographic press.[27]

His wife Selina, who survived him, lived on at 'Winwood' until her death on 8 September 1909.

Figure 50 Headstone to the Robinson family grave in Tunbridge Wells cemetery, carved by H. P. Robinson himself, as it was in 1979. Harker collection

Their youngest (unmarried) daughter Ethel May Robinson occupied the family home until her death on 9 April 1932, following which 'Winwood' was sold.

In 1901, after his father's death, Ralph Robinson reprinted many of Henry's exhibition pictures in platinotype for sale by the Rembrandt Studio and by print sellers. He acquired additional premises in Guildford and opened a second studio there, which was managed by his daughter, Margaret Winwood Robinson. For a short period they were assisted by A. Horsley Hinton, the pictorialist, who was a member of the Linked Ring.

In 1942, Ralph Winwood Robinson died. His daughter closed the Rembrandt Studio, Redhill, which her father had opened fifty-four years previously, but continued in practice at the Guildford studio. Two years later her mother Janet died, and in 1946, after the strain of continuing in business in wartime Britain and the consequent changes in photography, she decided to sell the business and retire.

Epilogue

In many respects Henry Peach Robinson was the most celebrated photographer in Britain during his lifetime. It has been said that he dominated the world of art photography for a period of over thirty years. George Davison, leader of Impressionistic photography, stated in a 'Biographical Note', published in 1901: 'He was the greatest man of his time among photographers.'

Robinson's achievements were very considerable and he was a man of many parts, having at his command remarkable powers of expression, both verbal and visual. No other contemporary photographer sustained the production of major art photographs over such a long period on such a consistent level, or received as many medals and critical notices in praise of his work as he did.

He built a firm foundation for his theories on photographic art, based on the principles of the Picturesque Movement. His strength lay in his ability to put his theories into practice and to support his ideas by pictorial illustration. In this way he commanded great respect amongst artists as well as photographers, even though they did not always agree with him.

Above all else Henry Peach Robinson was a kind and generous man who freely gave his time to help others. He would have appreciated the comment made by the writer of the Obituary Notice which appeared in *Photographic News* of 1 March 1901, that he was 'a charming conversationalist, full of quiet fun, memory stored with amusing anecdote, quotation and facts that render an evening a pleasure to be looked back upon'.

NOTES

Abbreviations

AP *Amateur Photographer*
BJP *British Journal of Photography*
HPR Henry Peach Robinson
JPS *Journal of the Photographic Society*
MFH Margaret F. Harker
PN *Photographic News*
PP *Practical Photographer*
PSGB Photographic Society of Great Britain
RPS Royal Photographic Society

Chapter 1 Days in Ludlow

1 HPR, 'Autobiographical sketches', ch. I, *PP*, vol. VIII, Feb. 1897, p. 42.

2 Ibid., pp. 40–2.

3 Ibid.

4 D. W. F. Hardie, *A History of the Chemical Industry* (ICI Ltd 1950), printed by the Kynoch Press, Birmingham.

5 HPR, 'Autobiographical sketches', ch. II, *PP*, vol. VIII, April 1897, p. 97.

6 Ibid., p. 99.

7 HPR, 'Autobiographical sketches', ch. I. p. 39.

8 Robinson family collection.

9 HPR, 'Autobiographical sketches', ch. II, p. 98, ch. I, p. 42.

10 Ibid., p. 100.

11 Ibid., p. 98.

12 David J. Lloyd and Peter Klein, *Ludlow: A Historic Town in Words and Pictures* (Phillimore Press, 1984).

13 David J. Lloyd (ed.) *A History of Ludlow Grammar School*.

14 Henry T. Weyman, *Ludlow in Bye-Gone Days* (Palmers Press, Ludlow, 1986; 3rd reprint), p. 26.

15 Photographs produced on paper negatives and positive prints made from them, invented by William Henry Fox Talbot in 1841, being an improvement on his earlier invention (in 1839) of Photogenic Drawing.

16 Reference to daguerreotypes – photographs produced on silvered copper plates by the process invented by L. J. M. Daguerre (based on experiments by Nicéphore Niepce) in 1839.

17 M. E. Speight and D. J. Lloyd, *Ludlow Houses and their Residents*. Ludlow Research Papers, no. 1 (undated).

18 HPR, 'Autobiographical sketches', ch. III, *PP*, vol. VIII, June 1897, p. 163.

19 Ibid., pp. 162–3.

20 HPR, 'Autobiographical sketches', ch. IV, *PP*, vol. VIII, August 1897, pp. 231–2.

21 Private Collection: HPR, Diary, 1849–51.

22 Source: Peter Winwood Gossage. Letter from Ursula Warren, daughter of F. H. Gossage and his second wife, Amy Perrin, to Colin Midwood, 22 October 1964.

23 Thomas Wright, *History of Ludlow*, 1867 edition, pp. 193–4.

24 The wet collodion process was invented in 1851 by Frederick Scott Archer. Glass plates were used for making the negatives and had to be prepared and processed on site.

25 The Hereford Museum and Art Gallery have a fine collection of Gill paintings.

26 HPR, 'Autobiographical sketches', ch. II, pp. 100–1.
27 Ibid., p. 101.
28 Ibid.
29 HPR, Diary entry 14 May 1849.
30 HPR, 'Autobiographical sketches', ch. III, p. 165.
31 Ibid., p. 166.
32 Various publications on Ludlow, including the Official Guide, Thomas Wright: *History and Antiquities of Ludlow* (1826), and Oliver Baker: *Ludlow Town and Neighbourhood* (1888).
33 Correspondence: A. H. Slade to J. Ryder, 1977.
34 Dictionary definition of 'faze' is 'disconcerting'.
35 The Mary Annie Bibby album, on loan to the Ludlow Museum, is owned by A. H. Slade, grandson of Mary Annie Asterley, née Bibby.
36 A. H. Slade: the Bibby family's home was Llanfyllin Hall, Montgomery.

Chapter 2 Publishers and Bookshops

1 Private collection.
2 Alan Richards and others, *Byegone Bromsgrove*.
3 HPR Diary entry 20 December 1850.
4 Ibid., 30 March 1851.
5 Ibid.
6 HPR, 'Autobiographical sketches', ch. IV, p. 232.
7 HPR Diary entry August/September 1851.
8 Ibid., 1 October 1851.
9 Robert A. Sobieszek, Note 3 to Introduction to Helios reprint, 1972, of Robinson's *Pictorial Effect in Photography* (see ch. 4, note 11), Royal Academy Exhibition, 1852, item 250, *On the Teme near Ludlow*, listed in Algernon Graves, *The Royal Academy of Arts* (London, 1906), vol. 6, p. 337.
10 HPR, 'Autobiographical sketches', ch. IV, p. 235.
11 The copy in Kenilworth Public Library is inscribed 'J. Buckle Esq. with H.P.R.'s compts'.
12 HPR, 'Autobiographical sketches', ch. IV, p. 235. A few of these are in the Gernsheim Collection, Harry Ransom Humanities Research Center, University of Texas at Austin, USA.
13 HPR, 'The growth of picture making', PP, vol. VII, May 1896, p. 114.
14 Negative–positive photography employing glass for the negative image and albumenized paper for the print.
15 The camera had to be adapted to take darkslides necessary for use with the collodion glass plates, instead of the calotype paper.
16 His notebook containing these early chemical formulae is in the RPS Collection.
17 HPR, 'Autobiographical sketches', ch. IV, pp. 236–7.
18 At a later date renamed The Photographic Society

of Great Britain, which became The Royal Photographic Society of Great Britain in 1892.
19 This was probably the School relinquished by the Misses Powell earlier that year. Sources: Mrs. F. Robinson of Ludlow (not a relative of HPR) and 1856 Ludlow Directory.

Chapter 3 The Studio in Leamington

1 This form of photography was used almost entirely for portraiture and bears some resemblance to the daguerreotype with which it is often confused, as the images were of the same sizes and presented in the same way. Negatives made by the collodion process on glass were backed by black velvet or varnish which gave the image a positive appearance.
2 In modern times the street numbering was changed so that it is uncertain which was the original 15; however, it is in the immediate vicinity of the parked cab on the left in Robinson's photograph of Upper Parade, published in *Warwickshire Illustrated* (1858; see appendix I: 1858).
3 *Leamington Courier*, 24 January 1857.
4 HPR, 'Autobiographical sketches', ch. V, *PP*, vol. VIII, October 1897, p. 290.
5 Source: Miss M. Laird, great grandaughter. John Laird's father, William established the Birkenhead Iron Works in 1824 and the firm of William Laird & Son launched its first iron ship (a small lighter) in 1829. John Laird became Chairman of the Dock Commissioners in 1844 and the first Member of Parliament for Birkenhead in 1861, in which year he retired from the family business. The Laird and Gossage families were on very friendly terms.
6 If photographs in colour were required in the nineteenth century water colours or oil paint were applied by hand to the monochrome image. Not until the early years of the twentieth century did colour photography become possible.
7 Information supplied by his son, Geoffrey Messer, Brampton Bryan.
8 HPR, 'Autobiographical sketches', ch. V, p. 291.
9 Ibid.
10 HPR, 'The simplicity of the collodio-albumen process', *JPS*, 21 May 1857, pp. 286–7.
11 Average exposure on a bright day, using his collodio-albumen dry plates, was 5 minutes with a Ross No. 3 landscape lens $\frac{5}{8}$ inch diaphragm, and 2 minutes with a stereoscopic lens.
12 *Journal of the Athenaeum Club*, 5 June 1858.
13 *Leamington Courier*, 5 September 1857.
14 Ibid., 14 November 1857.
15 A major problem for photographers at that time was the slow speed of photographic materials, which required lengthy exposures. Several photo-

graphers were able, by various technical means, to reduce exposure times to near instantaneity.

16 HPR, 'Autobiographical sketches', ch. V, p. 291.

17 *JPS*, 2 April 1857.

18 Queen Victoria is said to have bought a copy for Prince Albert.

19 E. Yoxall Jones, *Father of Art Photography: O. G. Rejlander, 1813–1875* (David & Charles, 1973).

20 W. Lake Price, *Photographic Manipulation*, (John Churchill & Sons, 1868, 2nd edn) p. 168, in which Price stated that he took *The Baron's Feast*, in which five figures and numerous accessories were introduced, in forty seconds in January, with a 4½ inch (11.5 cm) double Ross lens on a 12 by 10 inch (30.5 × 25.4 cm) plate camera. The image size of *Don Quixote* was 13 by 11 inches (33 × 28 cm); the depth dimension being seven feet (2.2 m) and the width nine feet (2.75 m) required to be in focus; the exposure time being fifty seconds.

21 HPR, 'The growth of picture making', *PP*, vol. VII, p. 119; and Christopher Wood, *Dictionary of Victorian Painters* (Antique Collectors' Club, 1981).

22 Letter from Berwick and Thomas Annan of Glasgow.

23 HPR, 'The growth of picture making', p. 119.

24 *Liverpool and Manchester Photographic Journal*, 15 June 1858, p. 154.

25 *Edinburgh Weekly Herald*, 1 January 1859.

26 *PN*, 1 October 1858, p. 40: 'Critical notices'.

27 *Edinburgh Weekly Herald*, 1 January 1859.

28 *JPS*, 1 January 1859: Exhibition review by Sel D'Or.

29 HPR, 'On printing photographic pictures from several negatives', *BJP*, 2 April 1860.

30 *BJP*, 15 June and 2 July 1860.

31 *BJP*, 2 July 1860.

32 HPR, 'Autobiographical sketches', ch. V, p. 292.

33 *Liverpool and Manchester Photographic Journal*, 1 October 1858, p. 237: Exhibition review.

34 Letter dated 17 November 1858, reproduced in *PP*, March 1895, p. 69: 'Our leaders, no. 25: Henry P. Robinson'.

35 *Leamington Courier*, 26 June 1858.

36 Ibid., 2 October 1858.

37 Ibid., 30 October 1858.

38 Ibid., 18 December 1858.

39 Letter from Benjamin Maund to Henry P. Robinson, 8 March 1859, in private collection.

40 Will and other documents in private collection.

41 *JPS*, 9 April 1859.

42 'New Portable Tent and Perabulator', *JPS*, 21 April 1859, p. 266.

43 *Leamington Courier*, 22 December 1860.

44 The carte-de-visite was a photograph mounted on card, the size of a visiting card and often used for that purpose, which usually had a well designed advertisement for the photographer's studio on the reverse. They could be produced cheaply and were very popular. Many people collected them and placed them in albums made for the purpose with cut-out apertures.

45 *Leamington Courier*, 22 December 1860.

46 HPR, 'Autobiographical sketches', ch. VI, *PP*, vol. VIII, December 1897, p. 355.

47 Ibid.

48 Ibid., p. 357.

49 Messer family records.

50 Census Return for Leamington, 1861.

51 HPR, 'Autobiographical sketches', ch. VI, p. 358. There is no record of what happened to this painting.

52 *Photographic Quarterly*, July 1892. pp. 104–5.

53 All Saints Church parish register, Leamington.

54 J. Ryder: genealogical chart.

55 HPR, 'Autobiographical sketches', ch. VII, *PP*, vol. IX, February 1898, pp. 29–31.

56 Now in the RPS Collection, with the original negatives.

57 *JPS*, 15 September 1863, p. 347. It is clear that he did not make the prints issued to members, and that they were made from a negative which was copied from one of the original prints. This was standard practice for smaller prints of his large composite photographs.

58 All Saints Church parish register, Leamington.

59 From correspondence in private collection.

60 'Mr Robinson's new picture', *PN*, 16 October 1863, pp. 493–5.

61 N. K. Cherrill, 'Combination printing', *BJP*, 15 January 1869.

62 *BJP*, 15 December 1863, pp. 427–8.

Chapter 4 Pictorial Effect

1 In 1866 G. W. Simpson was living at 36, Canonbury Park South, as recorded in HPR's records of meetings of the Solar Club and in letters exchanged between them.

2 *JPS. BJP, PN, PP, Humphrey's Journal*, New York, and others.

3 *JPS*, May 1866, p. 50.

4 *JPS*, October 1866, pp. 121–2. The major advantage of carbon prints is that, being made with a permanent substance, they are not liable to fading or other forms of deterioration.

5 RPS Document Archive: *The Origin of the Solar Club* (leaflet).

6 HPR, Record of Meetings of the Solar Club, in private collection. The first membership list included: Francis Bedford, Valentine Blanchard, J. H. Dallmeyer, William England, Jabez Hughes, J. E. Mayall, W. Mayland, H. Baden Pritchard, G. Wharton Simpson, J. Spiller, J. Werge, T. R. Williams, W. B. Woodbury, with H. P. Robinson as Chancellor and O. G. Rejlander as Vice-Chancellor.

7 *PN*, 5 July 1867, pp. 315–16: 'Critical notices. *Sleep*: a pictorial photographic composition, by H. P. Robinson'.

8 Extracts from 'Combination printing' are reproduced in Appendix II.

9 British editions: 1869, 1879, 1881, 1893; American: 1881, 1892; French: 1885; German: 1886.

10 Letter from H. W. Diamond to H. P. Robinson 19 Sept. 1869, in the Gernsheim Collection, Harry Ransom Humanities Research Center, University of Texas at Austin, USA.

11 Robert A. Sobieszek, Introduction to HPR, *Pictorial Effect in Photography*, reprinted by Helios, Pawlet, Vermont, USA in three impressions: 1971, 1972, 1973.

12 HPR, *Pictorial Effect in Photography*, p. 53.

13 HPR, *Picture Making by Photography*, pp. 33–4.

14 HPR, *Pictorial Effect in Photography*, principally on pp. 32, 60, 125, 130, 150–1, 177.

15 Ibid., p. 60.

16 Ibid., p. 15.

17 Ibid., p. 13.

18 Ibid., pp. 18–19, 28.

19 Ibid., p. 11.

20 Ibid., pp. 34–5, 37.

21 Ibid., pp. 69–70.

22 Ibid., p. 167.

23 Ibid., p. 51.

24 Ibid., p. 78.

25 Ibid., p. 109.

Chapter 5 Life in Tunbridge Wells

1 The 1871 Census records the following in residence at 21 Church Road: Henry Peach Robinson; Selina Robinson, (*both* are recorded as photographers); Edith Robinson (daughter), aged 11; Ralph Winwood Robinson (son), aged 9; Maud Robinson (daughter), aged 8; Ethel May Robinson (daughter), aged 6. Leonard (the younger son) is not recorded as being present. It is stated that all four children were born in Leamington. Also it is reported that they had a housemaid and cook 'living in'.

2 Alan Savidge, *Royal Tunbridge Wells* (Midas Books, 1975).

3 Good examples may be seen in the Tunbridge Wells Museum.

4 C. H. Strange, *Jubilee of Tunbridge Wells as an Incorporated Borough* (Corporation of Tunbridge Wells, 1939).

5 HPR, 'Photography as a business', *PP*, vol. I, no. 9, September 1890.

6 Strange, *Jubilee of Tunbridge Wells*.

7 *PN*, 12 October 1866. p. 428: 'A critical notice, *Views of the English Lake Scenery* by Nelson K. Cherrill'.

8 *Kelly's Directory of Kent* and *Kent Courier*: trade and residential lists, 1868–71.

9 *BJP*, 4 September 1868, p. 427; *PN*, 4 September 1868, p. 432.

10 *PN*, 1866, pp. 459, 483, 532, 603. 'Experiments with Carbon Printing by Nelson K. Cherrill, Number 2', pp. 483–4, refers to his experiments with transfer to surfaces other than paper, especially silk.

11 *Pelton's Illustrated Guide to Tunbridge Wells, 1871–2* carries an advertisement for Robinson and Cherrill's studio in the Public Buildings.

12 HPR, 'Combination printing' in *Pictorial Effect in Photography* (1869), p. 191; Nelson K. Cherrill, 'On combination printing', *BJP*, 15 January 1869, 'Combination printing', *PN*, 15 January 1869, p. 25.

13 *PN*, 18 December 1868, p. 601; and *JPS*, November/December 1868.

14 In the early 1860s Robinson had worked out a method for making near instantaneous exposures of subjects which were in motion.

15 *PN*, 30 July 1869. p. 362: 'Critical notices'.

16 *PN*, 20 September 1869: Correspondence.

17 *PN*, 27 September 1869: Correspondence.

18 Savidge, *Royal Tunbridge Wells*. Out of 30,000, 65 per cent of the adult population were churchgoers.

19 St John's Church parish register, Tunbridge Wells.

20 Reminiscences of Vera Tomkins (HPR's granddaughter).

21 Robinson family records.

22 *Pelton's Illustrated Guide to Tunbridge Wells, 1871–2*.

23 'Noteworthy studios: Messrs. Robinson and Cherrill's Studio at Tunbridge Wells', *PN*, 8 September 1875. pp. 427–8.

24 Ibid.

25 'About a studio at Tunbridge Wells by a modest contributor', *PN*, 20 September 1872, p. 449.

26 Ibid.

27 HPR, *The Photographic Studio and What to Do in It* (Piper & Carter, 1885).

28 This was because the light sensitive materials then in use were 'colour blind' and recorded yellows and

reds as very dark greys or blacks and blues as lighter in tone than they appear to the eye.

29 Examples of his carte-de-visite portraits are in the Alexander Turnbull Library, Wellington, New Zealand.

30 N. K. Cherrill, 'On ceramic enamels', *PN*, January and February 1878.

31 *PN*, 11 June 1880. p. 278: advertisement – 'Mr H. P. Robinson at the Great Hall Studio, Tunbridge Wells'.

32 Carte-de-visite of Mrs C. Tattershall Dodd, 1877, reveals the likeness.

33 These plates had greatly increased light sensitivity compared with collodion plates, thereby substantially reducing length of exposure times.

34 Refer to appendix IV for select list.

35 *PN*, 8 September 1876. pp. 430–1.

36 N. K. Cherrill, 'Photography in Melbourne', *PN*, 1 December 1876, pp. 572–3.

37 Letter to Bill Jay, Head of Photography, Art Department, Tempe University, Arizona, USA from Auckland Public Library, New Zealand, 4 May 1979.

38 HPR, 'The tools we use', *PN*, 26 July 1872, p. 353.

39 Letter in the Gernsheim Collection, Harry Ransom Humanities Research Center, University of Texas at Austin, USA.

40 *PN*, 15 September 1871, pp. 434–5: 'First Silver Medal at Falmouth'.

41 *BJP*, 24 October 1873, p. 513.

42 *JPS*, 21 October 1873.

43 The *Tunbridge Wells Gazette* and the *Kent and Sussex Couriers* carried advertisements for the Great Hall Studio on 31 March 1876 under the name of H. P. Robinson alone.

44 'Mr H. P. Robinson at the Great Hall Studio, Tunbridge Wells', *PN*, 11 June 1880, pp. 278–9.

45 Ibid.

46 Probably either electric carbon arc lamps or limelight (the stage footlights).

47 RPS Collection: Letter attached to a page of Robinson's Press Cuttings Album, No. 2.

48 RPS Collection: H. P. Robinson's Press Cuttings Album, No. 2.

49 HPR, 'Autobiographical sketches', ch. VI, *PP*, vol. VIII, p. 356.

50 *Photography as a Business*, first serialized in *PP*, vol. I, nos. 1–12, January–December, was published by Percy Lund & Company, Bradford. 1890.

51 *PN*, 8 June 1877. pp. 271–3: Correspondence.

Chapter 6 Picture Making by Photography

1 HPR, *Picture Making by Photography*, (Piper and Carter, London, 1884).

2 Ibid., p. 77.

3 HPR, *The Elements of a Pictorial Photograph*, 1896, pp. 139–47.

4 HPR, *Picture Making by Photography*, p. 55.

5 HPR, 'Autobiographical sketches', ch. IV, *PP*, vol. VIII, p. 237.

6 HPR, *Elements of a Pictorial Photograph*, p. 104.

7 HPR, *Picture Making by Photography*, p. 52.

8 Ibid., p. 53.

9 Ibid., pp. 54–5.

10 Ibid., p. 54.

11 HPR, *Elements of a Pictorial Photograph*, p. 98.

12 Ibid., p. 95.

13 HPR, *Picture Making by Photography*, p. 56.

14 HPR, *Elements of a Pictorial Photograph*, p. 104.

15 Source: Peter Winwood Gossage. Gossage family records and letter from Ursula Warren, daughter of F. H. Gossage and Amy, née Perrin, to Colin Midwood, 22 October 1964.

16 F. H. Tate family records.

17 Research: Joan Ryder.

18 E. R. W. Robinson family records.

19 *PN*, 7 July 1882, p. 388.

20 *Philadelphia Photographer*, ed. by Edward L. Wilson, April 1882, pp. 7–8.

21 HPR, 'Genesis of a picture', in *Picture Making by Photography*, pp. 59–63.

22 HPR, *Elements of a Pictorial Photograph*, p. 50.

23 HPR, 'Brush and Camera in Wales', *PN*, 25 July 1884.

24 Ibid.

25 Ibid.

Chapter 7 The Last of Life

1 HPR, 'The growth of picture making', *PP*, May 1896, pp. 113–22.

2 Helmut Gernsheim, 'The 150th anniversary of photography', *History of Photography* quarterly, Jan. 1977, p. 6.

3 HPR, 'The growth of picture making', p. 113.

4 HPR, *Picture Making by Photography* (Piper and Carter, 1884), pp. 86–7.

5 Helmut Gernsheim, 'The 150th anniversary of photography', *History of Photography* quarterly, January 1977, p. 6.

6 Supplement to *PN*, 23 October 1885.

7 P. H. Emerson, *Naturalistic Photography* (1889, 1st

edition Hazell, Watson and Viney Ltd), pp. 170–3, chapter: Naturalistic Photography and Art.

8 HPR, 'A certain amount of softness', *Camera Club Journal*, 1889.

9 HPR, *Picture Making by Photography*, p. 145.

10 MFH, *The Linked Ring. The Secession in Photography, 1892–1910* (RPS and Heinemann, 1979), p. 31.

11 HPR, *Elements of a Pictorial Photograph*, pp. 70–1.

12 Ibid., pp. 87–8.

13 HPR, 'The two sides of photography', *PN*, 19 August 1892.

14 MFH, *The Linked Ring*, pp. 52–4.

15 Letters in the Turner Collection: Chapman Jones to Robinson, 22 September and 12 December 1891; James Glaisher to Robinson, 23 September 1891; Bird to Robinson, 18 January 1892. Letters in the RPS Document Archive: Robinson to Bird, 13 and 16 December 1891; Sawyer to Bird, 2 June 1892; Mackie to Johnston, 1923–31; Mantell to Mackie, 16 July 1931.

16 MFH, *The Linked Ring*, pp. 82–4.

17 RPS Archive. A copy of the information sheet is in 'The Book of the Linked Ring', being a record of meetings, business transacted and decisions made by the Links.

18 'Our leaders, no. 25: Henry P. Robinson', *PP*, vol. VI, March 1895, pp. 65–6.

19 Ibid., p. 70.

20 *Tunbridge Wells Journal*, 26 June 1889.

21 HPR, *Elements of a Pictorial Photograph*, p. 123.

22 *Newcastle Chronicle*, 25 Janury 1892: Report on lecture given at Tyneside Sunday Lecture Society.

23 *Newcastle Chronicle*, 28 January 1892: Letter from Sawyer.

24 HPR, *Picture Making by Photography*, pp. 110–11.

25 HPR, *Elements of a Pictorial Photograph*, pp. 57–8.

26 The grave is registered as Plot B 15131.

27 Including *BJP*, 1 March 1901: 'Death of Mr Robinson'; *AP*, 1 March 1901, pp. 163–4: 'In memoriam (H. P. Robinson); *AP*, 8 March 1901: 'Notes and comments on H. P. Robinson'; *PN*, 1 March 1901: 'Obituary Notice: H. P. Robinson'.

Appendix I

CONCISE CHRONOLOGY

1830 Henry Peach Robinson (hereafter HPR) born 9 July at Linney, Ludlow, Shropshire, to John Robinson, schoolmaster, and his wife Eliza, née Peach. Baptized the same day at parish church of St Laurence, Ludlow, where parents were married on 11 August 1820.

1832 Frederick Herbert Gossage born on 16 November.

1834 Robinson family moved to house in Corve Street, Ludlow. Second child, a daughter, born to John and Eliza and baptized Clara on 15 June.

1835 HPR sent to Misses Tomkins's school (a Dame's school), in Middleton, three miles from Ludlow as boarder for one year.

1836 HPR attended Horatio Russell's Academy, Mill Street, Ludlow as day scholar for seven years.

Frederick Henry Messer born, third child of Frederick and Fanny Peach Messer (sister of Eliza Robinson).

1838 Walter Vickerstaff Messer born 17 July, fourth child of Frederick and Fanny Messer.

Selina Grieves born 20 July, fourth daughter of John E. Grieves, chemist of Ludlow, and his wife Elizabeth. (Selina became the wife of Henry Peach Robinson.)

1839 Second daughter born to John and Eliza Robinson. Baptized Anne on 5 February. Lived eight months only; buried on 30 October.

1841 Robinson family moved to house in Mill Street, Ludlow. Employed domestic servant.

1842 Fanny Maria Messer born. Sixth child and only daughter of Frederick and Fanny Messer. Became one of Henry Peach Robinson's early models, but died in 1863, aged only twenty-one.

1843 HPR finished schooling aged thirteen. Allowed one year to practise drawing and painting.

1844 On 20 May HPR went to Richard Jones – printer, stationer, bookseller – 5, Broad Street, Ludlow, to study trades of printing and bookselling. On birthday, 9 July, aged fourteen, indentured to Richard Jones for five years.

Read and influenced by *Modern Painters*, Vol. 1 by John Ruskin and *Burnet on Composition*.

1845 Fourth child of John and Eliza Robinson, born 9 July, baptized Herbert John 11 July. Known in family as 'Bob'.

First literary production by HPR and engraving of his pencil drawing of Ludlow Castle, reproduced in November issue of *Illustrated London News*.

Wealthy art patron tried to buy HPR out of his indentures in order to send him to London to study art. His employer refused the offer. HPR bitterly disappointed.

1846 Fanny Peach Messer, aunt of HPR, died aged thirty-four.

HPR and William Ward Gill, landscape painter, became 'constant companions' during the years of Henry's apprenticeship and after.

1847 F. H. Gossage, aged fifteen, apprenticed to J. R. Marston, Ludlow chemist.

1848 *The Lovers' Quarrel*, a literary piece by HPR, published under the pseudonym of H.J. in the *World of Fashion* on 1 July.

'Ludlow Castle' illustrated, by engraving of pencil drawing by HPR, published in the *London Journal* on 15 July. On 22 December he finished watercolour drawing of Castle Street, Ludlow, priced 12*s*., for Mr. S. Stead.

1849 *Illustrated London News* reproduced sketch and description of Wigmore castle by HPR on 3 March. He made a 'coloured drawing' of the newly discovered original reredos in Ludlow parish church as reported in the *Literary Gazette*, 21 April.

Robinson family moved house to Dinham, Ludlow.

On nineteenth birthday, 9 July, HPR celebrated last day of his apprenticeship.

1849–50 Given time in which to further study of drawing and painting after rigours of apprenticeship.

Assisted Blackburn, sculptor, in the restoration of the reredos in Ludlow parish church.

Took an interest in historical costume design, and in December designed two costumes as worn in early part of Charles II's reign.

1850 On 27 November Robinson arrived in Bromsgrove to take up first employment, as assistant to Benjamin Maund, FLS, bookseller and distinguished botanical author.

1851 Visiting daguerreotypist took his portrait. Learnt process from practitioner, acquiring materials with which to experiment.

Went to London with mother on 26 August, travelling on the Birmingham Coach, for a week of sightseeing.

On 1 September joined Whittaker & Company, Booksellers and Publishers, Paternoster Row, London, to extend experience of publishing. Was engaged as collector.

1851–2 During year began experiments with photogenic drawing and calotype process. Exposed first piece of sensitized paper in a 'cigar box and spectacle lens' camera.

1852 HPR's oil painting *On the Teme near Ludlow* exhibited in the annual exhibition of the Royal Academy.

In November left London and went to Ludlow for the winter.

1853 In spring took job with bookseller in Brighton but not satisfactory. Left Brighton, and became employed by the bookseller's former partner in Leamington Priors. Found situation very congenial and was employed in bookselling and publishing until middle of 1856.

1853–5 Subscribed to *Journal of the Photographic Society* from its commencement and became very enthused by photography, working the calotype process from Dr Diamond's directions in the *Journal*. Also practised collodion process with success.

1854 Visited by Dr H. W. Diamond, who had seen his photographs of children. Encouraged by Diamond's enthusiasm, decided to prepare to practise photography as livelihood. 'From that day my life has been devoted to photography as a business, and as an art; a hobby and a devotion.' Spent all the time he could afford at weekends at Dr Diamond's house in Wandsworth, London, learning photography.

1855 John Robinson died 7 February. Henry assumed responsibilities as head of household, taking care of mother, sister and young brother. Moved home to Castle Street, Ludlow, at which Eliza and Clara Robinson ran a small school.

HPR took a number of photographs of Leamington and locality, using collodion process, which sold well at 4*s*. each.

1856 Mary Annie (Marianne) Bibby, Robinson's first childhood sweetheart, married Henry Asterley and went to live on remote farm in Montgomeryshire.

Robinson's photograph of Guy's Cliffe, Warwickshire (large ancestral mansion in parkland) included in the Photographic Exchange Club's Album bearing inscription: '06.30 a.m. 1856. My first landscape. HPR'.

In autumn HPR rented 15, Upper Parade, Leamington, at £80 a year, for use as home and business premises and built studio in garden. Brought his family from Ludlow to live with him. On 13 December the *Leamington Courier* carried notice of the opening of a 'Photo-

graphic Institution' by H. P. Robinson, at 15, Upper Parade, Leamington Spa.

1857 Photography studio opened to public on 12 January at 15, Upper Parade, Leamington, with Walter Vickerstaff Messer, cousin aged nineteen, as assistant.

Exhibited *Mr Werner as Richelieu*, and other photographs, in March and commenced a series of narrative studies on the Passions.

Elected member of the Photographic Society of London.

1858 With Nathaniel Meridew published a book for one guinea: *Warwickshire Illustrated, a History of some of the most remarkable places in the County of Warwick, illustrated by a choice series of photographic views taken by the Collodio-Albumen process by Henry Peach Robinson (member of the Photographic Society)*.

Discouraged by limited demand for portraits, advertized business for sale in spring, but no potential buyers.

In April took negatives for first major composite photograph, *Fading Away*. After two month's hard work succeeded in making a good print, which was exhibited at Crystal Palace in autumn and afterwards at Leeds in connection with the British Association. Publicity derived from *Fading Away* and other exhibition pictures greatly increased demand for HPR's portraits. George R. Gill, boyhood friend, described as 'eminent miniature painter', employed to finish Robinson's studio portraits in colour.

In October–November HPR suffered from partial blindness but recovered in time to resume full business activities in December.

1859 HPR married Selina Grieves, daughter of Grieves, chemist of Ludlow, in February.

Elected to serve on Collodion Committee of the Photographic Society in March.

Eliza Robinson (HPR's well-loved mother) died 25 June. Her will, made 31 January, left entire estate to HPR, making him sole executor.

Exhibitions of photographs displayed on premises stimulated business, which prospered. Anticipated the cartes-de-visite craze, and re-equipped studio for their production.

On 16 July *Leamington Courier* announced: 'Mr Robinson has made arrangements for taking instantaneous portraits of animals in the best style and of any size' to coincide with Royal Agricultural Show at Warwick.

1860 Clara Robinson married Frederick Herbert Gossage on 5 January at Widnes, Lancashire.

In spring first child born to Henry and Selina Robinson, and baptized Edith.

A most successful year, owing to demand for cartes-de-visite. Awarded first medal for exhibition photograph *Here They Come!* Composite photograph of the year, *A Holiday in the Wood*, exhibited in autumn.

Walter Messer left HPR in December, complaining of ill-health caused by fumes of chemicals used in photography. Sailed for New Zealand in January 1861. HPR's own health began to suffer from overwork.

1861 Boom in cartes-de-visite increased, sitters ordering portraits by the hundred instead of the usual twenty.

Census return for Leamington, 1861, records names of three photographic assistants in household: two young women and Henry's brother Bob, aged fifteen; and two house servants.

Major composite photograph of year, *The Lady of Shalott*.

Second child born to Henry and Selina Robinson and baptized Ralph Winwood on 11 September.

1862 HPR elected member of Council of the Photographic Society of London (renamed: of Great Britain in 1874) on which he served for thirty years.

Member of the Jury (Photographic Section) for the Great International Exhibition at the Crystal Palace, Sydenham.

Major composite photograph of year, *Bringing Home the May*, printed from nine separate negatives, 38 cm high × 102 cm wide. 'My most ambitious effort, but perhaps not my best picture.'

Ambitious business and artistic projects made larger premises imperative. In October HPR announced in press that 15, Upper Parade was 'To Let'. On 29 November the *Leamington Courier* announced: 'In removing from No. 15 to No. 16, Upper Parade, Mr Robinson has availed himself of the opportunity to

build one of the most complete suites of rooms for photographic purposes in the kingdom . . . open from Nine till Six'. There was also a stable and 'every accommodation for photographing horses'.

1862 Third child born to Henry and Selina Robinson early in December and baptized Maud on 4 January 1863. She became one of his favourite child models.

At year end health once again affected by tensions and overwork.

1863 Major composite photograph of year, *Autumn*.

1864 On 25 May fourth child born to Henry and Selina Robinson and baptized Ethel May.

HPR suffered serious breakdown in health, blaming prolonged overwork and constant intake of fumes of ether and collodion (used in photography) for the nervous disorder to which he succumbed.

On 17 December, in the *Leamington Courier*, Robinson obliged to 'inform his patrons and friends that in consequence of ill-health he has been compelled to relinquish his duties as a Photographer'.

1865 Robinson family went to live at 68, Canonbury Park South, north London, to be near Henry's friend, George Wharton Simpson, editor of *Photographic News*, who lived in the same road. Whilst in poor health he assisted with editing of *Photographic News*, 'as a recreation' and wrote intensively on photography, his articles being published in the *Journal of the Photographic Society*, *The Practical Photographer*, *Humphrey's Journal*, *British Journal of Photography*, as well as *Photographic News*.

1866 Invited by HPR, seven 'gentlemen connected with photography' met on 12 February to dine at Blanchards, Beak Street, and then adjourned to 236, Regent Street, the studio of T. R. Williams, to form the Solar Club.

As his health began to improve, HPR set up a 'private studio' at 68, Canonbury Park South and continued with the production of photographs for exhibitions, and a limited number of portraits.

1867 Concentrated on writing first and most influential book: *Pictorial Effect in Photography*.

In making a good recovery from illness,

began to investigate suitable places in which to open another professional photography studio.

Exhibited major composite picture: *Sleep*.

1868 Decided to set up photography business in Tunbridge Wells, Kent. Installed family in 5, Belvedere Terrace (later named Church Road), in early months of year. Persuaded by wife, he acquired business partner, Nelson King Cherrill, member of the Photographic Society of London and talented photographer of landscape, who was trained as a civil engineer. Together they set up a studio at 1, Grove Villas, Upper Grosvenor Road, and conducted their business there from 1868 to 1871.

Pictorial Effect in Photography was published in instalments in *Photographic News*.

Composite photograph *Watching the Lark, Borrowdale* exhibited in autumn under signatures of Robinson and Cherrill.

1869 *Pictorial Effect in Photography*, with added chapter on 'Combination Printing', published in volume form (1st edn). Thirteen editions and reprints published, including translations in French and German, in later years.

HPR commissioned the building of 2, Queen's Road, Tunbridge Wells, as permanent residence for himself and family. Building commenced 1869 and completed in 1871.

1870 Elected Vice-President of Photographic Society of London.

1871 Robinson and Cherrill moved to impressive new business premises in North Wing of the Public Buildings (later called The Great Hall) opposite Tunbridge Wells Station in Mount Pleasant, which they called the Great Hall Studio.

Robinson household moved to their new home: 'Winwood', 2, Queen's Road, Tunbridge Wells.

1872 Fifth and youngest child born to Henry and Selina Robinson and baptized Leonard Lionel. In adult life he became Borough Engineer for Hackney, and married Kathleen Bell. He died in 1944.

1872–5 Business prospered. Exhibition pictures made during this period signed by both photographers: H. P. Robinson and N. K. Cherrill. Many medals awarded to them, and to Robinson alone for photo-

graphs prior to 1868.

Robinson continued to write for photographic press, give lectures, act as adjudicator and advise photographers, both professional and amateur. Cherrill also wrote numerous articles for photographic press 1865–80, and gave lectures.

1874　Clara Gossage, HPR's sister, died in childbirth.

1875　Late in year HPR and Cherrill dissolved partnership for reasons unknown, but it is certain that the business could no longer support two high salary earners.

1876　Whilst Robinson remained in business at the Great Hall Studio, Cherrill sailed for Australia in January. He moved to Christchurch, New Zealand, in 1877 and practised photography there until 1881, when he returned to England.

Robinson's painting *A Quiet Evening in October* exhibited in Art Gallery of Westminster Aquarium, London, in January.

HPR's brother Herbert John (Bob) married Agnes Esther Tate, youngest daughter of Sir Henry Tate, on 26 October. Bob Robinson died in 1906.

1877　Major composite photograph of year, *When the Day's Work is Done*, one of his most popular and successful photographs.

1879　Edith Robinson's painting on china exhibited at Howell & James Galleries in Regent Street, London, in June.

c.1880　HPR sent his two younger daughters, Maud and Ethel, to a finishing school in Germany.

1880–4　The Robinson, Gossage and Tate families enjoyed holidays in North Wales where house parties were held at the country residence of Sir Henry Tate, at Gelligynan, and the shooting lodge rented by F. H. Gossage at Gwysaney. Robinson took many photographs on these occasions, which were carefully composed studies of figures in landscape.

1881　*The Art and Practice of Silver Printing* published. The joint authors were H. P. Robinson and Captain W. Abney.

1884　His book *Picture Making by Photography* published.

1885　His book *The Photographic Studio and What to Do in It* published.

Major composite picture of year, *Dawn and Sunset*, widely acclaimed a great success. *Hope Deferred* was also a popular picture.

Suffered illness resulting in severe operation from which he took a long while to recover.

1886　Ralph Winwood Robinson summoned to help run the business. A dutiful son, Ralph gave up his own career as analytical chemist in the Gossage works at Widnes to join his father at the Great Hall Studio, Tunbridge Wells.

HPR attended the second annual soirée of the Tunbridge Wells 'Natural History and Antiquarian Society' to which he contributed oil paintings and etchings.

1887　Ralph Winwood Robinson married Janet Spence Reid, daughter of John Robertson Reid, RA, one of Robinson's artist friends. They had four children, all girls.

Tunbridge Wells Amateur Photographic Association founded in January. Both Henry and Ralph Robinson were founder members.

Five leather-bound volumes in the County Library, Tunbridge Wells, are inscribed on the covers; 'Tunbridge Wells in the Jubilee Year, portraits of some of the residents in 1887 photographed by H. P. Robinson, Great Hall Studio, in platinotype.' The first portrait is Chairman of the Local Board, the last of Robinson himself.

1888　HPR decided that the time had come for him to retire from business (he was fifty-eight). He relinquished the Great Hall Studio, and the premises were acquired by Cox & Durrant. In 1892 the Studio was occupied by Paul Lankester, a distinguished professional photographer.

Maud Robinson married Dr George Craigie Bell on 28 August at St John's Church, Tunbridge Wells. He was twenty-seven and she was twenty-five. He was a surgeon from Leytonstone, who became an eminent practitioner in Tunbridge Wells.

HPR's *Letters on Landscape Photography* published.

Ralph Winwood Robinson acquired premises in Redhill, Surrey, for the professional practice of photography and established 'H. P. Robinson & Son' in the Rembrandt Studio. He specialized in portraits and animal photography. His wife, a keen photographer, worked with him in the business. He was also assisted in later years by his daughter, Margaret Winwood Robinson.

1890	HPR continued active participation in photography by taking photographs, writing books and articles, and judging exhibitions. He was a prolific exhibitor.

Photography as a Business serialized in the *Practical Photographer* magazine, from January to December.

1891 At October Council meeting of the Photographic Society of Great Britain, Robinson (a Vice-President) was censured for the part he played in the selection of the annual exhibition. This was followed by Robinson and Davison seceding from the Society.

1892 On 9 May Robinson met together with Lyonel Clark, George Davison, H. H. Cameron and Alfred Maskell at the Restaurant d'Italie in Old Compton Street, Soho, London, to form an association which was named 'The Linked Ring'. On 27 May, fifteen founder members (including those named above) met at the Camera Club to agree the proposed constitution.

In late spring Edith Robinson (HPR's eldest daughter) married Dr George Abbott. She was thirty-two. He was sixteen years her senior. He was a medical man and a specialist in ophthalmology, also a distinguished geologist and a celebrity in Tunbridge Wells. Their home was at 2, Rusthall Park. They had no children but adopted an Italian boy who achieved a Master of Arts degree in Mathematics. He was lost 'presumed dead' in the 1914–18 war.

1893–c.1900 Robinson played a prominent part in the Photographic Salon, the annual exhibition of the Linked Ring, acting as Chairman of the Judges, with responsibility for the display and hanging of the exhibits.

1895 HPR's *Art Photography in Short Chapters* was published in the *Amateur Photographer Library* series.

A member of the Photographic Convention held in Shrewsbury, HPR took pride in showing other members round the old haunts of his native town of Ludlow.

1896 HPR's book *Elements of a Pictorial Photograph* published.

HPR was President of the Photographic Convention at Leeds. He exhibited several pictures of yachts, sea and water, taken whilst on holiday in Scotland, with a Kodak hand camera, such as *Atlanta*, and *In Holy Loch*.

1899 One of the most appealing of his photographs taken in later years, *Old Dapple*, exhibited.

1900 HPR unanimously elected as Honorary Fellow of the Royal Photographic Society 'in consideration of his services to photography and to the Society in the past'.

He suffered a paralytic seizure and was housebound for many months.

1901 HPR died on 21 February, aged seventy, following the paralysis which had assailed him the previous year. He was buried in the Ben Hall Road Cemetery, Tunbridge Wells. The headstone of the grave was designed and carved by him in the style of the lintel carving over the front door of 'Winwood', 2 , Queen's Road, Tunbridge Wells. All the living members of his family attended the funeral as well as other relatives and many friends. Later in the year his son Ralph reprinted all his father's best exhibition pictures in platinotype, as a memorial to him, and offered them for sale to the public.

1909 Selina Robinson died on 7 September.

1924 Ralph Winwood Robinson gave a quantity of HPR's photographs, including the giant glass negatives prepared for combination printing, to the Royal Photographic Society.

1932 'Winwood', Queen's Road, sold after death of Ethel May Robinson on 9 April.

1942 Ralph Winwood Robinson died on 11 April.

1944 Margaret Winwood Robinson closed Rembrandt Studio in Redhill but continued photographic practice of H. P. Robinson & Son at their Guildford branch..

Janet Robinson died on 27 October.

1945 Margaret Robinson retired and sold goodwill of H. P. Robinson & Son outright. New owners permitted to trade under name for seven years, after which the firm by this name ceased to exist.

1952 Edith Abbott (HPR's eldest daughter) died, aged ninety-two. She possessed a fine collection of her father's works: paintings, drawings, books, as well as photographs. The majority of these items were acquired by Helmut Gernsheim for his collection, which is now in the Harry Ransom Humanities Research Center, the University of Texas at Austin, USA.

Appendix II

COMBINATION PRINTING

The following extracts have been taken from this final chapter in Pictorial Effect in Photography *by H. P. Robinson to convey his working methods as far as possible.*

Combination Printing [*is*] a method which enables the photographer to represent objects in different planes in proper focus, to keep the true atmospheric and linear relation of varying distance, and by which a picture can be divided into separate portions for execution, the parts to be afterwards printed together on one paper, thus enabling the operator to devote all his attention to a single figure or sub-group at a time, so that if any part be imperfect for any cause, it can be substituted by another without loss of the whole picture, as would be the case if taken at one operation. By thus devoting the attention to individual parts, independently of the others, much greater perfection can be obtained in details, such as the arrangement of draperies, refinement of pose, and expression.

Perhaps the greatest use to which combination printing is now put is in the production of portraits with natural landscape backgrounds . . . In the figure negative, everything should be stopped out, with the exception of the figure, with black varnish; this should be done on the back of the glass when practicable, which produces a softer join; but for delicate parts – such as down the face – where the joins must be very close, and do not admit of anything approaching to vignetting, the varnish must be applied on the front. A much better effect than painting out the

background of the figure negative is obtained by taking the figure with a white or very light screen behind it; this plan allows sufficient light to pass through the background to give an agreeable atmospheric tint to the distant landscape; and stopping out [*with black varnish*] should only be resorted to when the background is too dark, or when stains or blemishes occur, that would injure the effect. An impression [*print*] must now be taken which is not to be toned or fixed. Cut out the figure, and lay it, face downwards, on the landscape negative in the position you wish it to occupy in the finished print. It may be fixed in its position by gumming the corners near the lower edge of the plate. It [*the landscape negative*] is now ready for printing. It is usually found most convenient to print the figure negative first. When this has been done, the print must be laid down on the landscape negative so that the figure exactly covers the place prepared for it by the cut-out mask. [*At this stage the image was clearly visible on the printing paper. No chemical development was needed.*] When printed [*the two negatives onto one sheet of paper*], the picture should be carefully examined, to see if the joins may be improved or made less visible. It will be found that, in many places, the effect can be improved and the junctions made more perfect, especially where a light comes against a dark – such as a distant landscape against the dark part of a dress – by tearing away the edge of the mask covering the dark, and supplying its place by touches of black varnish at the back of the negative; this, in printing, will cause the line to

be less defined, and the edges to soften into each other. If the background of the figure negative has been painted out, the sky will be represented by white paper; and as white paper skies are neither natural nor pleasing, it will be advisable to sun it down. [*Give a short exposure of the 'sky' to light, whilst the rest of the print is shielded from it. An alternative procedure was to obtain a light-toned background for the figure negative, so that it printed to a grey, not white. A piece of tissue paper with clouds painted on it with indian ink was then attached to the negative, the outline corresponding with that of the landscape on the second negative. When the 'figure' negative was printed the cloud effect was visible, leaving a middle area blank into which the landscape was printed from the second negative. This procedure was followed by Robinson and Cherrill for* Watching the Lark, Borrowdale *(plate 69).*]

If a full figure be desired, it will be necessary to photograph the ground with the figure, as it is almost impossible to make the shadow of a figure match the ground on which it stands in any other way. This may be done either out of doors or in the studio. The figure taken out of doors would, perhaps, to the critical eye, have the most natural effect, but this cannot always be done, neither can it be, in many respects. done so well. The light is more unmanageable out of doors, and the difficulty arising from the effect of wind on the dress is very serious. A slip of natural foreground is easily made up in the studio; the error to be avoided is the making too much of it. The simpler a foreground is in this case, the better will be the effect.

The composition of a group should next engage the student's attention. In making a photograph of a large group, as many figures as possible should be obtained in each negative, and the position of the joins so contrived that they shall come in places where they will be least noticed, if seen at all. It will be found convenient to make a sketch in pencil or charcoal of the composition before the photograph is commenced. The technical working out of a large group is the same as for a single figure; it is, therefore, not necessary to repeat the details.

Robinson then referred to his composite photograph Autumn *(plate 60), which he used to illustrate his methods because*

the junctions are more plainly visible . . . than in my recent productions.

A small rough sketch was first made of the idea . . . Other small sketches were then made,

modifying the subject to suit the figures available as models, and the scenery accessible . . . From these rough sketches a more elaborate sketch of the composition, pretty much as it stands, and of the same size, was made, the arrangement being divided so that the different portions may come on 15 by 12 plates, and that the junctions may come in unimportant places, easy to join, but not easy to be detected afterwards. The separate negatives were then taken. The picture is divided as follows. The first negative taken includes the four figures to the left, the tree trunks, and stile, with the wheat sheafs and ground immediately under them. The join runs round the edges of the figures, and down the foreground, where it is rather clumsily vignetted into the next negative, consisting of the remaining figure and the rest of the foreground. The landscape is in two pieces, vignetted into each other just over the arm of the girl with the hand to her head, the only place where they come in contact.

At first sight, it will appear difficult to place the partly-printed pictures in the proper place on the corresponding negative. There are many ways of doing this . . . Sometimes a needle may be run through some part of the print, the point being allowed to rest on the corresponding part of the second negative. The print will then fall in its place at that point. Some other point has then to be found at a distance from the first; this may be done by turning up the paper to any known mark on the negative, and allowing the print to fall upon it; if the two separate points fall on the right places, all the others must be correct. Another way of joining the prints from the separate negatives is by placing a candle or lamp under the glass of the printing-frame – practically, to use a glass table – and throwing a light through the negative and paper, the join can then be seen through. But the best method is to make register marks on the negatives. This is done in the following manner. We will suppose that we wish to print a figure with a landscape background from two negatives, the foreground having been taken with the figure. At the two bottom corners of the figure negative make two marks with black varnish, thus 'L' 'L'; these, of course, will print white in the picture. A proof is now taken, and the outline of the figure cut out accurately. Where the foreground and background join, the paper may be torn across, and the edges afterwards vignetted with black varnish on the back of the negatives. This mask is now fitted in its place on the landscape negative.

Another print is now taken of the figure negative, and the white corner marks cut away very accurately with a pair of scissors. The print is now carefully applied to the landscape negative, so that the mask entirely covers those parts of the print already finished. The landscape is then printed in. Before, however, it is removed from the printing-frame, if, on partial examination, the joins appear to be perfect, two lead pencil or black varnish marks are made on the mask round the cut-out corners at the bottom of the print. After the first successful proof there is no need for any measurement or fitting to get the two parts of the picture to join perfectly; all that is necessary is, merely to cut out the little white marks, and fit the corners to the corresponding marks on the mask; and there is no need to look if the joins coincide at other places, because, if two points are right, it follows that all must be so. This method can be applied in a variety of ways to suit different circumstances . . .

It is true that combination printing, allowing, as it does, much greater liberty to the photographer, and much greater facilities for representing the truth of nature, also admits, from these very facts, of a wide latitude for abuse; but the photographer must accept the conditions at his own peril. If he find that he is not sufficiently advanced in knowledge of art, and has not sufficient reverence for nature, to allow him to make use of these liberties, let him put on his fetters again, and confine himself to one plate.

ADDITIONAL SOURCES OF INFORMATION ON COMBINATION PRINTING

Journal of the Photographic Society, November/December 1868.

Photographic News, 18 December 1868, p. 601; 15 January 1869, p. 25: 'Combination printing'.

British Journal of Photography, 15 January 1869: Nelson K. Cherrill, 'On combination printing'.

Appendix III

SCHEDULE OF EXHIBITION PICTURES

ABBREVIATIONS AND CODES

*Denotes a composite photograph involving combination printing. No mention made of those photographs in which a sky from separate negative was combined with scene at printing stage.

†Denotes re-printing on sepia platinotype paper by R. W. Robinson, c.1902.

Collections:

HRHRC Gernsheim Collection in Harry Ransom Humanities Research Center, University of Texas at Austin, USA

IMP/GEH International Museum of Photography, George Eastman House, Rochester, USA

JPG John Paul Getty Museum, California, USA

MFH	Margaret F. Harker
MW	Michael Wilson
NGC	National Gallery of Canada
NMPFTV	National Museum of Photography, Film and Television, Bradford
PCL	Polytechnic of Central London
RPS	Royal Photographic Society
SM	Science Museum
SW	The Smithsonian Institution, Washington DC, USA
TW	Tunbridge Wells Museum and Art Gallery
VA	Victoria & Albert Museum, London

Date of production	Title/description	Negative & printing processes	Print size	Venue & date of first exhibition (where known)	Collection(s) (where known)
1852	The River Teme near Ludford Bridge, Ludlow	Oil painting	25.7 × 35.8 cm	Royal Academy of Art, London, 1852	HRHRC
1852	Night and Day	Oil painting			
1856	Guy's Cliffe, Warwickshire (plate 8)	Collodio-albumen, albumen	15.9 × 21 cm	Photographic Exchange Club Album, 1856–7	IMP/GEH, RPS
1857	On the Avon, Stoneleigh, Warwickshire (plate 7)	Collodio-albumen, albumen	19.1 × 24.1 cm	Photographic Exchange Club Album, 1856–7	IMP/GEH, RPS

Date of production	Title/description	Negative & printing processes	Print size	Venue & date of first exhibition (where known)	Collection(s) (where known)
1857	Mr Werner as Richelieu (plate 33)	Wet collodion, albumen	19.7 × 14 cm	Manchester Art Treasures Exhibition, 1857	RPS
1857★	Jenny (plate 44)	Wet collodion, albumen, sepia colour wash over sky	31.3 × 24.8 cm		RPS
1857	'I Know!' (two girls walking and chatting together)	Wet collodion, albumen		Photographic Exhibition at the Crystal Palace, 1858	
1857	Wild Flowers (little girl draped in wild flowers)	Wet collodion, albumen		Photographic Exhibition at the Crystal Palace, 1858	
1857	Child studies in form of vignettes in two frames (figure 13)	Wet collodion, albumen	Various small prints, vignetted	Photographic Exhibition at the Crystal Palace, 1858	RPS
1857	Juliet (young girl with phial of poison in hand contemplating death)	Wet collodion, albumen	21.6 × 16.5 cm	Photographic Society of London Exhibition, South Kensington, 1858	RPS
1857	The Passions: Vanity (plate 31)	Wet collodion, albumen	21.6 × 16.5 cm	Photographic Society of London Exhibition, South Kensington, 1858	MFH
1857	The Passions: Fear	Wet collodion, albumen	21.6 × 16.5 cm	Photographic Society of London Exhibition, South Kensington, 1858	
1857	The Passions: Devotion	Wet collodion, albumen	21.6 × 16.5 cm	Photographic Society of London Exhibition, South Kensington, 1858	
1857	The Passions: The Miniature (Love)	Wet collodion, albumen	21.6 × 16.5 cm	Photographic Society of London Exhibition, South Kensington, 1858	
1857	The Model (Miss Cundall) (figure 15)	Wet collodion, albumen	21.6 × 16.5 cm	Photographic Exhibition at the Crystal Palace, 1858	
1857	The Garland of Flowers (plate 29)	Wet collodion, albumen	21.6 × 16.5 cm	Photographic Exhibition at the Crystal Palace, 1858	MFH
1857	She Never Told Her Love (plate 45)	Wet collodion, albumen	17.8 × 24.1 cm	Photographic Exhibition at the Crystal Palace, 1858	RPS
1858–9	Mariana (figure 8)	Wet collodion, albumen	21.6 × 16.5 cm (approx.)	Photographic Society of London Exhibition, Pall Mall Gallery, 1859	

Date of production	Title/description	Negative & printing processes	Print size	Venue & date of first exhibition (where known)	Collection(s) (where known)
1858★†	Fading Away (plates 46/47)	Wet collodion, albumen	23.8 × 37.9 cm	Photographic Exhibition at the Crystal Palace, 1858	IMP/GEH, RPS
1858	The Story of Little Red Riding Hood (4 photographs; plates 48–51)	Wet collodion, albumen	24 × 19 cm (approx.)	Photographic Exhibition at the Crystal Palace, 1858	RPS (complete set)
1858–9	Lulu	Wet collodion, albumen		Photographic Society of London Exhibition, Pall Mall Gallery, 1859	
1858–9	Sulee (plate 53)	Wet collodion, albumen	24.3 × 20.1 cm	Photographic Society of France, Paris, 1859	MW
1858–9	The Cottage Window (family group of mother, baby and Sulee)	Wet collodion, albumen		Photographic Society of London Exhibition, Pall Mall Gallery, 1860	
1859★	A Cottage Home (plate 54)	Wet collodion, albumen	24.1 × 34.3 cm	Photographic Society of London Exhibition, Pall Mall Gallery, 1860	RPS
1859	Ludlow Castle	Wet collodion, albumen		Photographic Society of London Exhibition, Pall Mall Gallery, 1860	
1859	The Keep, Ludlow Castle	Wet collodion, albumen		Photographic Society of London Exhibition, Pall Mall Gallery, 1860	
1859	'Here They Come!' (group portrait of two girls in 'moorland' setting) (plate 32)	Wet collodion, albumen	24.1 × 20.3 cm	Photographic Society of Scotland Exhibition, Edinburgh, 1859/60	MFH
1859	Sour Apples	Wet collodion, albumen		Photographic Society of Scotland Exhibition, Edinburgh, 1859/60	
1859	Lavinia (girl in 'wheatfield')	Wet collodion, albumen		Photographic Society of Scotland Exhibition, Edinburgh, 1859/60	
1859	Norman Doorway, Ludlow Castle	Wet collodion, albumen		Photographic Society of Scotland Exhibition, Edinburgh, 1859/60	
1859★	Nearing Home (three girls resting on a mound, with Ludlow in distance)	Wet collodion, albumen		Photographic Society of London Exhibition, Pall Mall Gallery, 1860	Private

Date of production	Title/description	Negative & printing processes	Print size	Venue & date of first exhibition (where known)	Collection(s) (where known)
1859★	Preparing to Cross the Brook (two girls seated on bank beside stream; Whitcliffe, Ludlow in distance)	Wet collodion, albumen		Photographic Society of London Exhibition, Pall Mall Gallery, 1860	HRHRC
1859	The Gleaners (two girls resting in a wheatfield)	Wet collodion, albumen		Photographic Society of London Exhibition, Pall Mall Gallery, 1860	
1859	Ophelia (a girl with sprig of flowers in hand and wreath on head. The head printed from one negative, the body from another)	Wet collodion, albumen		Photographic Society of London Exhibition, Pall Mall Gallery, 1860	
1859–60	Portrait (a study in profile of young woman in sun bonnet with water jug; plate 43)	Wet collodion, albumen		Photographic Society of London Exhibition, Pall Mall Gallery, 1860	MFH
1859–60	Elaine Watching the Shield of Lancelot (plate 55)	Wet collodion, albumen	25.4 × 20.3 cm	British Association Exhibition, 1861	RPS, VA
1860★	A Holiday in the Wood (plate 38)	Wet collodion, albumen	50.3 × 60.4 cm	Photographic Society of London Exhibition, Pall Mall Gallery, 1861	IMP/GEH, RPS (single negative)
1860★	At the Top of the Hill (girl barefoot, with pitcher at feet, on sloping ground with River Teme from Whitcliffe, Ludlow in distance)	Wet collodion, albumen		Photographic Society of Scotland Exhibition, 1861	
1860	On the Hill-Top (plate 30)	Wet collodion, albumen	13.3 × 9.5 cm	An illustration in *Pictorial Effect in Photography* by H. P. Robinson, 1869	

Date of production	Title/description	Negative & printing processes	Print size	Venue & date of first exhibition (where known)	Collection(s) (where known)
1860	Early Spring (a river scene with country girl on bank in mid-distance)	Wet collodion, albumen	23 × 28 cm	British Association Exhibition, 1861	VA
1860–1*†	The Lady of Shalott (plate 52)	Wet collodion, albumen	31.8 × 52.1 cm	British Association Exhibition, 1861	RPS, HRHRC
1861	Shakespeare's House	Wet collodion, albumen			HRHRC
1861*	Somebody Coming (preliminary study for Autumn; plate 59)	Wet collodion, albumen	31.8 × 25.3 cm	Photographic Society of London Exhibition, Pall Mall Gallery, 1863	IMP/GEH, HRHRC
1861–3	Stoneleigh Deer Park, Warwickshire	Wet collodion, albumen		Royal Cornwall Polytechnic Society Exhibition, 1863	IMP/GEH
1862*†	Bringing Home the May (plate 58)	Wet collodion, albumen	38.8 × 100.3 cm	Royal Cornwall Polytechnic Society Exhibition, September 1862	RPS, HRHRC (small print)
1862	The May Queen (portrait vignette)	Wet collodion, albumen		Photographic Society of London Exhibition, Pall Mall Gallery, 1863	
1862	The May Gatherer (vignette) (plate 56)	Wet collodion, albumen		Photographic Society of London Exhibition, Pall Mall Gallery, 1863	SM
1862	A frame of cartes-de-visite portraits (said to be exquisite)	Wet collodion, albumen		Photographic Society of London Exhibition, Pall Mall Gallery, 1863	
1863*	Autumn (plate 60)	Wet collodion, albumen	36.8 × 57.8 cm	Photographic Society of London Exhibition, Pall Mall Gallery, 1864	RPS, HRHRC
1864–6	Down to the Well (plate 61)	Wet collodion, albumen	37 × 27.8 cm	Photographic Society of London Exhibition, Conduit Street Gallery, 1870	HRHRC
1864–6	Load of Ferns (plate 62)	Wet collodion, albumen	36.2 × 27.7 cm	Photographic Society of London Exhibition, Conduit Street Gallery, 1870	HRHRC
1864–6	Basket of Ferns (similar to plate 62 but another model)	Wet collodion, albumen	37 × 27.8 cm	Photographic Society of London Exhibition, Conduit Street Gallery, 1870	HRHRC
1864–6	Waiting for the Boat (plate 63)	Wet collodion, albumen	36.2 × 28.6 cm	Probably 1866–7	RPS

Date of production	Title/description	Negative & printing processes	Print size	Venue & date of first exhibition (where known)	Collection(s) (where known)
1864–6	On the Way to Market (plate 64)	Wet collodion, albumen	36.2 × 28.6 cm	Probably 1866–7	RPS
1864–6	A Mountain-Dew Girl: Killarney	Wet collodion, Woodburytype		*Photographic News* presentation print, 26 January 1866	
1864–6★	A Mountain-Dew Girl from the Gap of Dunloe, Killarney, Ireland	Wet collodion negative (original print unknown)	43 × 30.5 cm	Probably 1866–7	RPS (single negative)
1866★†	Sleep (plate 71)	Wet collodion, albumen	38.1 × 55.2 cm	Probably Photographic Society Exhibition, Conduit Street Gallery, 1867	HRHRC, TW, RPS
1867–8★	Returning Home (a country girl, with sheaf of gleanings under her arm, returning from a wheatfield to escape the approaching storm)	Wet collodion, albumen (printed from five negatives)	43 × 61 cm	Probably Photographic Society of London Exhibition, Conduit Street Gallery, 1868 'In many respects this is one of Mr Robinson's most successful pictures', *PN*, 18 Sept. 1868, p. 447	
1868★	Watching the Lark, Borrowdale (signed by Robinson and Cherrill; plate 69)	Wet collodion, albumen	24.4 × 20.1 cm	Photographic Society of London Exhibition, Conduit Street Gallery, 1868	HRHRC, NGC
1868–9★	Over the Sea (two children on bank overlooking sea, contre-jour lighting; two seagulls hover close to shore; signed by Robinson and Cherrill)	Wet collodion, albumen (printed from several negatives)	40.6 × 55.8 cm	London International Exhibition, 1871	HRHRC
1868–9	Seagulls (signed by Robinson and Cherrill)	Wet collodion, albumen	30.5 × 40.6 cm	Probably Photographic Society of London Exhibition, Conduit Street Gallery, 1869	RPS, HRHRC
1869–70	The First Hour of Night (seascape, dark tones	Wet collodion, albumen	25.4 × 45.6 cm	Probably Photographic Society of London Exhibition, Conduit Street Gallery, 1870	RPS, HRHRC

Date of production	Title/description	Negative & printing processes	Print size	Venue & date of first exhibition (where known)	Collection(s) (where known)
	throughout with full moon in upper half centre; signed by Robinson and Cherrill)				
1870	The Beached Margent of the Sea (signed by Robinson and Cherrill; plate 74)	Wet collodion, albumen	27.9 × 38.1 cm	London International Exhibition, 1871	RPS, HRHRC, JPG
1870★	The Trysting Tree (rustic maiden reclining near trunk of large tree)	Wet collodion, albumen (printed from four negatives)	39 × 55 cm	London International Exhibition, 1871	MFH
1870	Outward Bound (seascape; signed by Robinson and Cherrill)	Wet collodion, albumen		London International Exhibition, 1871	
1870–1	West Hill Farm (signed by Robinson and Cherrill)	Wet collodion, albumen		London International Exhibition , 1871	
1870–1	Breaking Waves (signed by Robinson and Cherrill)	Wet collodion, albumen		London International Exhibition, 1871	
1870–1	A Country Lane (signed by Robinson and Cherrill)	Wet collodion, albumen		London International Exhibition, 1871	
1870–1	Daybreak (signed by Robinson and Cherrill)	Wet collodion, albumen		London International Exhibition, 1871	
1870–1	Boxing a Butterfly (signed by Robinson and Cherrill)	Wet collodion, albumen		London International Exhibition, 1871	
1870–1	The Turn of the Tide (signed by Robinson and Cherrill)	Wet collodion, albumen		London International Exhibition, 1871	
1870–1	6.30 p.m. (signed by Robinson and Cherrill)	Wet collodion, albumen		London International Exhibition, 1871	

Date of production	Title/description	Negative & printing processes	Print size	Venue & date of first exhibition (where known)	Collection(s) (where known)
1868–70	Series of Landscapes near Tunbridge Wells by Robinson and Cherrill, including: Rusthall Common (plate 65), Evening on Culverden Down (plate 67), Landscape with Ferns (plate 66), The Haycart (plate 68)	Wet collodion, albumen (skies added at printing stage)	27.9 × 38.1 cm	Various exhibitions, notably one organized by Bengal Photographic Society, Dalhousie Institute, Calcutta, January 1871, at which a gold medal was awarded for this series	RPS, HRHRC, JPG
1871	The Bridesmaid (Miss Rose Harriet (Trotty) Crawshay)	Wet collodion, albumen	55.0 × 39.8 cm	Royal Cornwall Polytechnic Society Exhibition, Falmouth, 1871 (exhibited under pseudonym Ralph Ludlow)	
1871–2★	Waiting at the Stile (rustic maiden on stepping stones about to step onto stile; signed by Robinson and Cherrill)	Wet collodion, albumen	40.6 × 53.2 cm	Probably Photographic Society of Great Britain, Pall Mall East, London, 1872	
1871–2★	A Gleaner (signed by Robinson and Cherrill; plate 77)	Wet collodion, albumen	55.9 × 40.6 cm	Probably 1872	TW
1873★	Preparing Spring Flowers for Market (signed by Robinson and Cherrill; plate 78)	Wet collodion, albumen	55.9 × 77.5 cm	Probably Photographic Society of Great Britain, Pall Mall East, London, 1873	TW
1873	A Portrait Study (head and shoulders of girl in sun bonnet; signed by Robinson and Cherrill, figure 34)	Wet collodion, albumen	54 × 40.6 cm	Photographic Society of London, 1873	TW, RPS (single negative)

Date of production	Title/description	Negative & printing processes	Print size	Venue & date of first exhibition (where known)	Collection(s) (where known)
1875–7*†	When the Day's Work is Done (plate 79)	Wet collodion, albumen	53.7 × 76.4 cm	Photographic Society of Great Britain Exhibition, Pall Mall East, London, 1877	JPG, PCL, HRHRC, IMP/GEH, RPS, TW, VA
1876	A Quiet Evening in October	Oil painting		Westminster Aquarium Gallery	

PHOTOGRAPHS SELECTED FOR EXHIBITION FROM THE NORTH WALES 'FIGURES IN LANDSCAPE' SERIES

Gwysaney

1880	In Maiden Meditation Fancy Free	Silver gelatine, albumen	28 × 38 cm	Probably at Photographic Society of Great Britain, 1881	IMP/GEH
1880†	The Old Boat (plate 85)	Silver gelatine, albumen	28 × 38 cm	Probably at Photographic Society of Great Britain, 1881	MFH
1881	Her Ancestor (young lady in panelled room with oil paintings)	Silver gelatine, albumen	28 × 38 cm	Photographic Society of Great Britain, London, 1881	
1881†	Is it a Dog?	Silver gelatine, albumen	28 × 38 cm	Photographic Society of Great Britain, 1881	
1881†	Can I Jump It? (plate 93)	Silver gelatine, albumen	18 × 38 cm	Photographic Society of Great Britain, 1881	TW, RPS
1881†	The Swan	Silver gelatine, albumen	28 × 38 cm	Photographic Society of Great Britain, 1881	
1881†	Rook Shooting (plate 84)	Silver gelatine, albumen	28 × 38 cm	Photographic Society of Great Britain, 1881	RPS
1881†	'Here They Are!'	Silver gelatine, albumen	28 × 38 cm	Photographic Society of Great Britain, 1881	
1881†	A Talk with the Keeper	Silver gelatine, albumen	28 × 38 cm	Photographic Society of Great Britain, 1881	
1881	Visitors to the Hall	Silver gelatine, albumen	28 × 38 cm		NGC
1881†	Fishing	Silver gelatine, albumen	28 × 38 cm	Photographic Society of Great Britain, 1881	
1881†	Over Hedge and Ditch	Silver gelatine, albumen	28 × 38 cm	Photographic Society of Great Britain, 1881	
1881	The Keeper	Silver gelatine, albumen	28 × 38 cm	Photographic Society of Great Britain, 1881	RPS, NGC
1882†	A Merry Tale (figure 39)	Silver gelatine, albumen	28 × 38 cm	Photographic Society of Great Britain, 1882	IMP/GEH, RPS (pair of negatives)
1882†	Artist and Model	Silver gelatine, albumen	28 × 38 cm	Photographic Society of Great Britain, 1882	
1882†	Wayside Gossip (plate 87)	Silver gelatine, albumen	28 × 38 cm	Photographic Society of Great Britain, 1882	HRHRC, MFH, RPS (single negative)
1882†	'Hark! Hark! the Lark'	Silver gelatine, albumen	28 × 38 cm	Photographic Society of Great Britain, 1882	IMP/GEH, NGC

Date of production	Title/description	Negative & printing processes	Print size	Venue & date of first exhibition (where known)	Collection(s) (where known)
1882	'Will they never come!'	Silver gelatine, albumen	28 × 38 cm	Gold Medal, Edinburgh Photographic Society, 1882	
1882†	Thinking of Jack (girl seated on grass deep in thought)	Silver gelatine, albumen	28 × 38 cm	Photographic Society of Great Britain, 1882–3	
1882†	The Margin of the Lake	Silver gelatine, albumen	28 × 38 cm	Photographic Society of Great Britain, 1882–3	
1882†	Confidences (two girls beside stream talking together, seated)	Silver gelatine, albumen	28 × 38 cm	Photographic Society of Great Britain, 1882–3	HRHRC, RPS
1882†	Foxgloves and Ferns (small group in field gathering the flowers)	Silver gelatine, albumen	28 × 38 cm	Photographic Society of Great Britain, 1882–3	HRHRC, RPS, MFH
1882†	Her Ladyship (group in field curtseying to one of the girls)	Silver gelatine, albumen	28 × 38 cm	Photographic Society of Great Britain, 1882–3	
1882	The Skylark (figure 40)	Silver gelatine, albumen	28 × 38 cm	Photographic Society of Great Britain, 1882–3	
1882†	Coming down the Lane	Silver gelatine, albumen	28 × 38 cm	Photographic Society of Great Britain, 1882–3	
1882†	Paddlers (group gathered at lakeside)	Silver gelatine, albumen	28 × 38 cm	Photographic Society of Great Britain, 1882–3	HRHRC, RPS
1882†	The Skylark's Nest	Silver gelatine, albumen	28 × 38 cm	Photographic Society of Great Britain, 1882–3	
1882†	Mushroom Gatherers (plate 86)	Silver gelatine, albumen	28 × 38 cm	Photographic Society of Great Britain, 1882–3	
1882†	The Stanger	Silver gelatine, albumen	28 × 38 cm	Photographic Society of Great Britain, 1882–3	
1882†	Pamela (plate 70)	Silver gelatine, albumen	36.8 × 54.6 cm (print size)	Photographic Society of Great Britain, 1882–3	TW, RPS
1883†	'Under a Haycock fast Asleep'	Silver gelatine, albumen	28 × 38 cm	Photographic Society of Great Britain, 1883–4	

Gelligynan

1884†	The Music of the Birds	Silver gelatine, albumen	28 × 38 cm	Photographic Society of Great Britain, 1884–5	RPS (single negative)
1884†	Yn Cymraiy a Saesny (in	Silver gelatine, albumen	28 × 38 cm	Photographic Society of Great Britain, 1884–5	TW, RPS (single negative)

Date of production	Title/description	Negative & printing processes	Print size	Venue & date of first exhibition (where known)	Collection(s) (where known)
	Welsh and English) (plate 90)				
1884†	'Come Across'	Silver gelatine, albumen	28 × 38 cm	Photographic Society of Great Britain, 1884–5	
1884†	The Shortest Way in Summer-time (girl crossing stream on stepping stones, others watch)	Silver gelatine, albumen	28 × 38 cm	Photographic Society of Great Britain, 1884–5	RPS (print and single negative)
1884†	The Stream in Summer	Silver gelatine, albumen	28 × 38 cm	Photographic Society of Great Britain, 1884–5	
1884†	A Chat with the Miller	Silver gelatine, albumen	28 × 38 cm	Photographic Society of Great Britain, 1884–5	IMP/GEH, HRHRC, RPS (single negative)
1884†	'He Never Told His Love' (plate 89)	Silver gelatine, albumen	28 × 38 cm	Photographic Society of Great Britain, 1884–5	IMP/GEH, HRHRC, RPS (print and single negative)
1884†	Feeding the Calves (two girls in field with calves, sunset sky)	Silver gelatine, albumen	28 × 38 cm	Photographic Society of Great Britain, 1884–5	IMP/GEH, RPS (pair of negatives)
1884†	The Mill Door (plate 91)	Silver gelatine, albumen	28 × 38 cm	Photographic Society of Great Britain, 1884–6	RPS (single negative)
1884	'Come Along!' (figure 42)	Gelatine bromide, albumen	28 × 38 cm	Photographic Society of Great Britain, 1884–6	
1884†	Midsummer (cows in stream) (plate 88)	Gelatine bromide, albumen	28 × 38 cm	Photographic Salon Exhibition 1894	
1884†	'Loves me, Loves me Not'	Silver gelatine, albumen	28 × 38 cm	Photographic Society of Great Britain, 1884–6	
1884†	Creigiog Mill	Silver gelatine, albumen	28 × 38 cm	Photographic Society of Great Britain, 1884–6	
1884	Summer Evening	Silver gelatine, albumen	28 × 38 cm	Photographic Society of Great Britain, 1884–6	HRHRC
1884†	Trespassers	Silver gelatine, albumen	28 × 38 cm	Photographic Society of Great Britain, 1884–6	HRHRC

The two albums of photographs taken in North Wales at Gwysaney and Gelligynan are complete in a private collection.

Date of production	Title/description	Negative & printing processes	Print size	Venue & date of first exhibition (where known)	Collection(s) (where known)
OTHER PHOTOGRAPHS					

Date at left margin denotes first showing, if production date is not known. In a few instances, when out of date order, they are known to be the production dates.

Date of production	Title/description	Negative & printing processes	Print size	Venue & date of first exhibition (where known)	Collection(s) (where known)
1882	Thinking It Over	Silver gelatine, albumen	26.8 × 37 cm		
1883★†	A Nor'Easter (plate 96)	Silver gelatine, albumen	28 × 38 cm (plate size)	Photographic Society of Great Britain, 1883	MW (print), RPS (original pair of negatives)
1883★†	What Luck? (plate 40)	Silver gelatine, albumen	28 × 38 cm	Photographic Society of Great Britain, 1883	MFH (ceramic jardinière)
1884†	The Cuckoo (young woman with children beside a garden fence)	Silver gelatine, albumen	35.6 × 54 cm	Photographic Society of Great Britain, 1884	RPS, TW
1884★	Gossip on the Beach (figure 43)	Silver gelatine	33.5 × 63 cm	Photographic Society of Great Britain, 1884	RPS, HRHRC
1885†	Teaching the Blackbird	Silver gelatine, albumen	28 × 38 cm	Photographic Society of Great Britain, 1885	
1885★†	Dawn and Sunset (plate 80)	Silver gelatine, albumen	53.3 × 76.2 cm	Photographic Society of Great Britain, 1885	IMP/GEH, HRHRC, RPS
1885†	The Valentine (plate 81)	Silver gelatine, albumen	55.9 × 42.6 cm	Photographic Society of Great Britain, 1885	RPS
1885†	Who Could Have Sent It? (same theme as The Valentine)	Silver gelatine, albumen	55.9 × 42.6 cm	Photographic Society of Great Britain, 1885	TW
1885★†	Hope Deferred (interior: boy playing with dog)	Silver gelatine, albumen	55.9 × 42.6 cm	Issued as supplement to *Photographic News*, 23 October 1885. Awarded Gold Medal at International Photographic Exhibition, Oporto, Portugal, April 1886	
1885†	A Normandy Peasant (interior)	Silver gelatine, albumen	26.8 × 37 cm	Photographic Society of Great Britain, 1885–6	
1885†	Peeling Potatoes (interior)	Silver gelatine, albumen	26.8 × 37 cm	Photographic Society of Great Britain, 1885–6	
1887★†	Carolling (plate 82)	Silver gelatine, platinum	33 × 63.5 cm	Photographic Society of Great Britain, 1887	RPS, TW, HRHRC, IMP/GEH
1887	A Preliminary Study for Carolling (vertical format)	Silver gelatine, silver gel	46.3 × 33.2 cm		HRHRC

Date of production	Title/description	Negative & printing processes	Print size	Venue & date of first exhibition (where known)	Collection(s) (where known)
1888†	The Lobster Boat (plate 101)	Silver gelatine, black platinum	36.8 × 62.2 cm	Photographic Society of Great Britain, 1888	TW
1888	The Rick	Silver gelatine, platinum	26.8 × 37 cm	Photographic Society of Great Britain, 1888	
1888	The Launch of the Deal Galley Punt	Silver gelatine, platinum	26.8 × 37 cm	Photographic Society of Great Britain, 1888	
1888†	A Cowslip-ball	Silver gelatine, platinum	26.8 × 37 cm	Photographic Society of Great Britain, 1888	
c.1890	Sheep Grazing at Twilight	Silver gelatine, platinum	26.8 × 37 cm		
1890★†	A Strange Fish (figure 36)	Silver gelatine, platinum	31.5 × 49.1 cm	Photographic Society of Great Britain, 1890	RPS
1890†	Trudging Homewards (two fishermen walking on riverside path)	Silver gelatine, platinum	31.5 × 49.1 cm	Photographic Society of Great Britain, 1890	HRHRC, RPS
1890†	Shrimping	Silver gelatine, platinum	30.5 × 45.6 cm	Photographic Society of Great Britain, 1890	
1890†	Shakespeare's Cliff	Silver gelatine, platinum	30.5 × 45.6 cm	Photographic Society of Great Britain, 1890	HRHRC
1890†	A Race with Grandad	Silver gelatine, platinum	30.5 × 45.6 cm	Photographic Society of Great Britain, 1890	
1890†	Cuckmere Haven	Silver gelatine, platinum	30.5 × 45.6 cm	Photographic Society of Great Britain, 1890	
1890†	Shades of Evening	Silver gelatine, platinum	26.8 × 37 cm	Photographic Society of Great Britain, 1890	
1890†	'Fair Falls the Eventide'	Silver gelatine, platinum	26.8 × 37 cm	Photographic Society of Great Britain, 1890	
1884†	Over the Hedge	Silver gelatine, platinum	26.8 × 37 cm	Photographic Society of Great Britain, 1890	
1884†	Moor-hens	Silver gelatine, platinum	26.8 × 37 cm	Photographic Society of Great Britain, 1890	
1884†	Stalking a Trout	Silver gelatine, platinum	26.8 × 37 cm	Photographic Society of Great Britain, 1890	
1884†	Selecting Flies	Silver gelatine, platinum	26.8 × 37 cm	Photographic Society of Great Britain, 1890	
1890†	'What is it?'	Silver gelatine, platinum	26.8 × 37 cm	Photographic Society of Great Britain, 1890	
1884†	Ferrying them over	Silver gelatine, platinum	26.8 × 37 cm	Photographic Society of Great Britain, 1890	
1884	May-fly Time	Silver gelatine, platinum	26.8 × 37 cm	Photographic Society of Great Britain, 1890	
1890†	The Shrimpers' Story	Silver gelatine, platinum	26.8 × 37 cm	Photographic Society of Great Britain, 1890	
1890†	Cockle-gatherers	Silver gelatine, platinum	26.8 × 37 cm	Photographic Society of Great Britain, 1890	

Date of production	Title/description	Negative & printing processes	Print size	Venue & date of first exhibition (where known)	Collection(s) (where known)
1890†	Preparing for Shrimping	Silver gelatine, platinum	26.8 × 37 cm	Photographic Society of Great Britain, 1890	
1891★†	Primrose Time (plate 95)	Silver gelatine, platinum	26.8 × 37 cm	Photographic Society of Great Britain, 1891	IMP/GEH, RPS (pair of negatives)
1891†	Through the Butter-burr	Silver gelatine, platinum	26.8 × 37 cm	Photographic Society of Great Britain, 1891	
*c.*1891★	The Gilly Flower (plate 97)	Silver gelatine, platinum	37 × 26.8 cm	Photographic Society of Great Britain, 1891	Copy negative in Kodak Collection, NMPFTV
1892†	The Rising Lark	Silver gelatine	48.3 × 33 cm		HRHRC
1893†	Morning Mist (plate 94)	Silver gelatine, platinum	45.7 × 33.2 cm	Photographic Salon, 1893	RPS
1893★†	Coming Boats (plate 100)	Silver gelatine, platinum	48.3 × 38.1 cm	Photographic Salon, 1893	HRHRC, SW
1893†	Wild Weather (young woman on beach walking against high wind)	Silver gelatine, platinum	48.3 × 38.1 cm	Photographic Salon, 1893	SW
1894	Mid-day	Silver gelatine, platinum	48.3 × 38.1 cm	Photographic Salon, 1894	
1894†	Ready for the Collier, Morning (plate 102)	Silver gelatine, silver gel	45.1 × 36.2 cm	Photographic Salon, 1894	HRHRC, SW
1894†	Summertime	Silver gelatine, platinum	48.3 × 38.1 cm	Photographic Salon, 1894	
1894†	Storm Clearing Off (sheep on pastureland beneath a stormy sky)	Silver gelatine, platinum	48.3 × 38.1 cm	Photographic Salon, 1894	RPS
1895†	In Kilbrennan Sound (plate 75)	Silver gelatine, platinum	10.8 × 19.1 cm	Photographic Salon, 1895	RPS, MFH
1895†	Off Arran (plate 76)	Silver gelatine, platinum	30.5 × 45.7 cm	Photographic Salon, 1895	HRHRC, TW
1895†	Rusthall Quarry	Silver gelatine, platinum	38 × 48.3 cm	Photographic Salon, 1895	HRHRC, MFH
1895	A Watering Place	Silver gelatine, platinum	38 × 48.3 cm	Photographic Salon, 1895	
*c.*1885	At Sunset Leaps the Lusty Trout (plate 92)	Silver gelatine, black platinum	48.3 × 38 cm	Photographic Salon, 1895	HRHRC
1895	Portrait of Henry Moore, RA	Silver platinum, platinum	48.3 × 38 cm	Photographic Salon, 1895	
1896†	Returning to the Fold	Silver gelatine, platinum	48.3 × 38 cm	Photographic Salon, 1896	

Date of production	Title/description	Negative & printing processes	Print size	Venue & date of first exhibition (where known)	Collection(s) (where known)	
1896		A Gleam after Rain (sheep)	Silver gelatine, platinum	48.3 × 38 cm	Photographic Salon, 1896	HRHRC
1896†	A Breeze of Morning Moves	Silver gelatine, platinum	26.8 × 37 cm	Photographic Salon, 1896	HRHRC	
1896†	Atlanta (plate 103)	Silver gelatine, platinum	26.8 × 37 cm	Photographic Salon, 1896	RPS, MFH	
1896†	Early Morning	Silver gelatine, platinum	26.8 × 37 cm	Photographic Salon, 1896		
1896†	A Silver Sea	Silver gelatine, black platinotype	26.8 × 37 cm	Photographic Salon, 1896	RPS	
1896†	The Harbour Mouth	Silver gelatine, platinum	26.8 × 37 cm	Photographic Salon, 1896		
1896†	Minding Sheep	Silver gelatine, platinum	26.8 × 37 cm	Photographic Salon, 1896		
1896†	In Holyloch	Silver gelatine, platinum	26.8 × 37 cm	Photographic Salon, 1896	HRHRC	
1897†	Geese and Goslings	Silver gelatine, black platinotype	48.3 × 38 cm	Photographic Salon, 1897	TW	
1897	Geese	Silver gelatine, black platinotype	48.3 × 38 cm	Photographic Salon, 1897		
1897	In Springtime	Silver gelatine, platinum	48.3 × 38 cm	Photographic Salon, 1897		
1897	A Strange Bird	Silver gelatine, platinum	48.3 × 38 cm	Photographic Salon, 1897	HRHRC	
1898†	A Bit of Old Ludlow	Silver gelatine, platinum	48.3 × 38 cm	Photographic Salon, 1898		
1898†	Noon-day Shade	Silver gelatine, platinum	48.3 × 38 cm	Photographic Salon, 1898		
1898†	Asking the Way	Silver gelatine, platinum	26.8 × 37 cm	Photographic Salon, 1898		
1899†	Old Dapple (plate 98)	Silver gelatine, platinum	48 × 61 cm	Photographic Salon, 1899	MFH, JPG	
1899†	Must He be Sold?	Silver gelatine, platinum	48.3 × 38 cm	Photographic Salon, 1899		
1900†	The Starling's Nest (plate 99)	Silver gelatine, sepia platinum	48.3 × 38 cm	Photographic Salon, 1900	TW	
1900†	Flecked with Sunshine	Silver gelatine, black platinotype	48.3 × 37 cm	Photographic Salon, 1900	HRHRC	
1900†	A Dream of Fairyland	Silver gelatine, platinum	26.8 × 37 cm	Photographic Salon, 1900		
1900†	Initials	Silver gelatine, platinum. Also produced as an etching	26.8 × 37 cm	Photographic Salon, 1900	HRHRC, RPS, (etched version)	

Appendix IV

SELECT BIBLIOGRAPHY

BOOKS BY HENRY PEACH ROBINSON

1869 *Pictorial Effect in Photography. Being Hints on Composition and Chiaroscuro for Photographers*, published by Piper & Carter, illustrated with three photographic prints (two carbon and one albumen), of Maud and Ethel May Robinson reading, *On the Hill-Top*, *Autumn*, and wood engravings of paintings. A chapter on 'Combination Printing' appears at the end of the book. There were thirteen further editions and reprints, including two published in the USA and translations into German and French.

1881 *The Art and Practice of Silver Printing*, published by Piper & Carter. The scientific parts of the book were written by Captain W. de W. Abney, the rest by H. P. Robinson. Also published in the USA the same year.

1884 *Picture Making by Photography*, published by Piper & Carter, and illustrated with many engravings of his own photographs (*A Merry Tale*, *What Luck?*, *Can I Jump It?*, *Wayside Gossip*, *Watching the Newts*, *Is it a Dog?*) and paintings by other artists. The second edition in 1889, which was revised, included additional chapters on 'Instantaneous Photography and the Persistence of Vision' and 'Naturalistic Photography'. Many editions and reprints, last in 1916.

1885 *The Photographic Studio and What to Do in It*, published by Piper & Carter, illustrated by engravings of portraits and sketches of designs for studios, and groups taken at the house parties in North Wales, 1881–4.

1888 *Letters on Landscape Photography*, reprinted from the *Photographic Times* (in which they had been serialized) by Scovill Manufacturing Company, New York.

1890 *Photography as a Business*, reprinted from serialization in the *Practical Photographer* by Percy Lund & Company, Bedford.

1895 *Art Photography in Short Chapters*, no. 4 in the *Amateur Photographer Library* series, published by Hazell, Watson & Viney, illustrated with photographic reproductions of *Wayside Gossip*, and *A Nor'Easter* by Robinson and *Sleepy Hollow* by Colonel Joseph Gale, also some engravings of paintings. Previously serialized in the *Amateur Photographer* from 5 April to 6 September 1889.

1896 *The Elements of a Pictorial Photograph*, published by Percy Lund & Company of Bradford and London and illustrated with many early photographic reproductions of Robinson photographs, including *Storm Clearing Off*; *The Old Boat*; *What Luck?*; *She Never Told Her Love*; *Somebody Coming*; *A Mountain-Dew Girl from the Gap of Dunloe, Killarney, Ireland*; *Cows Crossing the Stream*; *The Song of the Birds*; *In Holy Loch*; and *Atlanta*. Also engravings of Myles Birket Foster's drawings made to illustrate the twelve months of the year.

SELECT LIST OF HIS PUBLISHED ESSAYS AND ARTICLES

Amateur Photographer

27 March 1869	The Hand Camera Taken Seriously pp. 270–1
1 April 1892	The Camera Club Conference pp. 262–3
23 March 1900	An Incident p. 223

The American Annual of Photography and Photographic Times Almanac

1889	So Natural! pp. 54–7
1892	The Use and Abuse of Models pp.144–6

1895 Expression in Landscape
 pp. 168–73

British Journal of Photography
20 April 1859 Cutting Glass Under
 Water pp. 112

2 April 1860 On Printing Photographic
 Pictures from Several
 Negatives p. 94

2 July 1860 Composition *Not*
 Patchwork pp. 189–90

15 October 1861 Photographic Contributions to
 Art pp. 355–6

1 February 1864 Changes to Photography During
 the Last Few Years p. 39

6 December 1872 Photographing Doubles p. 76

1890 Sight Memory pp. 386–7

22 July 1892 Individuality in Photography
 pp. 468–9

7 February 1896 Digressions, Imitation and the
 Bearings Lie in the
 Application p, 84

25 December 1896 A Correction and The Linked
 Ring Discussion p. 832

Hereford Times
1851 Nature Triumphant: A True Tale
 for Young Artists ('by H. P.
 Robinson of Ludlow'). In 2 parts

Humphrey's Journal
15 March 1867 The Use of Light pp. 340–2

*The International Annual of Anthony's Photographic
Bulletin*
1888 Art or Accident? pp. 475–7

1889 Fog or Focus? pp. 196–8

Journal of the Photographic Society
21 May 1857 The Simplicity of The Collodio-
 Albumen Process p. 286

21 April 1859 New Portable Tent and
 Perambulator p. 266

20 January 1882 Foregrounds pp. 76–7

Photographic Mosaics Journal
1870 The Golden Syrup Solution for
 Wet Plates pp. 51–3

Photographic News
5 February 1864 The Poets and
 Photography pp. 62–3

8 July 1864 Old Saw and Photographic
 Instances p. 328

31 March 1865 Doubles – How to Do Them
 (ingenious device for getting two
 exposures on one plate) p. 149

11 August 1865 On the Selection of a Subject and
 its Management p. 378

16 February 1866 The Glass Room and its Contents

 (read at Photographic Society of
 Scotland 13 February 1866) p. 76

4 September 1868 Short Essays on Photography and
 Art pp. 424–5

23 April 1869 Correspondence: The Copyright
 of the Sea p. 201

6 August 1869 Golden Syrup Solution for Wet
 Plates pp. 381–2

14 January 1870 Correspondence: Golden Syrup
 Solutions p. 21

26 January 1872 Retouching and
 Exhibitions pp. 41–2

29 November 1872 Graduated Backgrounds p. 571

25 December 1884 Brush and Camera in North
 Wales

27 May 1892 The Enjoyment of
 Photography pp. 344–5

12 October 1894 Our Aims and End p. 649

Practical Photographer
May 1986 The Growth of Picture Making
 (ed. Matthew Surface), vol. VII,
 no. 77, pp. 113–22

February 1897– Autobiographical Sketches (ed.
February 1898 Matthew Surface), vols XIII–IX.

PUBLICATIONS BY NELSON K. CHERRILL

British Journal of Photography
15 January 1869 On Combination Printing
 pp. 25–6

Photographic News
9 June 1865 The Wet Collodion Process
 without the Use of the Nitrate
 Bath p. 271

3 November 1865 Collodion and the New Organic
 Iron Developer p. 322

4 August 1865 Splitting of the Collodion
 Film p. 364

1 September 1865 Gelatine Combinations with Iron
 Developers p. 413

1 December 1865 The New Developer p. 568

19 January 1866 The New Organic Iron Developer
 (read before Photographic Society
 of London, 9 January 1866) p. 28

26 January 1866 Stray Papers on Photography No.
 1 – Chemical Cleanliness p. 40

9 February 1866 Stray Papers No. 2 – Gradation of
 Photography p. 62

23 February 1866 Stray Papers No. 2 – Gradation of
 Photography (continued) p. 86

2 March 1866 On the Nature of the Chemical
 Actions Involved in the
 Production and Development of
 the Photographic Picture p. 100

9 March 1866 On the Nature of the Chemical

Actions Involved in the
Production and Development of
the Photographic Picture
(continued) p. 112

16 March 1866 On the Nature of the Chemical
Actions Involved in the
Production and Development of
the Photographic Picture
(continued) p. 123

20 April 1866 Stray Papers No. 3 – On Printing
Density p. 184

22 June 1866 Photographing Non-Actinic
Colours (recommends control of
chemicals in developer when
yellows in subject) p. 290

28 September 1866 Experiments with Carbon
Printing pp. 459, 483, 532, 603

8 March 1867 Cutting Glass Under Water with
a Pair of Scissors p. 111

26 April 1867 Diffusion of Focus and Pictorial
Softness p. 197

21 February 1868 On Natural Clouds and
Atmospheric Effects in Landscape
Photography p. 87

7 August 1868 Short Essays on Photography and
Art p. 276

15 January 1869 Combination Printing p. 25

1 February 1878 On Ceramic Enamels pp. 55–6

8 February 1878 On Ceramic Enamels (continued)
pp. 67–8

15 February 1878 On Ceramic Enamels (continued)
pp. 74–5

ESSAYS ABOUT HENRY PEACH ROBINSON

3 September 1869 *Photographic News*, p 429
Mr Robinson and his Method
of Working

26 August 1872 *Photographic News*, p. 311
Talk in the Studio: Robinson
and Cherrill's New Studio

20 September 1872 *Photographic News*, p. 449
About a Studio at Tunbridge
Wells by a Modest Contributor

3 September 1875 *Photographic News*, p. 427
Messrs. Robinson and Cherrill's
Studio at Tunbridge Wells

11 February 1876 *Photographic News*, p. 72
Painter and Photographer
(H. P. Robinson)

11 June 1880 *Photographic News*, pp. 278–9
Mr. H. P. Robinson at the
Great Hall Studio, Tunbridge Wells

April 1882 *Philadelphia Photographer*, vol.
XIX, no. 220, pp. 97–8
9 photographs in one presenta-
tion print on albumen paper of

figures in landscape taken at
Gwysaney, North Wales (not
titled)

7 July 1882 *Photographic News*, pp. 387–9
Picture Making with Mr
Robinson at Gwysaney Hall,
North Wales

February 1883 *Philadelphia Photographer*, vol.
XX, p. 43
9 photographs in one presenta-
tion print on albumen paper of
figures in landscape taken at
Gwysaney, North Wales: *Artist
and Model*; *The Paddlers*; *Her
Ladyship*; *A Merry Tale*; *Wayside
Gossip*; *Helping Her Over*; *Con-
fidences*; *Shy*; *Thinking of Jack*

11 July 1884 *Photographic News*
In Search of the Picturesque

January 1885 *Philadelphia Photographer*, vol.
XXII, pp. 6–8
9 photographs in one presenta-
tion print on albumen paper of
figures in landscape taken at Gelli-
gynan, North Wales: *Come
Along*; *Feeding the Calves*; *A Tres-
passer*; *He Never Told His Love*; *At
the Mill Door*; *Reading a Notice in
Welsh and English*; *A Chat with the
Miller*; *Gelligynan Mill*; *The Song
of the Birds*

1891 *Sun Artists*, pp. 10–11
Andrew Pringle: Mr H. P.
Robinson (illustrated with four of
his photographs) ed. W. Arthur
Boord. By Kegan Paul, Trench,
Trubner.

10 June 1892 *Photographic News*, pp. 376–7
Editorial: Fading Away being a
paper on the theme of 'want of
permanence in silver prints' based
on a paper read at the Camera
Club by H. P. Robinson: 'A Note
on Fading, and our Debt to
Science'

1892 *Photographic Review of Reviews*,
vol. I, p. 371
Mr H. P. Robinson at Home

6 April 1894 *Photographic Times*, pp. 213–16
Distinguished Photographers
(H. P. Robinson)

March 1895 *Practical Photographer*, vol. VI, no.
63, pp. 64–72
Our Leaders, no. 25, ed.
Matthew Surface

20 February 1901 *Photography Magazine*, pp. 146–8
Biographical Notes: H. P.
Robinson

INDEX

Note: page numbers in italic denote illustrations in the text.

Albert, Prince, 28
Anxious Hour, An (Mrs Alexander Farmer), *43*
assistants, studio, 61–2
Autumn, 39, 58, *plate 60*

Bibby, Marianne, 14–15, *plate 17*
Birket Foster, Myles, 39, *40*, 64
Blind Fiddler, The (Wilkie), 46–7, *47*
Bradley, E. (Cuthbert Bede), 31
Brett, John, 82
Bridge across the Stream in Armstrong Park, Hereford (Gill), *8*
Bringing Home the May, 34–8, *36–7*, *plate 58*
Bromsgrove, 16–17
Burnet on Composition, 6

Callcott, Augustus W., 64, *64*
carbon tissue process, 52
Carolling, 76, *plate 82*
Carroll, Lewis (C. L. Dodgson), 59
cartes-de-visite, 29
Cherrill, Nelson King, 51–3, 57–9
Childe Harold's Pilgrimage: Italy (Turner), *45*
Choosing the Wedding Gown (Mulready), *48*
Collodion Committee, 29
collodion process, 23
combination printing, 26, 52, 97–9
costume
 designed by Robinson, 12
 used by Robinson, 65–6
Cox, David, 64
Crawshay, Robert, 59–60

Cundall, Miss (Robinson's model), 26, *27*, 65

Dallmeyer, J. H., 42, *42*
Dawn and Sunset, 75–6, *plate 80*
Davison, George, 79
Diamond, Hugh Welch, 19, 25, 43–4, 52, *plate 72*
Don Quixote in His Study (Price), *25*
double printing, 26
Dutch Peasants Returning from Market (Callcott), *64*

Emerson, Peter Henry, 78–9
English Farmer's Fireside, The, *12*
equipment, photographic, 23

Fading Away, 26, *27*, *plates 46, 47*
Faed, Thomas, 76, *77*
Farmer, Mrs Alexander, *43*
Feathers Inn, Ludlow, *4*, 5
Fenton, Roger, 28
focus, diffusion of, 78–9
From Dawn to Sunset (Faed), 76, *77*

Gelligynan, 71–4
Gill, Edmund, 9
Gill, George Reynolds, 9, *9*, 28
Gill, William Ward, *8*, 9
Gilpin, William, 44
Gleaner, A, 58, *plate 77*
Glover, Joseph, 18
Gossage, Frederick Herbert, 7, 67
Gossage family: intermarriage with Robinson and Tate families, 67
Gossip on the Beach, 75, *76*

le Gray, Gustav, 26
Great Hall Studio (Tunbridge Wells), 54–6, *54*
Great Industrial Exhibition
 1851, 17
 1862, 33–4
Grieves, Selina, *see* Robinson, Selina
Gwysaney Hall, 67–71, *68*

'Here They Come!', 30, *plate 32*
Hicks, Edwin Thomas, 3
Holiday in the Wood, A, 30, *plates 37, 38*
Hope Deferred, 76
Horse and Groom, *39*

Jarvis, H., 61
Jenny, 26, *plate 44*
Jones, Richard, 5

Lady of Shalott, The, 18, 31, 32–3, *plate 52*
Lady of Shalott, The (Waterhouse), *32*
Laird, John, 22–3, *23*
landscape painting: Robinson's observations on, 11
landscape photographs, *plates 65, 66, 67, 68, 104*
Lee, F. R., 64
Linked Ring Brotherhood, 80
Little Red Riding Hood, 28, *plates 48–51*
Livingstone, David, 59
Ludlow, 1–15, *plates 20, 21, 22, 23, 28*

buildings, 4–5
Castle, 13, *plate 6*
Church, 11
Natural History Society, 3
trades, 5
traditional customs, 7
Ludlow Castle from the Whitcliffe, 13

Manchester Art Treasures
 Exhibition, 25
Mariana, 13–14, *14*
Maskell, Alfred, 80
Maund, Benjamin, 16, 17
Merry Tale, A, 68–9, *70*
Messer, Walter Vickerstaff, 23,
 30–1
Millais, John Everett, 32, *33,* 35,
 38
Mr Werner as Richelieu, 28, *plate 33*
models, 26, 65–6
Moore, Henry, 31, 54, *68, 82*
Mulready, William, 47, *48*
Munro, Alexander, 31

Niepce, Nicéphore, 75

Old Boat, The, 70, *plate 85*
Old Dapple, 83, *plate 98*
On Stretton Hills, 19, *20*
On the Hill-Top, 49, *plate 30*
On the Teme near Ludlow, 18
Ophelia (Millais), 32, *33*

Passions, The, 26, *plate 31*
Paton, Sir J. Noel, 27
Penson, Richard Kyrke, 11
Penwarne, Richard, 4
Photographic Society of Great
 Britain (PSGB), 79–80
 Robinson's resignation from
 PSGB, 79–80
Photographic Society of London,
 19, 25, 29
 see also Royal Photographic
 Society
*Photographic Studio and What to Do in
 It, The,* 56–7
Photography as a Business, 62
Pictorial Effect in Photography, 43–4
Picture Making by Photography, 64–5
plagiarism, 62–3
Polt, J. H., 44
portrait photography, 22, 24–5,
 29–30, 56–7, 59–60
Preparing Spring Flowers for Market,
 58, *plate 78*
Pre-Raphaelites, 31–4
Price, William Lake, 25
Primrose Time, 82, *plate 95*
Pritchard, Henry Baden, 54

Rejlander, O. G., 22, 25, 65
*Robin Hood and Maid Marion in
 Sherwood Forest, 10*
Robinson, Henry Peach
 chronological summary of life:
 birth, 1; childhood and youth,
 1–5; apprentice years, 5–9; post-
 apprenticeship year, 12–13; in
 Bromsgrove, 16–17; in London
 (1851–2), 17–18; first
 experiments in photography,
 18–19; in Leamington Priors,
 18–39; founder member of The
 Linked Ring, 80; opening of
 studio in Leamington, 21;
 marriage, 29; early retirement
 (1864), 40; in London (1865–8),
 41–9; in Tunbridge Wells,
 50–63; in North Wales, 67–74;
 retirement from Tunbridge
 Wells business, 78; resignation
 from Photographic Society,
 79–80; activity in retirement,
 80–3; death, 83
 other aspects: as cricketer, 7;
 health, 11, 29, 40, 76; love of
 dancing, 7; love of walking,
 7–8; as sculptor, 11–12, 53, *54,*
 83
 portrait by R. W. Robinson, *81*
 writings on photography, 23,
 43–9, 56–7, 62, 64–5, 68–9, 79,
 83
Robinson, Clara (sister, later Mrs
 Gossage), 2, 66–7
Robinson, Claude, *plate 41*
Robinson, Edith (daughter), 54, 67
Robinson, Eliza (mother), 29, *plates
 24, 26*
Robinson, Ethel May (daughter),
 67, 84
Robinson, Herbert John (Bob)
 (brother), 67, *plate 19*
Robinson, John (father), *plate 25*
Robinson, Leonard Lionel (son),
 53–4, 67
Robinson, Margaret Winwood
 (grand-daughter), 84
Robinson, Maud (daughter), 38–9,
 53, 67
Robinson, Ralph Winwood (son),
 33, *34,* 67, 77, 78, *78,* 84
Robinson, Richard (grandfather), 5,
 33
Robinson, Richard
 (great-grandfather), 67
Robinson, Selina (wife, *née* Grieves),
 29, *31, 34, 81,* 83, *plate 16*
Royal Photographic Society, 83
 see also Photographic Society

Ruskin, John, 6

Seagulls, 53
seascapes, 53, 58, *plates 74, 75, 76,*
 103
Shakespeare, William: *Works*
 illustrated, 2–3, *plates 11–14, 15*
Skylark, The, 70, *71*
Sleep, 43, *plate 71*
Solar Club, 42
Spring (Apple Blossom) (Millais), 35,
 38
Starling's Nest, The, 83, *plate 99*
Stonebreaker, The (Brett), *82*
Strange Fish, A, 66
Swan, Joseph Wilson, 42

Tableaux Vivants, 73–4
Tate, Agnes Esther, 67
Tate, Henry, 54, 67
Tate family: intermarriage with
 Gossage and Robinson families,
 67
theatrical scenes, 60–1
Tomkins, Vera (grand-daughter),
 81
Tunbridge Wells, 50–1, 77–8
Turner, J. M. W., 44–5, *45*
Two Ways of Life, The (Rejlander),
 25

Valentine, The, plate 81
Victoria, Queen, 28

Waiting for the Boat, 42, *plate 63*
Wales, North, 67–74
Wall, A. H., 27–8
Warwickshire Illustrated, 3, 23–4,
 plates 9, 10
Watching the Lark, Borrowdale, 52–3,
 plate 69
Wayside Gossip, 70, *plate 87*
When the Day's Work is Done, 61, 66,
 plate 79
Whitcliffe (Ludlow), 8–9
Wilkie, David, 46–7, *47*
Williams, T. R., 42
'Winwood' (Robinson's Tunbridge
 Wells house), 53, *54*
Winwood, Arthur, 67
Winwood Cap and Ring, plate 34
Winwood, Elizabeth (grandmother),
 33, 67
Winwood, Sir Ralph, 67
Winwood, William
 (great-grandfather), 5
Wright, Thomas, 6–7, 11

Young Gleaners Resting by a Stile
 (Birket Foster), 39, *40*

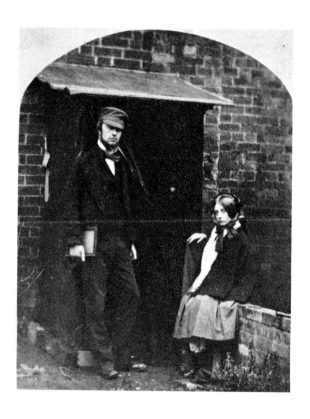

Plate 1 *'Ye House that Jack Built'*, 1853/4. Henry Peach Robinson and little Miss Cundall, his favourite model, outside the darkroom he built of oilcoth in the garden of his lodgings in Leamington Spa
Albumen print, 10.8 cm × 8.3 cm. Harker collection

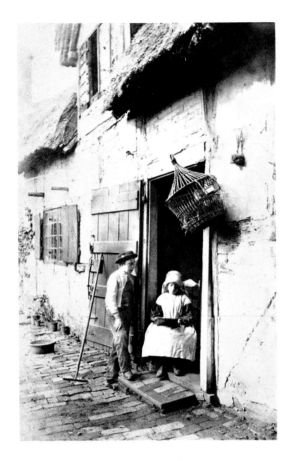

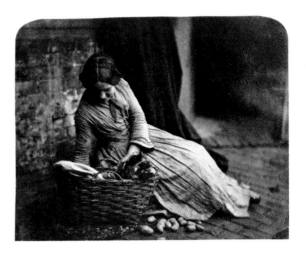

Plate 3 Young woman sorting vegetables, 1854/5
Albumen print, 12.0 cm × 14.8 cm. Private collection

Plate 2 Rustic scene, two children in a doorway,
1854/5
Albumen print, 17.3 cm × 11.4 cm. Private collection

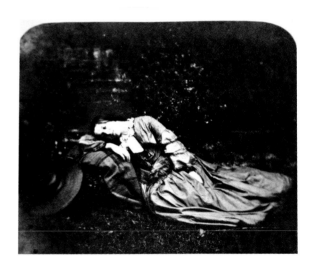

Plate 4 Young woman asleep, 1854/5
Albumen print, 12.0 cm × 14.8 cm. Private collection

Plate 5 Photographic views in a folder of places of interest in Warwickshire, 1859/60.
Left to right: Guy's Cliffe (2), Kenilworth Castle, Stoneleigh Abbey, church ruins,
Warwick Castle
Albumen prints, far left, 7.6 cm × 7.6 cm; others, slight variations. Harker collection

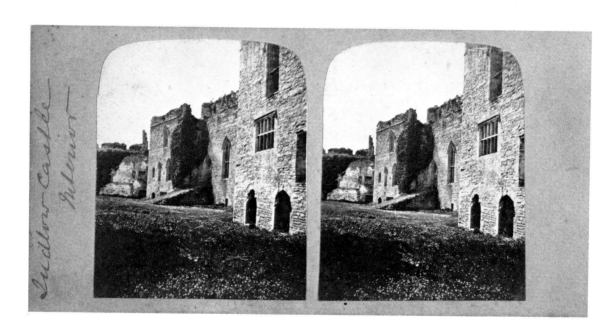

Plate 6 *Ludlow Castle Interior, c.*1859
Stereo card with albumen prints, 17.3 cm × 8.3 cm. Harker collection

Plate 7 *On the Avon, Stoneleigh*, 1857. One of the photographs in Robinson's own copy
of the Photographic Exchange Club Album, 1856/7
Negative by Robinson's own formula for the dry plate collodio-albumen process, albumen
print, 19.1 cm × 24.1 cm. Collection: The Royal Photographic Society

Plate 8 *Guy's Cliffe, Warwickshire*, 1856. Inscribed on matt: '6.30am, 1856. My first landscape. H.P.R.' The Photographic Exchange Club Album, 1856/7
Negative by a dry collodion process, albumen print, 15.9 cm × 21.0 cm. Collection: The Royal Photographic Society

Plate 9 *Stoneleigh Abbey, c.*1857. Number 5 in *Warwickshire Illustrated, a History of some of the most remarkable places in the County of Warwick*, published by Henry Peach Robinson and Nathaniel Merridew in 1858

Albumen print, 17.8 cm × 24.8 cm. Collection: County Records Office, Warwick

Plate 10 *Upper Parade, Leamington Spa, c.*1857. Number 1 of nine photographic views
taken by the collodio-albumen process published in *Warwickshire Illustrated* (see
caption to plate 9). Robinson's house and studio, 15 Upper Parade, is on the left
side adjacent to the cab
Albumen print, 17.8 cm × 24.8 cm. Collection: County Records Office, Warwick

Plates 11, 12 Charlecote Park, Warwick. Shakespeare was summoned for poaching
the deer in the Park by the land-owner, Sir Thomas Lucy

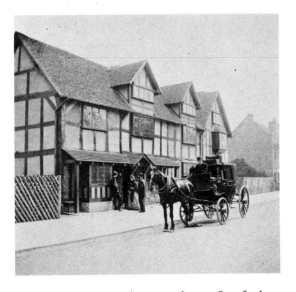

Plate 13 A sixteenth-century house, Stratford-
upon-Avon (Shakespeare's birthplace)

Plate 14 Interior of the Collegiate Church of the
Holy Trinity, Stratford-upon-Avon,
Warwickshire. In the chancel a life-size bust of
Shakespeare is set in the wall above his
gravestone
All approx. 7.6 cm × 7.6 cm. Private collection

Plates 11–14 Four of the albumen prints which illustrate the works of Shakespeare
in plate 15, 1859/63

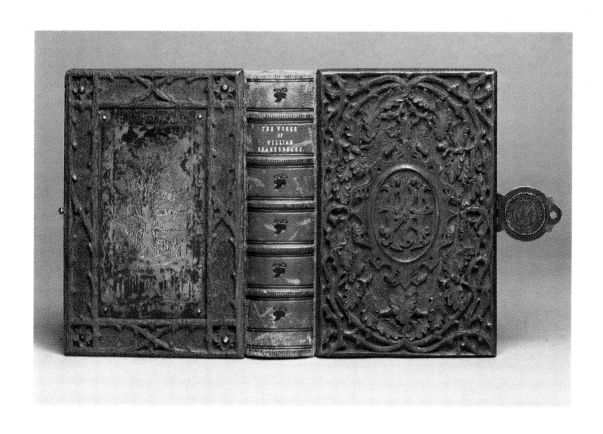

Plate 15 Volume of the *Works of Shakespeare*, with covers carved in wood from the
Herne Oak and etched in silver plate, by Henry Peach Robinson. The clasp is an inset
coin from the reign of Elizabeth I, 1864
Private collection

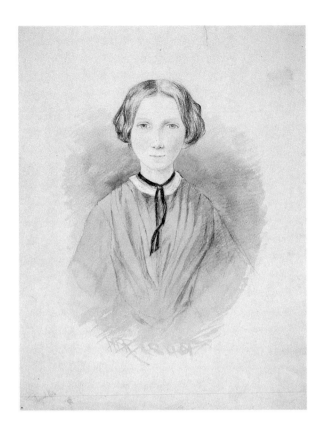

Plate 16 Selina Grieves, aged 16, 8 August 1854.
Future wife of Henry Peach Robinson
Pencil and watercolour, 34.1 cm × 27.2 cm. Collection:
Helmut Gernsheim, Harry Ransom Humanities Research
Center (henceforth HRHRC), University of Texas at
Austin

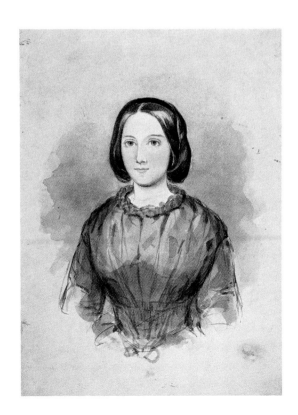

Plate 17 Mary Annie Bibby, aged 15–16, c.1850.
Henry Peach Robinson's sweetheart during his late
teens and early twenties.
Watercolour, 21.6 cm × 16.6 cm. Collection: Helmut
Gernsheim, HRHRC, University of Texas at Austin

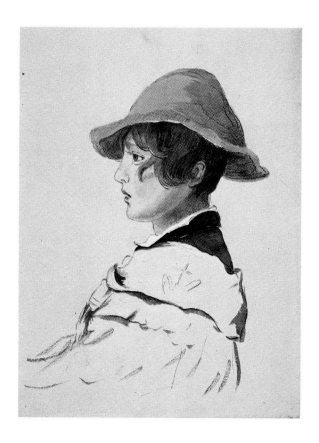

Plate 18 Portrait of boy in profile, *c.*1850
Pencil and watercolour, 25.4 cm × 19.3 cm. Collection:
Helmut Gernsheim, HRHRC, University of Texas at
Austin

Plate 19 Herbert John (Bob) Robinson,
aged 4½ years, January 1850, with
manuscript for phrenological chart
Pencil and watercolour, 15.1 cm × 12.7 cm.
Collection: Helmut Gernsheim, HRHRC,
University of Texas at Austin

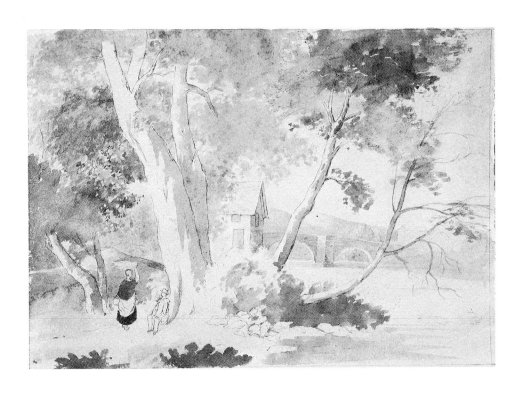

Plate 20 Banks of the River Teme near Ludford Bridge, Ludlow, 1852
Preliminary sketch in pencil and watercolour for an oil painting exhibited in the Royal
Academy exhibition of 1852, 19.6 cm × 27.6 cm. Collection: Helmut Gernsheim, HRHRC,
University of Texas at Austin

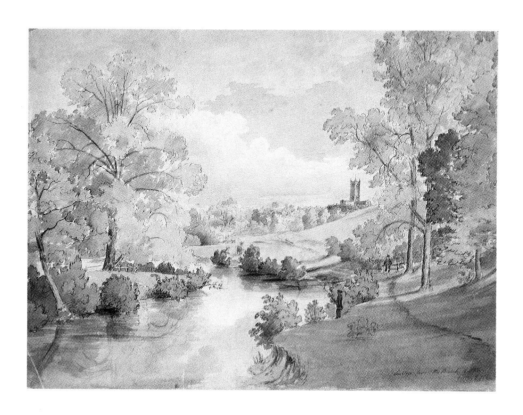

Plate 21 *Ludlow from the Brinks Coppice*, 2 October 1852
Pencil and watercolour, 31.4 cm × 42 cm. Collection: Helmut Gernsheim, HRHRC,
University of Texas at Austin

Plate 22 Dinham Bridge and River Teme near Ludlow, *c*.1850
Watercolour, 26.8 cm × 34.4 cm. Collection: Helmut Gernsheim, HRHRC, University
of Texas at Austin

Plate 23 *A Mill at Downton, near Ludlow,* c.1852
Watercolour and ink, 25.1 cm × 33.2 cm. Collection: Helmut Gernsheim, HRHRC,
University of Texas at Austin

Plate 24 Eliza Robinson, mother of Henry Peach Robinson, 1857/8
Albumen print, finished as an oil painting, 24.6 cm × 19.6 cm. Private collection

Plate 25 John Robinson, father of Henry Peach
Robinson, *c.*1846
Photograph of unattributed watercolour. Private
collection

Plate 26 Eliza Robinson, mother of Henry Peach
Robinson, *c.*1846
Photograph of unattributed watercolour. Private
collection

When autumn bathes the hills in light,
And tints with gold the forest leaves,
Ere grey mists rise from meadows low,
The little peasant children go
To glean among the sheaves.

And when at eve in golden pomp
The moon ascends heaven's purple dome,
Young lovers mid their converse sweet,
Wandring down woodland valleys, meet
The gleaners coming home.

Plate 27 *The Little Peasant Gleaners*, 1850. From the Bibby album
Pencil and wash drawing, 10.0 cm × 6.0 cm. A. H. Slade collection

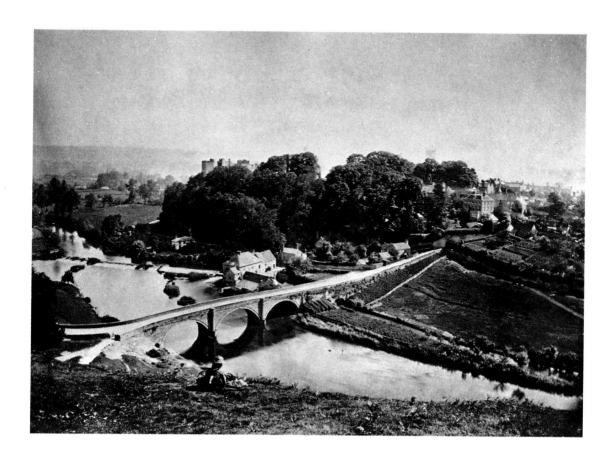

Plate 28 Ludlow and the River Teme from the Whitcliffe, *c*.1858. From the Kent album
Albumen print, 16.0 cm × 24.8 cm. Collection: Ludlow Library

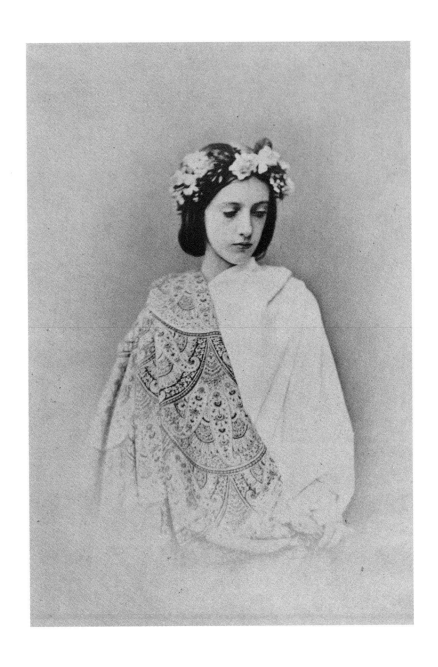

Plate 29 *The Garland of Flowers*, 1857/8
Albumen print vignette, 21.6 cm × 16.5 cm. Harker collection

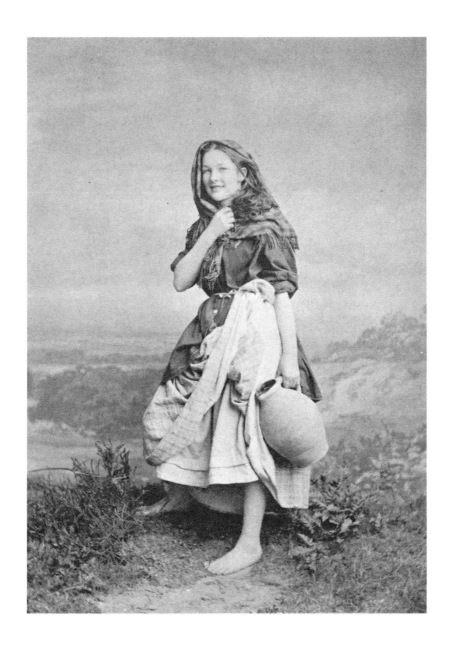

Plate 30 *On the Hill-Top*, 1860. Used by Robinson to illustrate his book,
Pictorial Effect in Photography, 1869
Albumen print, 13.3 cm × 9.5 cm. Harker collection

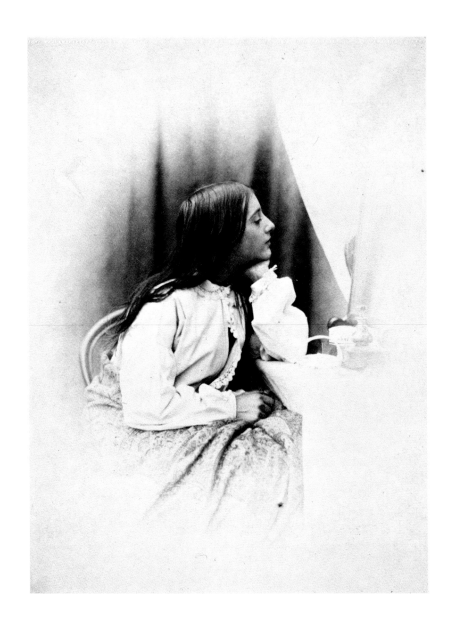

Plate 31 *Vanity*, 1857. One in a series on the Passions
Albumen print vignette, 21.6 cm × 16.5 cm. Harker collection

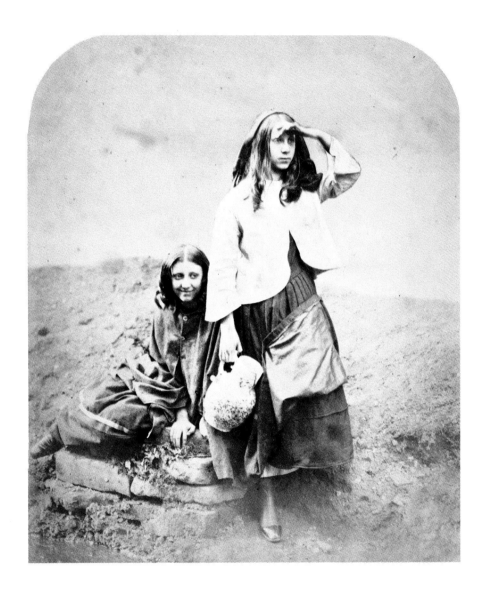

Plate 32 'Here They Come!', 1859. Awarded silver medal (Robinson's first) for best portrait/portrait group in the Photographic Society of Scotland's exhibition in Edinburgh, 1860, by the judge, Horatio Ross, Vice-President of the Society
Albumen print, 24.1 cm × 20.3 cm. The graduated 'sky' was obtained by second-stage printing after masking negative but has since faded. Harker collection

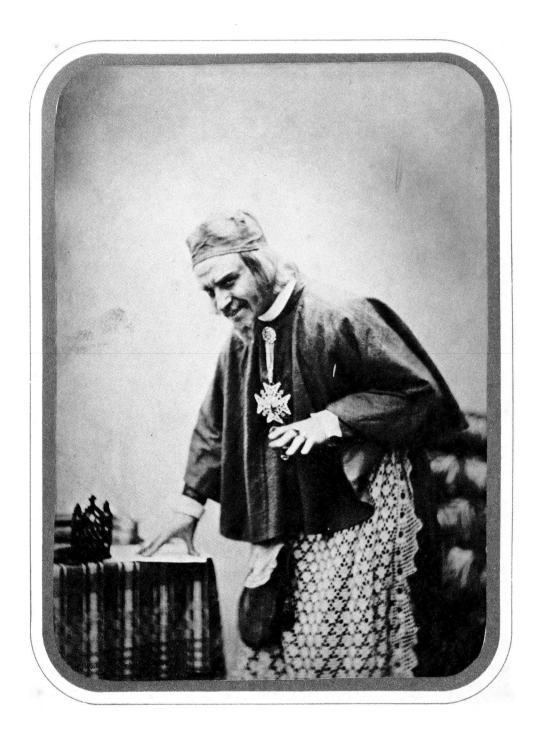

Plate 33 *Mr Werner as Richelieu*, 1857. Exhibited in the Manchester Art Treasures
exhibition of 1857
Albumen print, 19.7 cm × 14.0 cm. Collection: The Royal Photographic Society

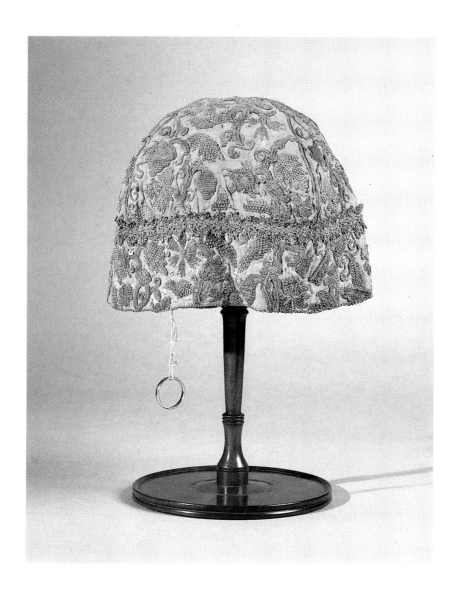

Plate 34 The Winwood Cap and Ring, supposed to have belonged to Sir Ralph Winwood,
Secretary of State to James I of England, which came into the possession of the
Robinson family through Elizabeth Robinson (née Winwood), Henry Peach
Robinson's great grandmother
Private collection

Plate 35 Group with recumbent figure, 1860
Preliminary study for a composite photograph. Pencil with wash and 'cut out' from albumen
print. Collection: Helmut Gernsheim, HRHRC, University of Texas at Austin

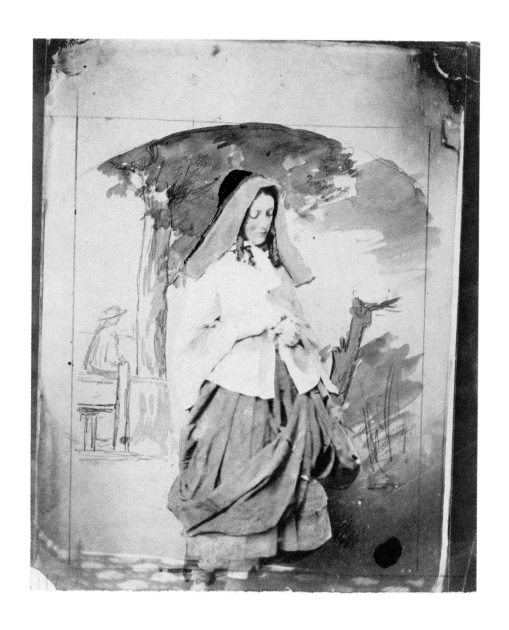

Plate 36 Genre portrait of girl in country dress and sun bonnet, 1861/2
Preliminary study for a composite photograph. Light albumen print, overlaid with
watercolour and pencil, 20.8 cm × 17.5 cm. Collection: Helmut Gernsheim, HRHRC,
University of Texas at Austin

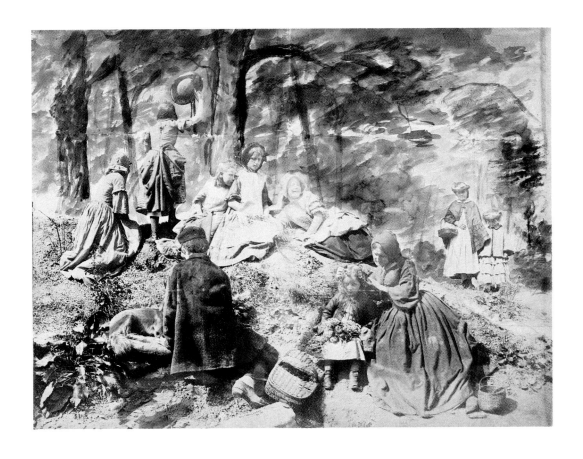

Plate 37 Photo sketch for *A Holiday in the Wood*, 1860
Albumen print from six negatives, background overlaid with watercolour, 20.8 cm × 17.5 cm.
Collection: Helmut Gernsheim, HRHRC, University of Texas at Austin

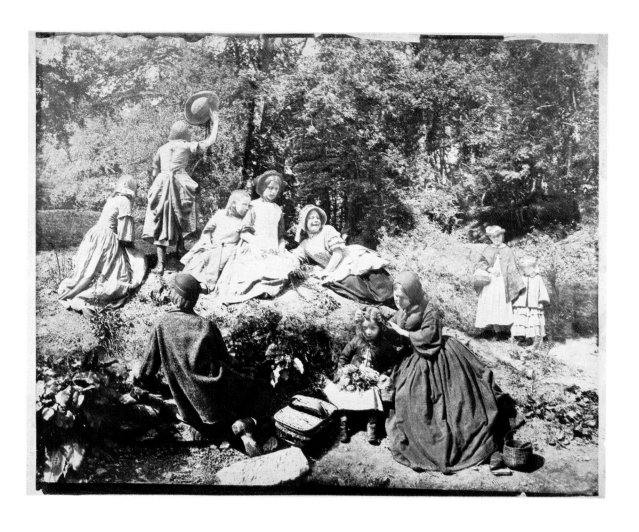

Plate 38 *A Holiday in the Wood*, 1860
Albumen print from six negatives, 50.3 cm × 60.4 cm. Collection: The International Museum of
Photography at George Eastman House, Rochester, New York

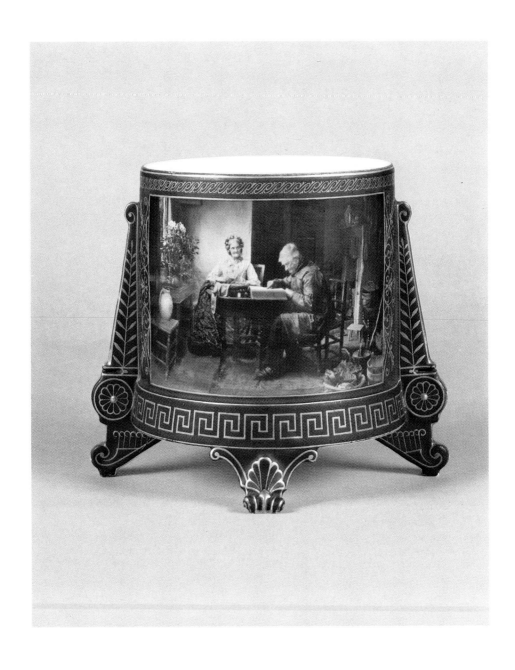

Plates 39, 40 The St Petersburg Jardinière, with *When the Day's Work is Done* on one face
and *What Luck?* on the other, *c*.1883
Carbon prints transferred to ceramic surface. Object, 21.6 cm × 25.4 cm. Harker collection

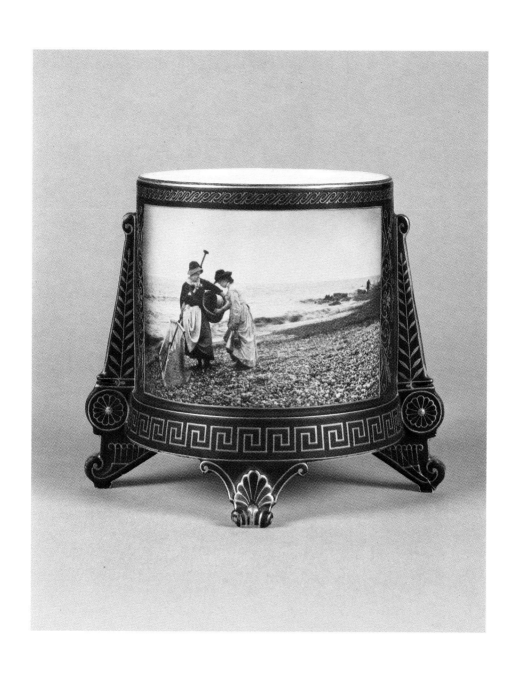

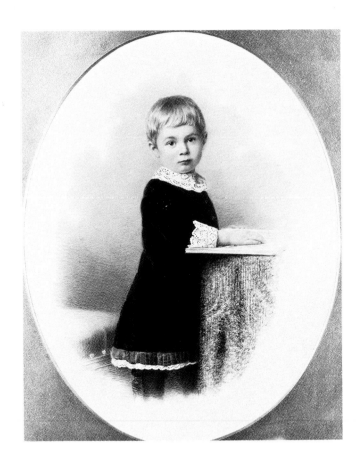

Plate 41 Claude Robinson, son of Herbert John Robinson and his wife, Agnes (née Tate), *c*.1883
Carbon print on large opal glass and coloured by hand, 38.0 cm × 30.4 cm. Private collection

Plate 42 Silver bracelet with portraits of the Robinson children, *c*.1877. *Left to right*:
Edith, Ralph, Maud, Ethel May, Leonard
Carbon prints transferred to enamelled copper plaques. Collection: The Science Museum

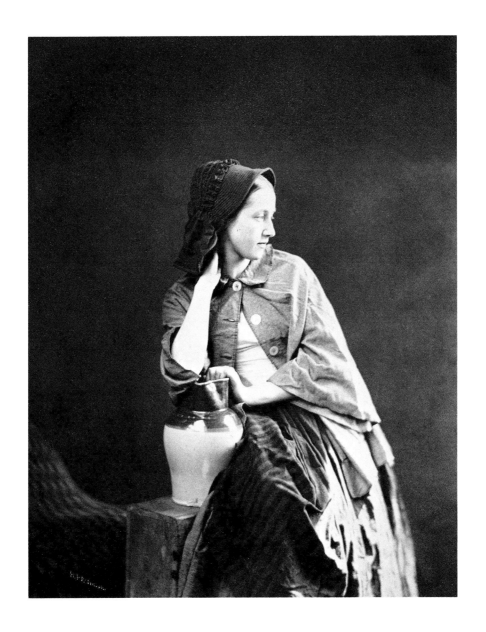

Plate 43 Study of young woman in sun bonnet with water jug, *c.*1860
Albumen print, 31.1 cm × 24.8 cm. Harker collection

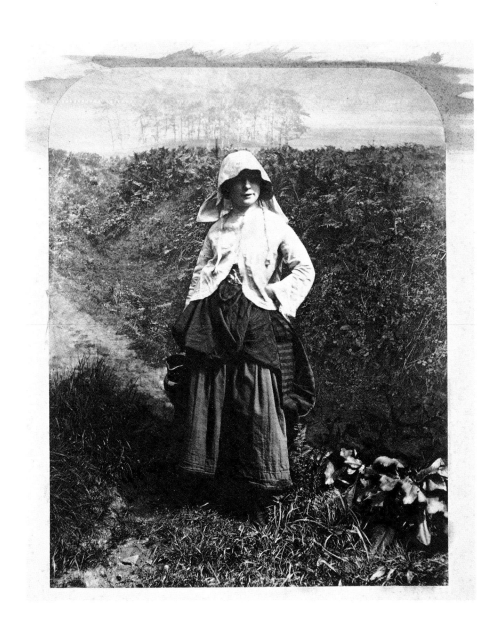

Plate 44 *Jenny*, 1857
Albumen print, 31.1 cm × 24.8 cm. Composite print from two negatives. Sepia
colour wash over sky area. Collection: The Royal Photographic Society

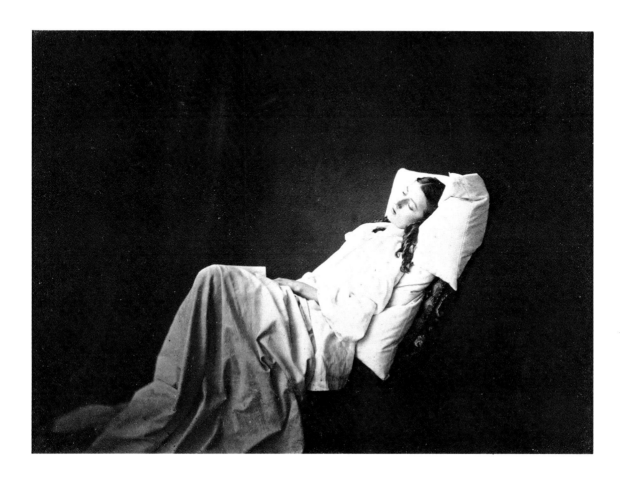

Plate 45 *'She Never Told Her Love'*, 1857. A preliminary study for *Fading Away*,
it was used as an exhibition picture illustrating verse on matt:

> She never told her Love
> But let concealment, like a worm i' the bud,
> Feed on her damask cheek.
>
> Shakespeare

Toned albumen print, 17.8 cm × 24.1 cm. Collection: The Royal Photographic Society

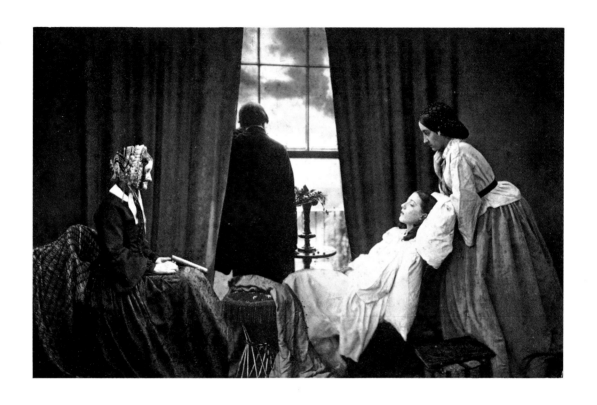

Plate 46 *Fading Away*, 1858. The alternative version to plate 47.
Toned albumen print from five negatives, 23.8 cm × 37.9 cm. Collection: The Royal Photographic
Society

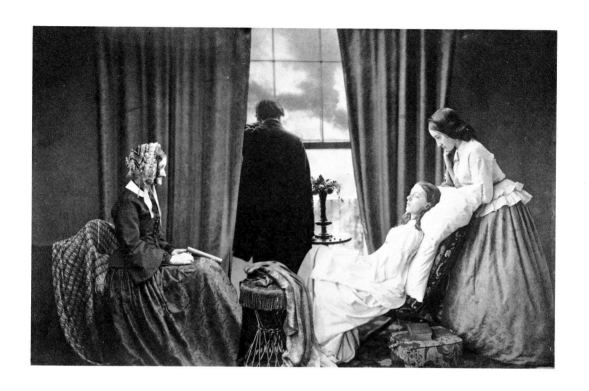

Plate 47 *Fading Away*, 1858. 'First Impression' inscribed on matt, plus the following verse:

> Must then that peerless form,
> Which love and admiration cannot view
> Without a beating heart, those azure veins
> Which steal like streams along a field of snow,
> That lovely outline which is fair
> As breathing marble, perish!
>
> <div align="right">Shelley</div>

Albumen print from five negatives, 23.8 cm × 37.9 cm. Collection: The Royal Photographic Society

Plate 48 Red Riding Hood accepts cakes from her mother to take to her bedridden grandmother

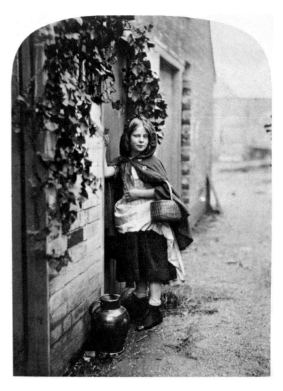

Plate 49 She arrives at the door of her grandmother's house

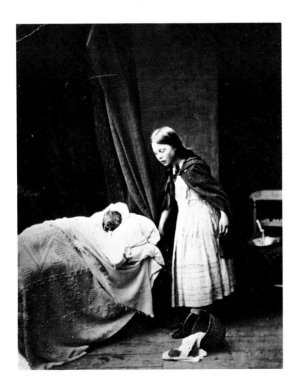

Plate 50 She discovers a wolf in place of the elderly lady

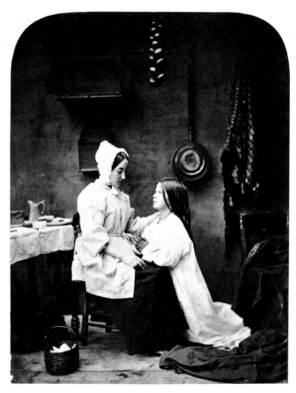

Plate 51 She runs home and tells her mother all about it

Plates 48–51 *The Story of Little Red Riding Hood*, 1858
Four-toned albumen prints, approx. 24.1 cm × 19.1 cm. Collection: The Royal Photographic Society

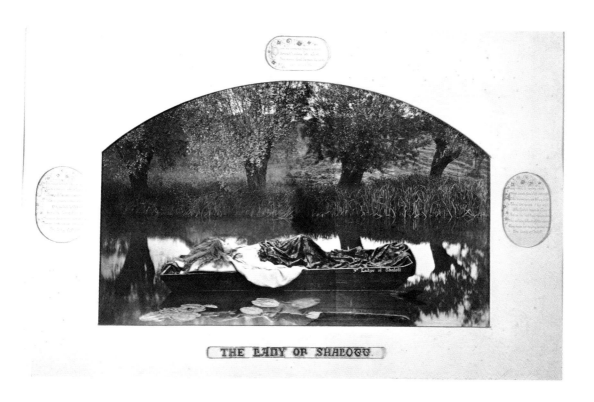

THE LADY OF SHALOTT

Plate 52 *The Lady of Shalott*, 1860/1. Robinson's original exhibition print, presented to The Royal Photographic Society by his son Ralph in 1924. The following verses from *The Lady of Shalott* by Tennyson are on matt:

Centre: Down she came and found a boat
 Beneath a willow left afloat
 And round about the prow she wrote
 The Lady of Shalott.

Left: And down the river's dim expanse
 Like some bold seer in a trance
 Seeing all his own mischance
 With a glassy countenance
 Did she look to Camelot.
 And at the closing of the day
 She loosed the chain and down she lay
 The broad stream bore her far away
 The Lady of Shalott.

Right: Lying robed in snowy white
 That loosely flew to left and right
 Thro' the noises of the night
 She floated down to Camelot.
 And as the boat head wound along
 The willowy hills and fields among
 They heard her singing her last song
 The Lady of Shalott.

Toned albumen print from two negatives, 31.8 cm × 52.1 cm. Collection: The Royal Photographic Society

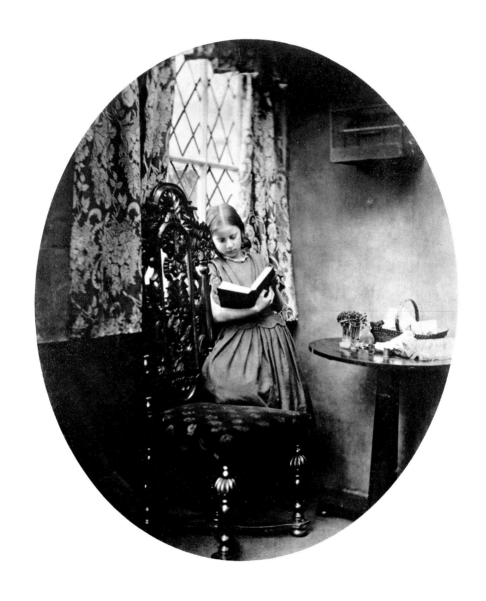

Plate 53 *Sulee*, 1859. Exhibited Paris, 1859
Albumen print, 24.3 cm × 20.1 cm. Michael Wilson collection

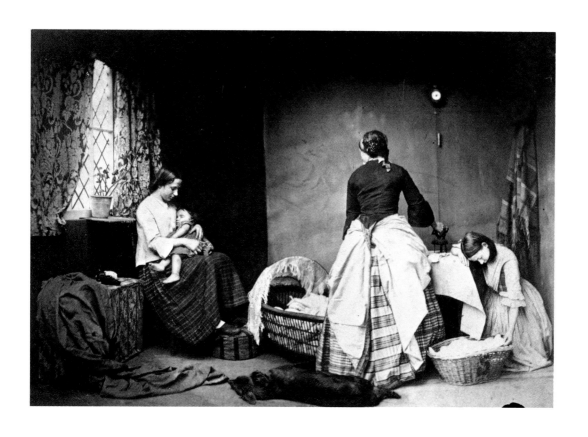

Plate 54 *A Cottage Home*, 1859
Albumen print from three negatives, 24.1 cm × 34.3 cm. Collection: The Royal
Photographic Society

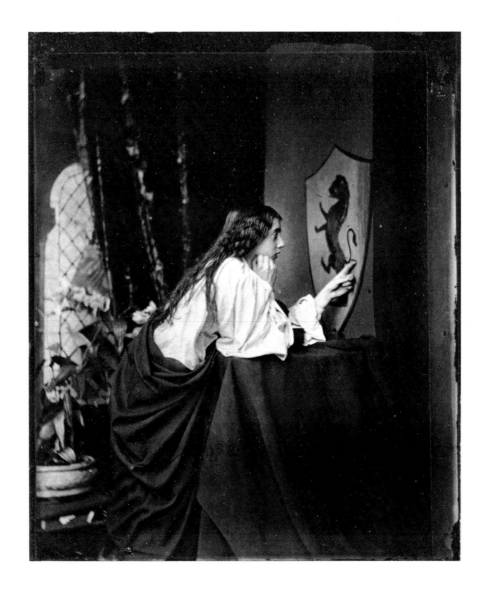

Plate 55 *Elaine Watching the Shield of Lancelot*, 1859/60. Verse inscribed on matt:

And ah God's mercy what a stroke was there!
And here a thrust that might have killed, but God
Broke the strong lance, and roll'd his enemy down
And seared him: so she lived in fantasy.

Tennyson, *Idylls of the King*

Toned albumen print, 25.4 cm × 20.3 cm. Collection: The Royal Photographic Society

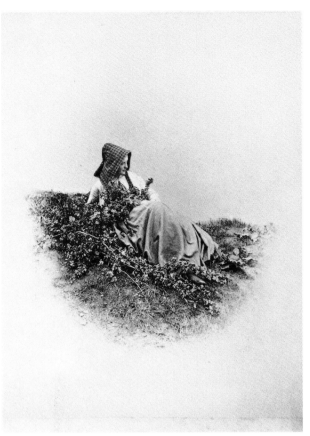

Plate 56 *The May Gatherer*, 1862. A preliminary
study for *Bringing Home the May*, it was used as
an exhibition picture
Albumen print vignette, 15.0 cm × 18.9 cm.
Collection: The Science Museum

Plate 57 A preliminary study for the central
figures in *Bringing Home the May*, 1862
Albumen print. Private collection

Plate 58 *Bringing Home the May*, 1862. The picture illustrates the following verse:

> . . . when all is ycladde
> With pleasaunce, the ground with grasse, the woods
> With greene leaves, the bushes with blossoming buds
> Youngthes folke now flocken in everywhere
> To gather May-buskets and smelling brere;
> And home they hasten the postes to dight
> And all the kirke pillours eare day light
> With hawthorne buds, and sweet eglantine,
> And girlands of roses, and soppes in wine.
>
> Spenser

Modern printing out paper print from original nine Robinson negatives in collection of
The Royal Photographic Society, 1980. 38.8 cm × 100.3 cm. Collection: The Royal
Photographic Society

Plate 59 *Somebody Coming*, 1861. A preliminary study for *Autumn*, it was used
as an exhibition picture
Albumen print from two negatives, 31.8 cm × 25.3 cm. Collection: Helmut Gernsheim,
HRHRC, University of Texas at Austin

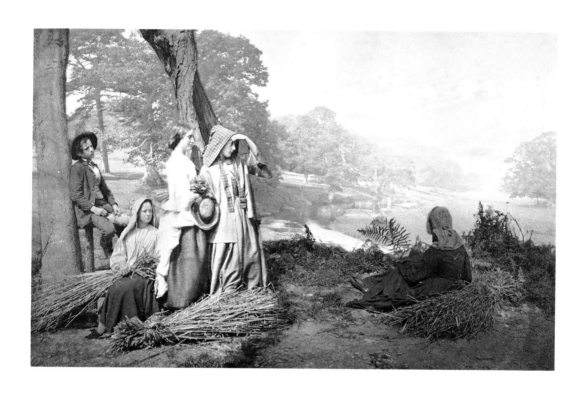

Plate 60 *Autumn*, 1863
Albumen print from four negatives, 36.8 cm × 57.8 cm. Collection: The Royal
Photographic Society

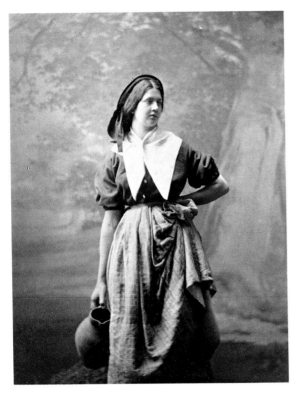

Plate 61 *Down to the Well*, 1864–6
Toned albumen print, 37.0 cm × 27.8 cm. Collection:
Helmut Gernsheim, HRHRC, University of Texas at
Austin

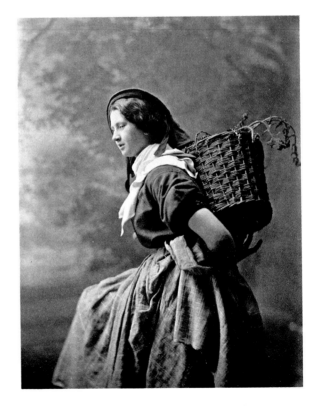

Plate 62 *Load of Ferns*, 1864–6
Toned albumen print, 36.2 cm × 27.7 cm. Collection:
Helmut Gernsheim, HRHRC, University of Texas
at Austin

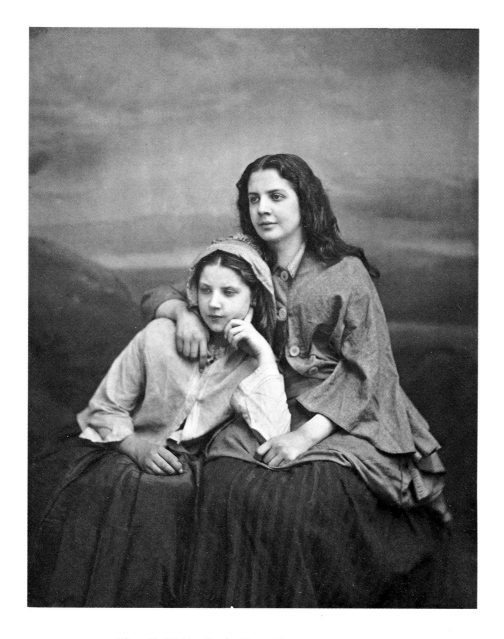

Plate 63 *Waiting for the Boat*, 1864–6. Verse on matt:

Musing I sit upon the Shore
Awaiting till the boat shall come.

J. Hain Friswell

Carbon print by Mawson and Swan, Printers, 36.2 cm × 28.6 cm. Collection: The Royal
Photographic Society

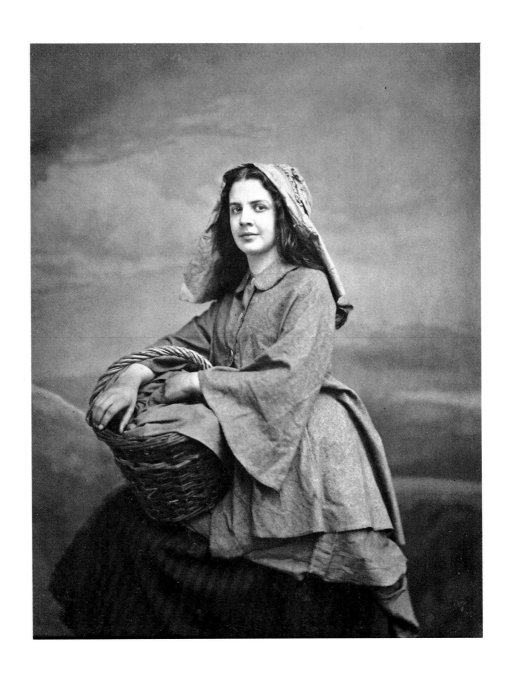

Plate 64 *On the Way to Market*, 1864–6
Carbon print, 36.2 cm × 28.6 cm. Collection: The Royal Photographic Society

Plate 65 *Rusthall Common, Tunbridge Wells, c.*1868, by H. P. Robinson and
N. K. Cherrill
Albumen print, 27.9 cm × 38.1 cm. Collection: The Royal Photographic Society

Plate 66 *Landscape with Ferns*, *c*.1868, by H. P. Robinson and N. K. Cherrill
Albumen print, 27.9 cm × 38.1 cm. Collection: The Royal Photographic Society

Plate 67 *Evening on Culverden Down, Tunbridge Wells*, *c*.1868, by H. P. Robinson and N. K.
Cherrill
Albumen print, 27.9 cm × 38.1 cm. Collection: The Royal Photographic Society

Plate 68 *The Haycart*, 1868
Albumen print, 27.9 cm × 38.1 cm. Collection: The Royal Photographic Society

Plate 69 *Watching the Lark, Borrowdale*, 1868, by H. P. Robsinon and N. K. Cherrill.
Robinson's photograph of his daughter, Maud, combined with Cherrill's
photograph of Borrowdale in the Lake District. It illustrates the lines of Wordsworth's
poem: 'Up with me, up with me, into the clouds'.
Albumen print from two negatives, 24.4 cm × 20.1 cm. Collection: Helmut Gernsheim, HRHRC,
University of Texas at Austin

Plate 70 *Pamela*, 1882. Interior of Gwysaney Hall, North Wales
Albumen print, 36.8 cm × 54.6 cm. Collection: Tunbridge Wells Museum

Plate 71 *Sleep*, 1867. Verse on matt:

They sleep in sheltered rest
Like helpless birds in the warm nest.

Matthew Arnold, *Tristan and Iseult*

Toned albumen print from four negatives, 38.1 cm × 55.2 cm. Collection: The Royal
Photographic Society

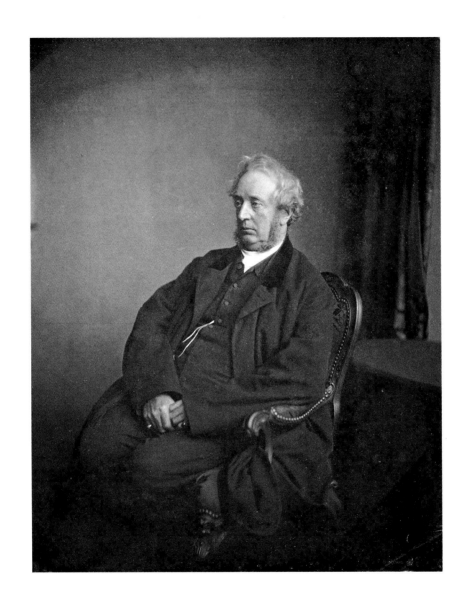

Plate 72 *Dr Hugh Welch Diamond*, 28 September 1869
Toned albumen print, 25.0 cm × 20.0 cm. Collection: The Royal Photographic Society

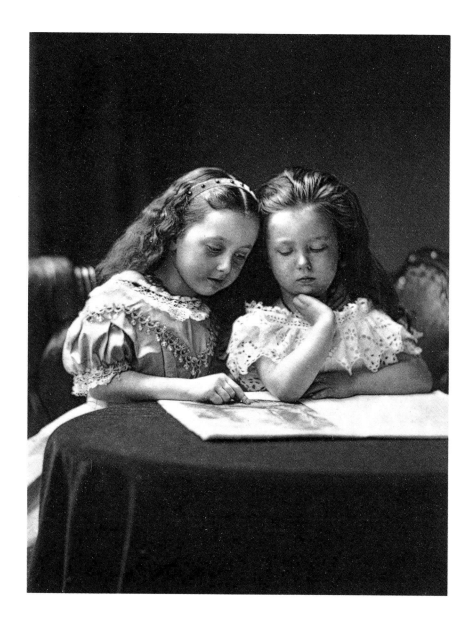

Plate 73 Maud and Ethel May Robinson, daughters of Henry and Selina Robinson, 1868. Frontispiece, *Pictorial Effect in Photography*, 1869
Carbon print, 11.3 cm × 8.9 cm. Harker collection

Plate 74 '*The Beached Margent of the Sea*', 31 May 1870, by H. P. Robinson and
N. K. Cherrill
Albumen print, 27.9 cm × 38.1 cm. Collection: The Royal Photographic Society

Plate 75 'In Kilbrennan Sound', 1894. Number 7 in Photographic Salon portfolio, 1895
Photogravure print, 10.8 cm × 19.1 cm. Harker collection

Plate 76 A seascape with headland, c.1885
Platinum print, 32.2 cm × 50.1 cm. Collection: Helmut Gernsheim, HRHRC, University
of Texas at Austin

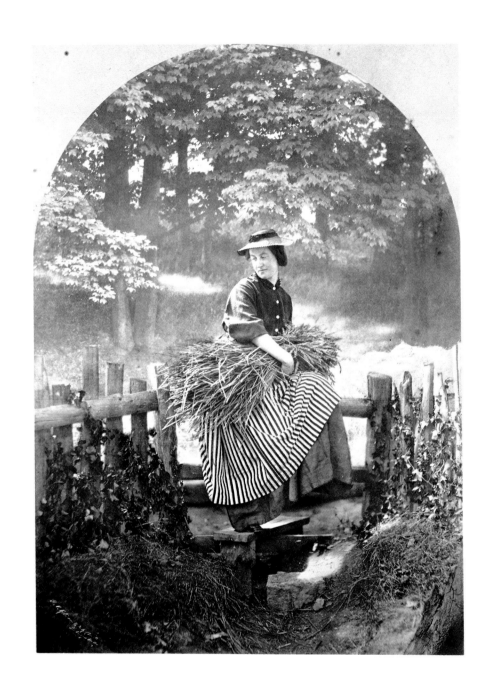

Plate 77 *A Gleaner*, 1872, by H. P. Robinson and N. K. Cherrill
Albumen print from two negatives, 55.9 cm × 40.6 cm. Collection:
Tunbridge Wells Museum

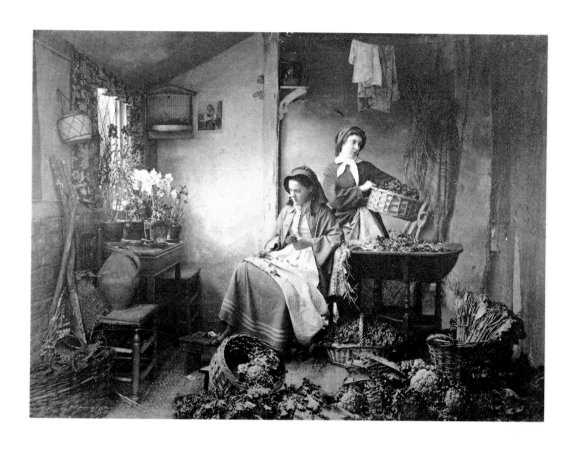

Plate 78 *Preparing Spring Flowers for Market*, 1873, by H. P. Robinson and
N. K. Cherrill
Albumen print from two or more negatives, 55.9 cm × 77.5 cm. Collection: Tunbridge
Wells Museum

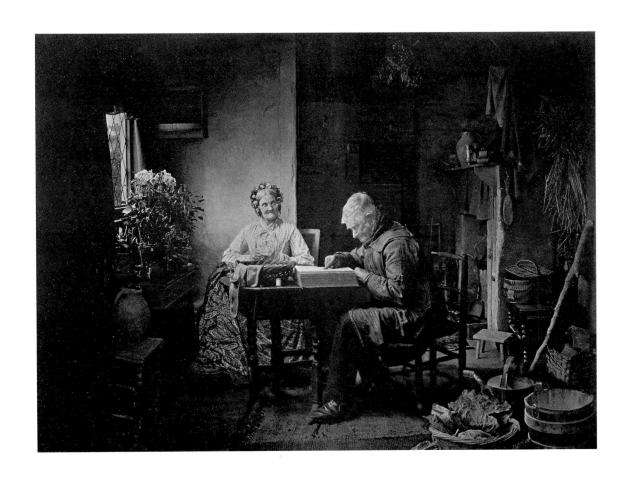

Plate 79 *When the Day's Work is Done*, 1877
Carbon print from six negatives, 53.7 cm × 76.4 cm. Collection: The Polytechnic of
Central London

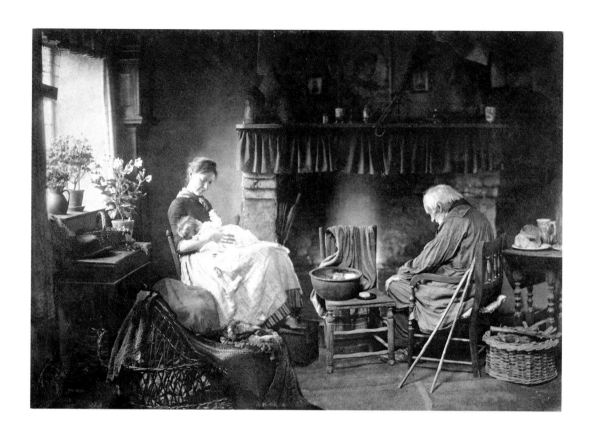

Plate 80 *Dawn and Sunset*, 1885
Toned albumen print from three negatives, 53.3 cm × 76.2 cm. Collection: The
Royal Photographic Society

Plate 81 *The Valentine*, 1885
Toned albumen print, 55.9 cm × 42.6 cm. Collection: The Royal Photographic Society

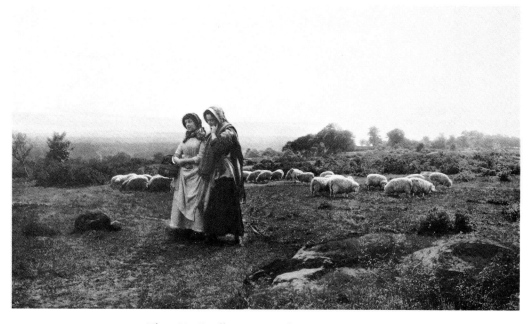

Plate 82 *Carolling*, 1887. The picture illustrates:

This Carol they began that hour,
How that a life was but a Flower
In Spring Time.

Shakespeare, *As You Like It*

Modern printing out paper print from a combination of the four Robinson negatives in collection of
The Royal Photographic Society, 1980. (Robinson's 1887 print was platinum.) 33.0 cm × 63.5 cm.
Collection: The Royal Photographic Society

Plate 83 Pencil sketch for *Carolling*, 1886/7. Note by Ralph Robinson on verso:
'Original design for Carolling before negatives were made, except that of sheep
on right'
33.0 cm × 63.5 cm. Collection: The Royal Photographic Society

Plate 84 *Rook Shooting*, 1881, from the Gwysaney, North Wales, 'Figures in Landscape' series
Albumen print, 26.7 cm × 36.8 cm. Private collection

Plate 85 *The Old Boat*, 1880, from the Gwysaney, North Wales, 'Figures in Landscape' series
Platinum print, 26.7 cm × 36.8 cm. Harker collection

Plate 86 *Mushroom Gatherers*, 1882, from the Gwysaney, North Wales, 'Figures in Landscape' series
Albumen print, 26.7 cm × 36.8 cm. Private collection

Plate 87 *Wayside Gossip*, 1882, from the Gwysaney, North Wales, 'Figures in Landscape' series. Selected by Robinson for presentation to members of the Photographic Society of Great Britain in 1883
Carbon print, by the Autotype Company, 27.3 cm × 36.2 cm. Harker collection

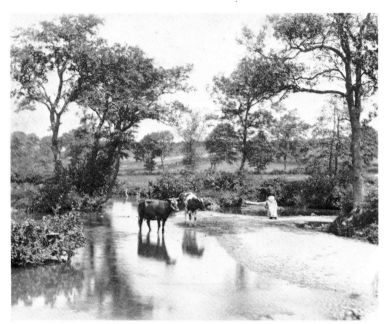

Plate 88 *Midsummer*, 1884. From the Gelligynan, North Wales,
'Figures in Landscape' series
Albumen print, 27.9 cm × 38.1 cm. Private collection

Plate 89 '*He Never Told His Love*', 1884, from the Gelligynan,
North Wales, 'Figures in Landscape' series
Albumen print, 27.9 cm × 38.1 cm. Private collection

Plate 90 *Yn Cymraiy a Saesny* (in Welsh and English), 1884, from the
Gelligynan, North Wales, 'Figures in Landscape' series
Albumen print, 27.9 cm × 38.1 cm. Private collection

Plate 91 *The Mill Door*, 1884, from the Gelligynan, North Wales,
'Figures in Landscape' series
Albumen print, 27.9 cm × 38.1 cm. Private collection

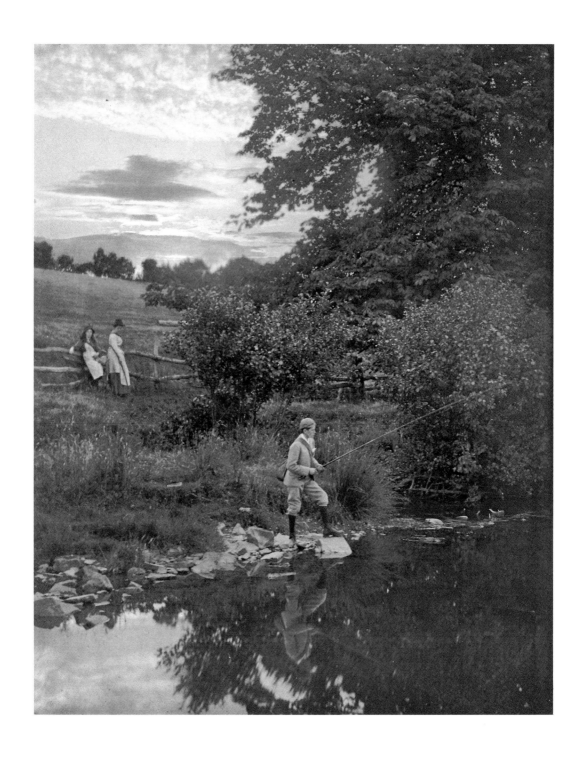

Plate 92 'At Sunset Leaps the Lusty Trout', c.1885
Platinum print, 50.9 cm × 40.3 cm. Collection: Helmut Gernsheim, HRHRC, University
of Texas at Austin

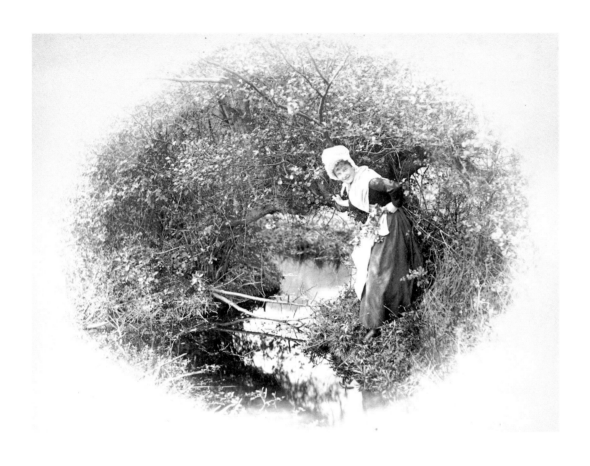

Plate 93 *Can I Jump It?* 1881, from the Gwysaney, North Wales, 'Figures in Landscape' series
Albumen print, 26.7 cm × 36.8 cm. Collection: Tunbridge Wells Museum

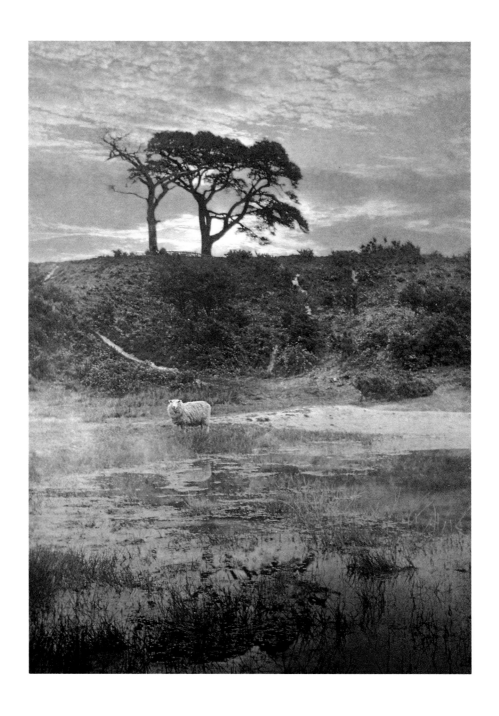

Plate 94 *Morning Mist*, 1893
Toned platinum combination print, sky with foreground, 45.5 cm × 33.0 cm. Collection: The Royal
Photographic Society

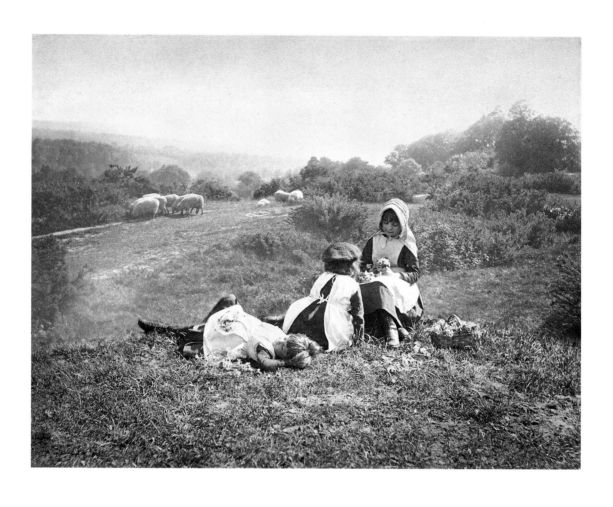

Plate 95 *Primrose Time*, 1891
Toned platinum print from two negatives, 26.8 cm × 37.0 cm. Collection: The
International Museum of Photography at George Eastman House, Rochester, New York

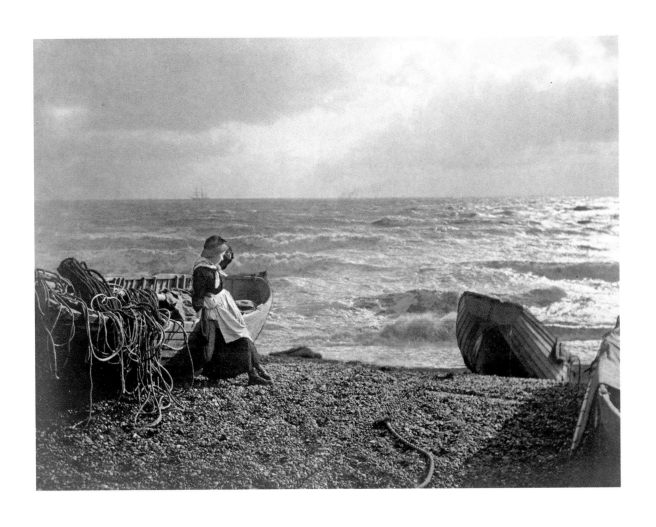

Plate 96 *A Nor'Easter*, 1883
Modern print, 19.7 cm × 24.0 cm. From a single negative made from the original
albumen combination print (two negatives), 26.7 cm × 36.8 cm. Collection: The Kodak
Collection, National Museum of Photography, Film and Television

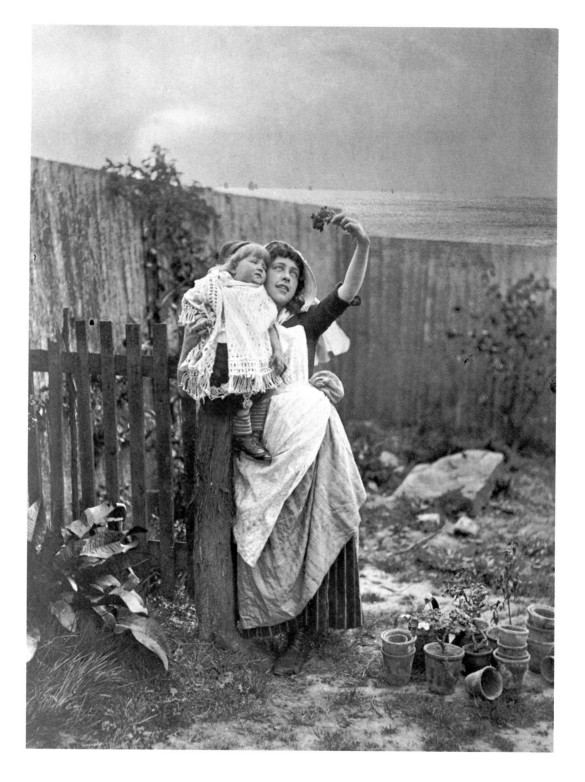

Plate 97 *The Gilly Flower*, *c*.1891
Modern print, 24.0 cm × 17.8 cm. From a single negative made from the original platinum
combination print (two negatives), 36.8 cm × 25.4 cm. Collection: The Kodak Collection, National
Museum of Photography, Film and Television

Plate 98 *Old Dapple*, 1899
Platinum print, 61.0 cm × 48.3 cm. Harker collection

Plate 99 *The Starling's Nest*, 1900
Toned platinum print, 48.3 cm × 38.1 cm. Collection: The Tunbridge Wells Museum

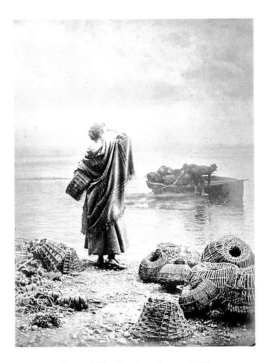

Plate 100 *Coming Boats*, 1893
Toned silver gelatine print from two negatives, 48.3 cm × 38.1 cm. Private collection

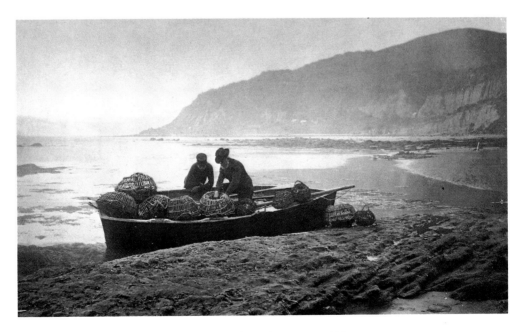

Plate 101 *The Lobster Boat*, 1888
Black platinum print, 36.8 cm × 62.2 cm. Collection: The Tunbridge Wells Museum

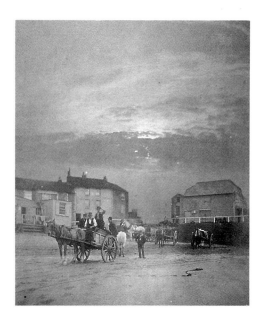

Plate 102 *Ready for the Collier, Morning*, 1894
Sepia toned silver gelatine print on rough textured paper, 45.1 cm × 36.2 cm. Combination
print from sky and foreground negatives. Collection: Helmut Gernsheim, HRHRC,
University of Texas at Austin

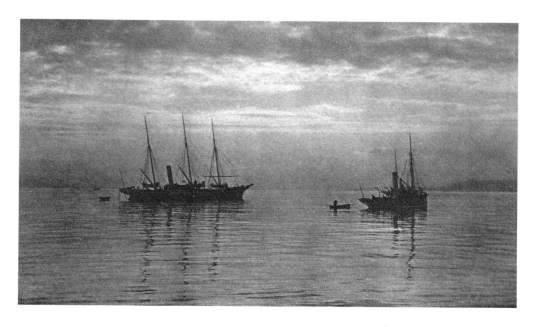

Plate 103 *Atlanta*, 1896. Number 12 in Photographic Salon portfolio, 1896
Photogravure print, 10.8 cm × 19.1 cm. Harker collection

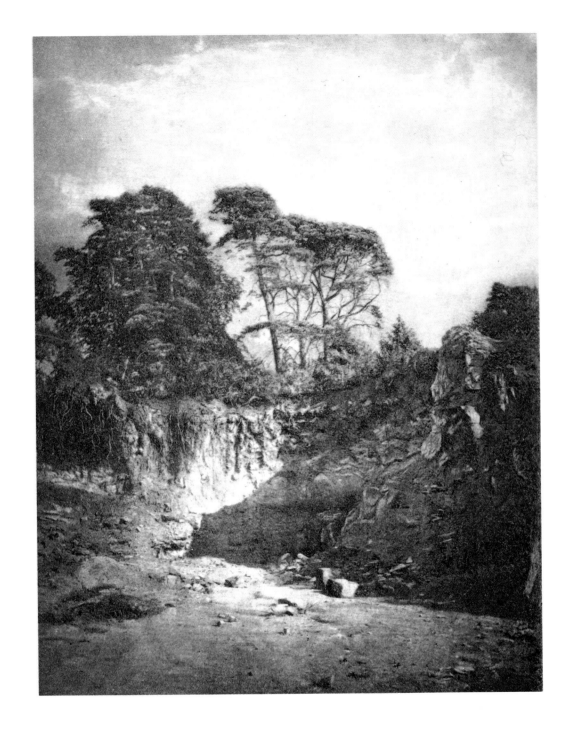

Plate 104 *Rusthall Quarry*, 1895
From photogravure print on japan tissue, 16.5 cm × 12.1 cm. First printing on
platinum paper, 48.3 cm × 35.6 cm. Harker collection